The Great New
GOLF COURSES
of CANADA

BY

JOHN GORDON

PHOTOGRAPHY BY

DOUG BALL

&

GORDIE BALL

WARWICK PUBLISHING

The Great New
GOLF COURSES
of CANADA

The Great New Golf Courses of Canada

Text Copyright ©2006 John Gordon

Photography © 2006 Doug Ball, Gordie Ball

We acknowledge the financial support of the Government of Canada through the Book Publishing Industry Development Program for our publishing activities.

The publisher wishes to thank **Nikon** for their support of this project.

ISBN: 1-894622-56-1

Published by Warwick Publishing Inc.
161 Frederick Street, Suite 200
Toronto, Ontario M5A 4P3 Canada
www.warwickgp.com

Distributed in the United States and Canada by
CDS
193 Edwards Drive
Jackson TN 38301
www.cdsbooks.com

Design: Clint Rogerson

Printed in Canada

TABLE *of* CONTENTS

DEDICATION

To "The Great Golf Family of Canada"
Leslie, Will, Allie and Maggie.
I count my blessings every day.

INTRODUCTION

I've been playing golf with a fellow named Mike St. Amand for 20 years.

Not long after we hooked up on the tee for the first time, he told me what I would soon realize was a personal mantra: "It's not so much where you play, it's with whom you play." (We call him Buddha, for his profundity as much as for his rotundity. It's certainly not because he hits it like a god.)

And if you can play a great layout with a good friend, there are few better experiences in this life.

Since the first edition of The Great Golf Courses of Canada was published in 1991, I've had that pleasure time and time and time again. There have been hundreds of rounds with my usual foursome, and other longtime friends, at many different courses around the world.

There have been scores of games across this country and others with new friends: the architects, the superintendents, and the pros responsible for the design, upkeep and operation of great courses, new and old.

While the present golf boom in Canada, which began more than 20 years ago, may appear to be continuing unabated, there are haunting signs that it may be petering out. Golf faces some serious challenges, not the least of which are the escalating amount of money and time it takes to play.

One reassuring sign is the re-emergence of a simpler school of design, one which fell out of favour decades ago. The resulting courses should be cheaper, quicker and more fun to play for all levels of golfers, which should attract more players to the game, and retain a higher percentage of existing players.

As in the previous three volumes, this edition of The Great Golf Courses of Canada offers a sampling of some of the best layouts built in this country in the past decade or so. Not a ranking, because that is a deeply flawed and irreparable concept, but a sampling, a smorgasbord of golf pleasures.

Some cost many millions to build and are very private. Others cost a fraction of that, are open to anyone with a few dollars in their pocket, and are evidence that "minimalist" architecture is being revived.

They all have their attractions, and they all offer a splendid place to smack a little white ball into a small hole with implements ill-designed for the purpose. (Winston Churchill said that, or so golf history would have it.)

Chances are you will have the opportunity to play one or, hopefully, more of the courses in this book. I guarantee you that you will have a wonderful time – doubly so, if you're playing with a good friend, like Mike St. Amand.

ACKNOWLEDGEMENTS

I feel extremely fortunate for having covered the game, those who play it, and the fields upon which we play it for a couple of decades.

Along the way, I have witnessed hundreds of games, from friendly matches to major championships, met scores of players, and taken grievous divots from hundreds of courses around the globe.

To write this book, those 20 years were invaluable. While the courses in this fourth edition of The Great Golf Courses of Canada are new, as are some of the people involved with them, many of the invaluable resources are old friends.

Most, if not all, of the sources are cited in their respective chapters, but I have to individually thank some very special people who not only are authorities, but friends. To an individual, they gave up their time and knowledge to help.

The architects: Graham Cooke, Tom McBroom, Doug Carrick, Jason Straka, Michael Hurdzan, Dana Fry, Les Furber, Rod Whitman, Wayne Carleton, Gary Browning, Wade Horrocks, Darrell Huxham. In typical Canadian fashion, almost all of these extremely talented guys are homegrown, but never get the international attention they deserve.

The photographer: Doug Ball, a friend and colleague for longer than either of us wants to acknowledge, who took the majority of the fantastic photos, and to his son, Gordie, the third generation of Ball photographers. I am in awe. (And what I said about the homegrown architects, ditto for these two talented fellows.)

The publisher: Nick Pitt. The 15 years between the first volume of this series and the fourth have taught both of us much about golf, and life.

I appreciate their help deeply and exempt them, and anyone else from whom I sought information, from any culpability for errors and omissions. Those, of course, are my responsibility alone.

John Gordon

Midland, Ontario

May 2006

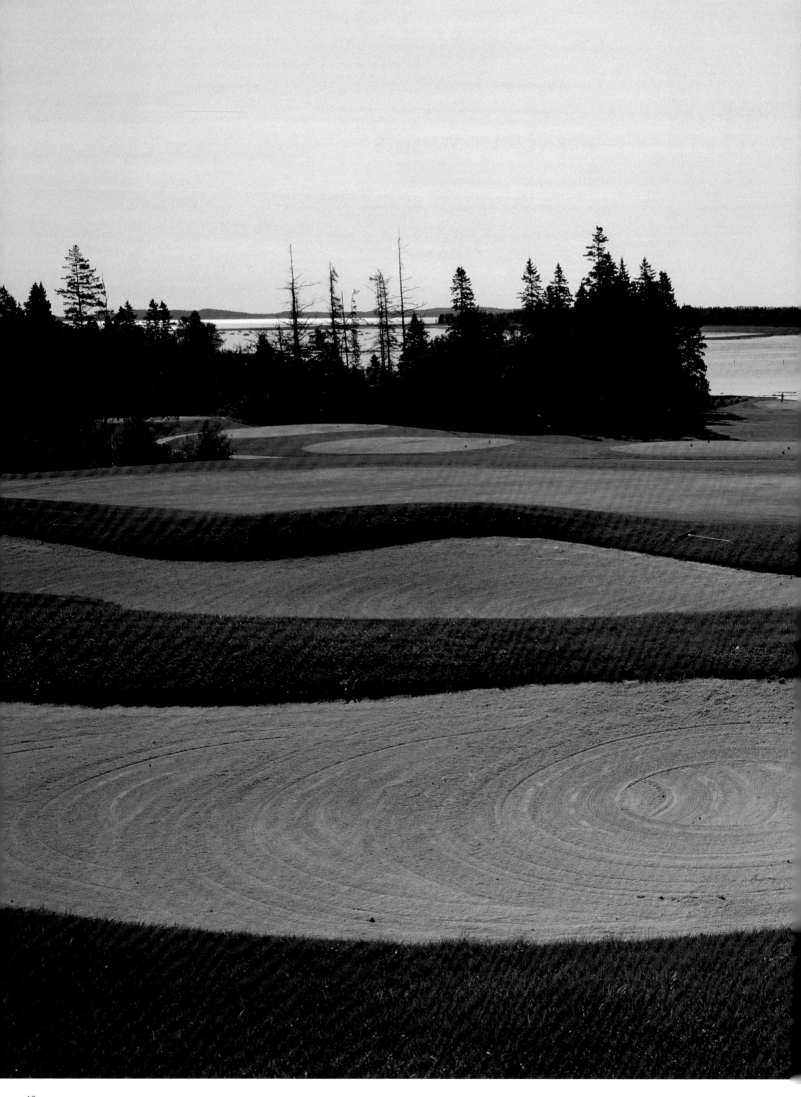

THE ALGONQUIN

St. Andrews By-The-Sea, New Brunswick

ASTUTE READERS OF THE GREAT GOLF COURSES OF CANADA SERIES WILL recall The Algonquin from the second edition back in 1993. But while the name of this golf course remains the same, the reality is totally different.

"It was a total nuke job," says architect Thomas McBroom, who first had to deal with the prickly task of persuading critics that blowing up a decent layout that bore the signature of the legendary Donald Ross was the thing to do.

That task took some doing, but eventually even the U.S.-based Donald Ross Society, dedicated to the preservation of courses designed by the father of more than 600 layouts including Pinehurst No. 2, admitted that the existing Algonquin was not worth saving.

"They tried to discover if Ross had ever been here and contributed to the work," says Director of Golf Steven Young. What they found that, even in the unlikely event that Ross, considered one of the fathers of modern course architecture, had set foot on the property, the design and construction of the course did not follow the blueprints he had created. The most probable scenario was that Ross, as he had done with many of his lesser designs, had simply mailed plans to the course owners more than 100 years ago.

Such was not the case when McBroom was contracted to totally redesign The Algonquin on the shore of Passamaquoddy Bay, the arm of the Atlantic Ocean which surrounds the charming and historic town of St. Andrews By-The-Sea.

Aside from obliterating the remnants, however questionable, of its Ross heritage, creating a new Algonquin on the site of the first course ever built in New Brunswick was a daunting task. It also required the razing of a nine-hole executive course, beloved by juniors, seniors, and beginners, and the acquisition of new lands. It demanded that the new course be appropriate for the stature of the affiliated Fairmont Algonquin resort, and the historic Loyalist

settlement itself. As well, McBroom's mandate included max-imizing its unique peninsula setting for the par-71, 7,000-yard course.

As you enter St. Andrews, you are treated to a panoramic view of the town and the bay, and the regal castle-like structure that is Fairmont Algonquin, which now is visible from every hole, as is the water. The first right turn in town takes you to the course, where bentgrass fairways contrast with Kentucky bluegrass roughs edged by gnarled trees, weather-beaten by the incessant Atlantic breezes. Top-notch service, a Fairmont specialty, is enhanced by traditional Atlantic Canadian hospitality to ensure your visit is without complaint. In 2004, Golf Digest singled out The Algonquin for special recognition in both the service and conditioning categories.

Standing on the first tee, inhaling the salt air, there is a sense that this experience will be something special. That anticipa-tion is not misplaced.

The par-4 seventh is "two-piece hole," says Young. The drive must avoid a clump of trees on the left of the landing area. Aiming too far right brings more trees into play and blocks a direct approach to the green. The shot off the tee is a fade that starts at the trees on the left. The humpbacked green is 20 yards below the level of the landing area, with a grass bunker at the front, and a morass of bunkers and fescue to the left. To the right of the green and behind it is all trees. The 219-yard par-3 eighth features an environmentally protected zone that must be

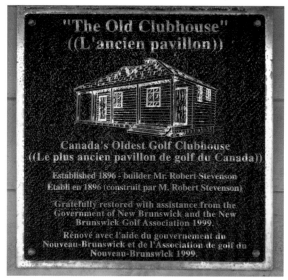

(Top) Note the white marker to the right of the 12th green? It indicates the border between Canada and the United States. (Below) The 13th hole pro-vides views of the state of Maine and Navy Island.

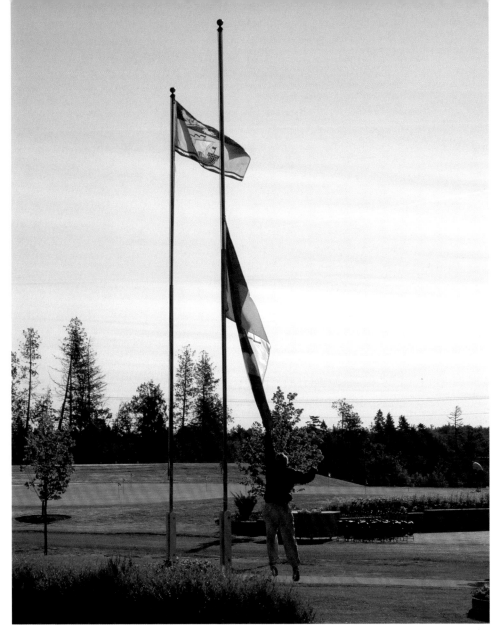

(Left) Director of Golf Steven Young lowers the flag to half staff upon hearing of the death of Canadian golf icon Moe Norman in September 2004. (Below) The 13th hole provides views of the state of Maine and Navy Island.

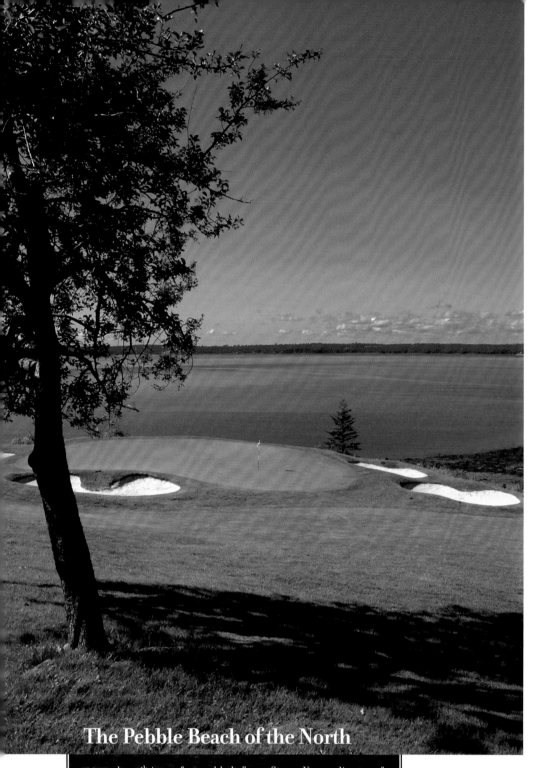

The Pebble Beach of the North

"The 12th is our featured hole," says Steven Young, director of golf at The Algonquin. "It's been called 'the Pebble Beach of the North,' in that it's like the seventh there. You play from 100 to 150 yards, depending on the tee, to a green that's far below. When you look beyond the green, all you see is the bay. Even the bunkering, with the fescue around it, reminds you of Pebble Beach. You're really on the edge of Canada, because what you see across the water is the United States.

"Once I hit a shot that looked to be all over the flag. We watched it in awe, but never saw it land because it went long into the water. So I teed up another ball, and holed it. A hole in three!"

The wind can confound club selection, calling for anything from a wedge to a 5-iron from the back tee deck, and may necessitate starting the ball out over the water in the hope that the breeze will carry the ball sideways back to the putting surface. A low-trajectory knock-down shot to cheat the wind is impossible because of the elevation change from tee to green.

carried if the pin is left. Any bailout to the right leaves a tough chip over a mound that flows down to the hole. Overly aggressive chips will run through the green into the environmental zone with its mandatory one-stroke penalty.

While the outward nine, with its traditional parkland styling, is excellent, visitors will recall for years the excitement of the seaside inward nine.

The 12th hole (see sidebar) is remarkable not only from the design and playing perspectives, but for its other attributes as well. The international boundary marker between Canada and the U.S. is just to the right of the green and is used for triangulation to determine the centre of the St. Croix River, and thus the border. Occasionally, huge freighters provide a massive backdrop to the green as they carry potatoes or ore up and down the waterway.

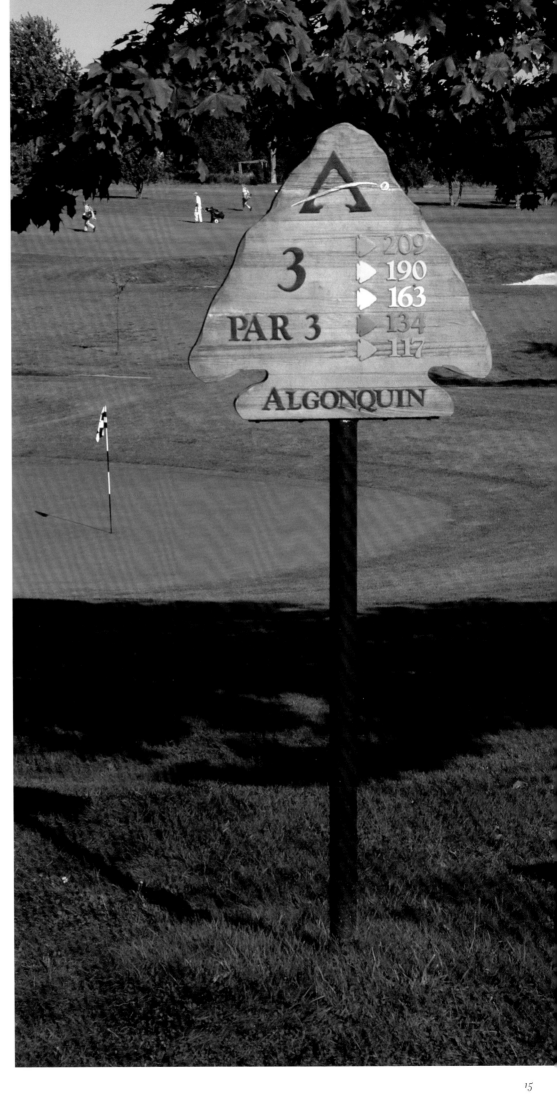

The subsequent hole used to play uphill away from the town and the water. McBroom's redesign provides sweeping views of the neighbouring state of Maine, Navy Island out in the bay, the town and the ships bobbing in its harbour. At the turn of the dogleg, the fairway balances on the edge of a cliff.

Like the Fairmont Algonquin resort, which has revitalized the spirit of this historic seaside destination, McBroom has fashioned a modern masterpiece in the tradition of the old maestros. It wouldn't be blasphemy to say that even Donald Ross would approve.

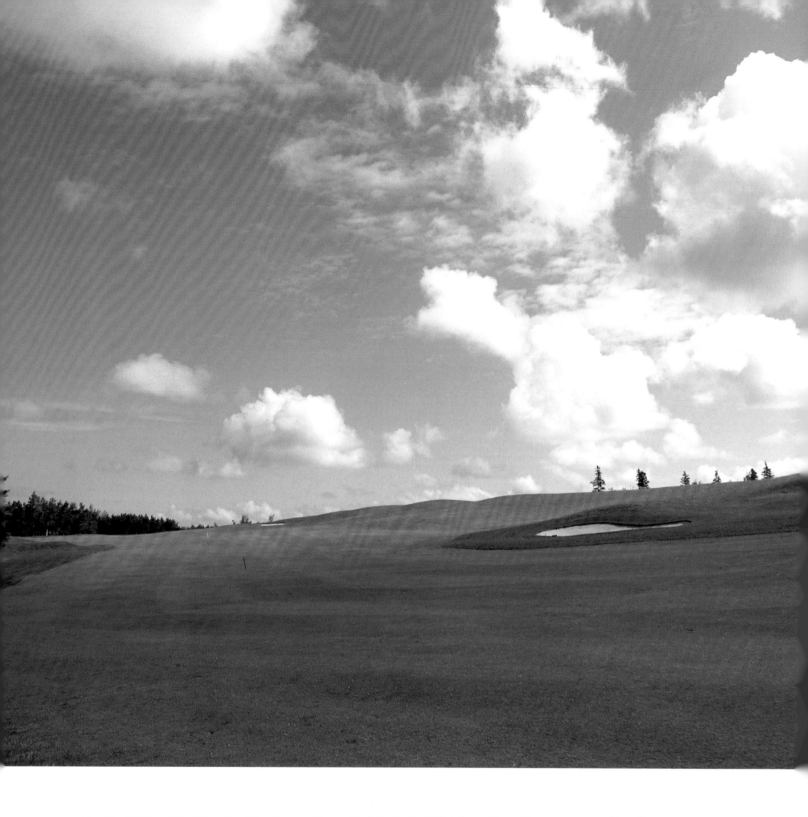

ANDERSONS CREEK GOLF COURSE

Stanley Bridge, Prince Edward Island

ALTHOUGH ARCHITECT GRAHAM COOKE HAD DONE LOTS OF RENOVATION and restoration work on Prince Edward Island, including Belvedere, Mill River, and Brudenell, Andersons Creek Golf Course was his first design on Canada's Atlantic vacation paradise.

He would have been hard-pressed to choose a more perfect site. "It is a beautiful Island landscape, with long sweeping views of the ocean," he says. "There was great flow to the property which had a little creek at the bottom, so it was very easy to

The front nine at Andersons Creek (left) is wide-open, offering vistas of Canada's smallest province. (Below) Five tee decks offer a fair test for golfers of all ability, while Graham Cooke's green complexes, like this one on No. 3, are well executed.

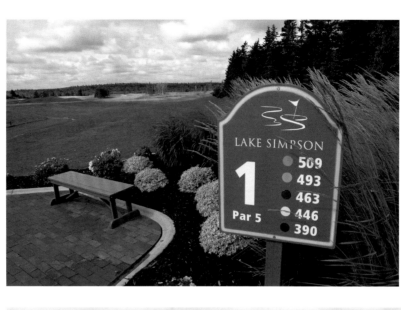

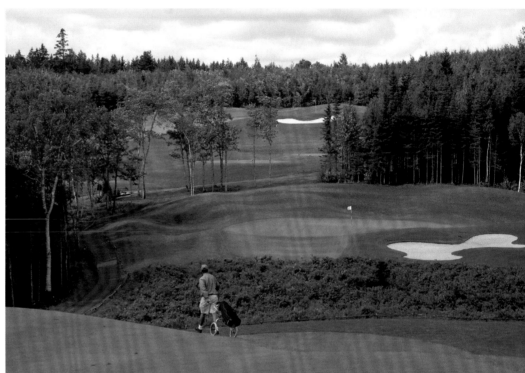

lay out. There were tons of topsoil, and the trees had been farmed around, so it had this immediate maturity.

"The toughest part was that we had to get down to the creek and then back up again but they turned into darn good holes because they're so breathtaking. It's a bit of a parkland course but with a real nice linksy flavour melded into it."

The result is an excellent resort-style course with more elevation change than usually encountered on P.E.I. courses. Each hole has at least five, and up to seven tee decks, stretching the course from 5,000 to 6,650 yards.

"It's a very forgiving course, with mounding defining the fairways on the front nine, and the back nine cut right out of the trees," says General Manager Kevin Champion. The mounds

serve to redirect slightly errant shots back into the fairway. Cooke's creativity is especially evident around the greens, with multiple bunkers protecting what could be the best conditioned greens on the Island. In addition, they are among the quickest, making reading the subtle breaks a real test even for good putters.

The back nine, especially holes 13 through 16, provides the meat of a round at Andersons Creek, Champion says.

"The 13th is a shorter par 4, only 321 from the back, but Andersons Creek runs right in front of the green. So, depending on what tees you are playing, a longer hitter might be tempted to go for it. Most people will pinpoint it down the fairway and then try to hit a wedge close. That's where you first hit over Andersons Creek, which comes into play four times on the

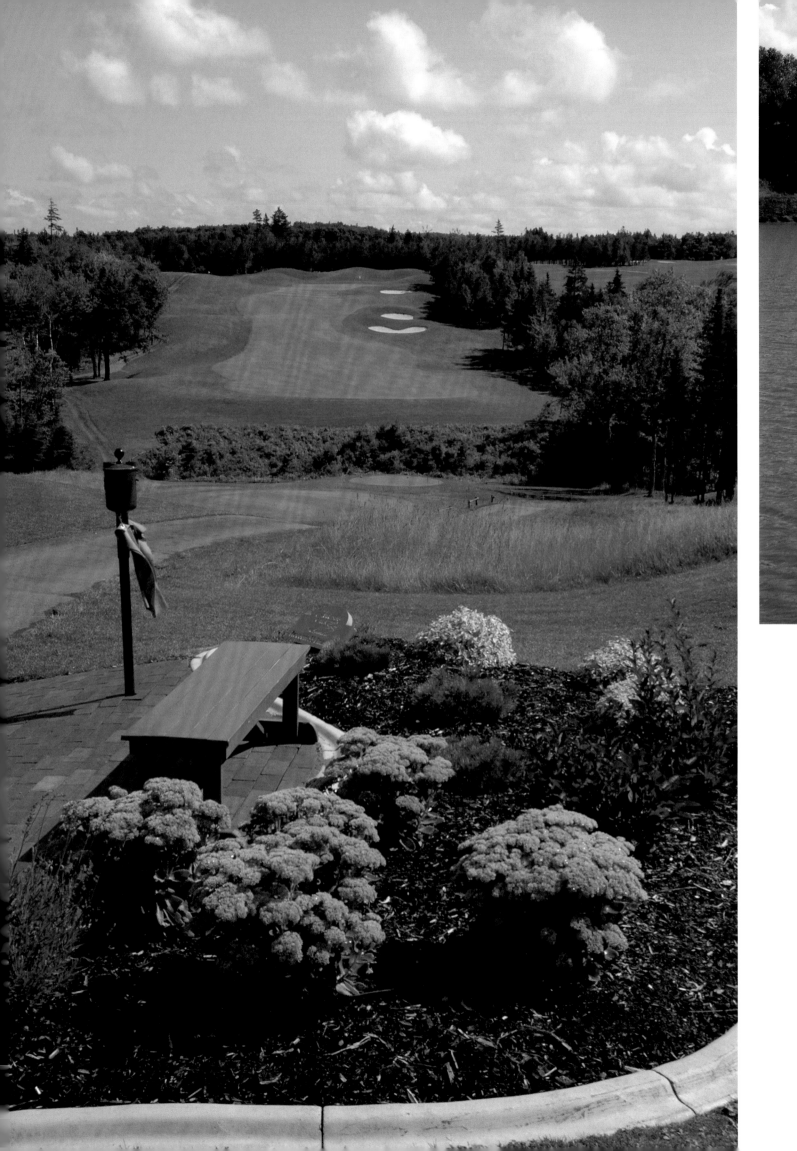

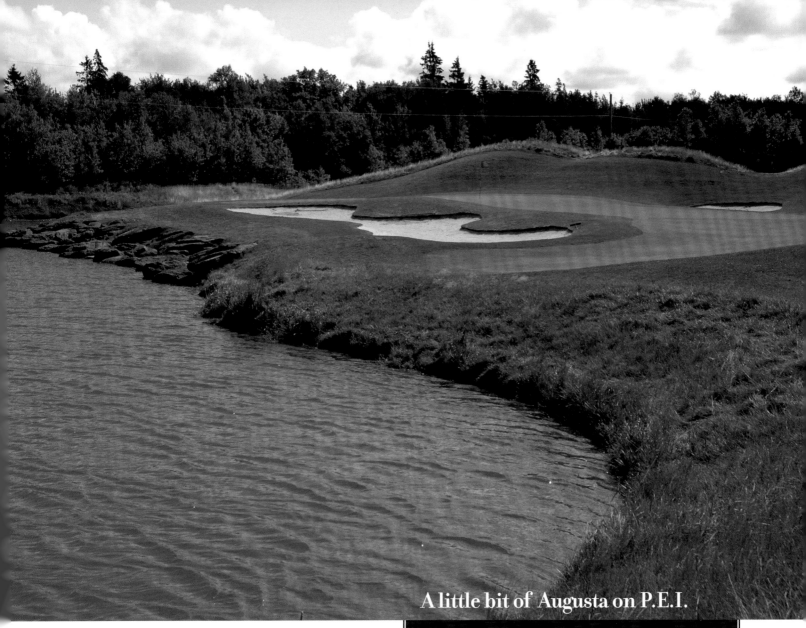

Routed through the forest, the back nine is in contrast to the linksy front. The tee shot on the par-4 15th (above) must carry the course's namesake water hazard. (Opposite) At only 523 yards, the 14th isn't long but plays uphill through a split fairway to a bowl-shaped green.

course." It should be noted that even though it is called a "creek" with typical Island understatement, this rugged watercourse can measure up to 30 yards wide in places.

The 14th, the No. 1 handicap hole, is a 603-yard par 5 which winds through the trees to an elevated green. "The tee on 15 [a 393-yard par 4] is very elevated and you have to hit over Andersons Creek, and then 16 is a great par 3 with pines surrounding it."

Andersons Creek is one of four courses — Eagles Glenn, Green Gables and Glasgow Hills are the others — in close proximity to the gorgeous Cavendish Beach vacation destination. All four have banded together for marketing purposes under the Cavendish Beach Golf Resort banner, making planning a golf trip easy.

Green Gables, designed by the legendary Stanley Thompson in 1939, is being restored in late 2005. Glasgow Hills, a Les Furber design, offers breathtaking views of the St. Lawrence River.

Andersons Creek is home to four terrific par 3s, including the 158-yard 10th which architect Graham Cooke admires because of the tee shot over water to a green faced with the typical red rock of Prince Edward Island. "A lot of visitors walk up on that tee before they even play and say, 'We can't wait to play this hole.'"

But with all due respect to the designer, Kevin Champion says the 179-yard fourth is the first among equals.

Champion, the course's general manager, says Cooke must have drawn inspiration for its design from the famous 12th at Augusta National, home of The Masters.

"When you stand on the tee, you would almost think you were on the 12th hole at Augusta. It's not a true replica, but the resemblance is uncanny.

"Instead of Rae's Creek, you're shooting over Andersons Creek, and it calls for the same shot. The green is shaped the same way and runs the same way and the tee is elevated, just like at Augusta. If the pin's back right, it's a tough one to get at, especially if there's any wind."

One difference is that the turf is not closely mown right down to the edge of Andersons Creek, whereas at Augusta National, any ball spinning back off the green finds the proverbial watery grave.

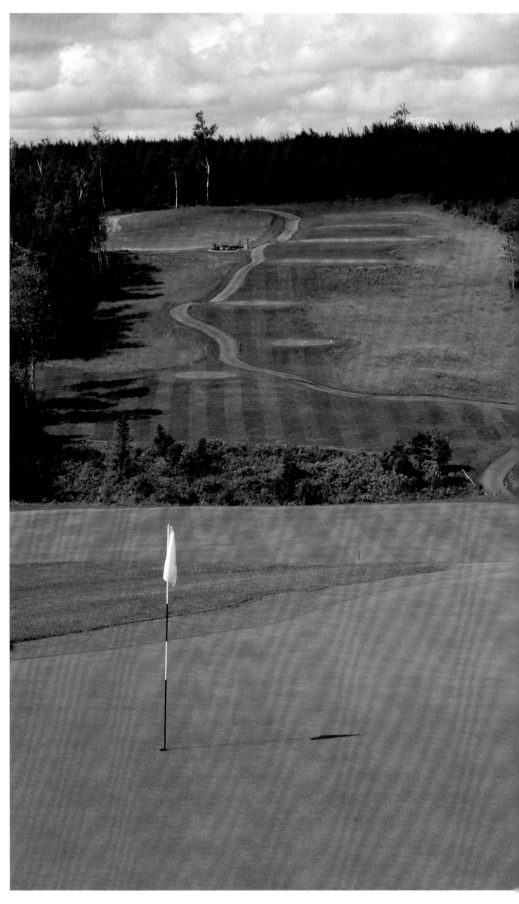

Eagles Glenn is another new Cooke design. Head Professional Ron Giggey says many visitors enjoy its user-friendly layout, often posting a career-best score while visiting it. Having said that, he says it can bare its teeth from the back tees, especially on the eighth and ninth holes.

"The eighth is 605 yards from the back, and although it's basically straightaway, the fairway zig-zags around bunkers. There's a deep gully right in front of an elevated green. The ninth is 420, uphill, and usually into the wind. If the nines were reversed, they would make a couple of the toughest finishing holes anywhere."

(Far left) Blair MacLauchlan and Charlie McLennan (right). (Top) The 420-yard ninth hole plays uphill and usually into the prevailing wind. (Bottom left) At 603 yards from the tips, the 14th is rated the toughest hole.

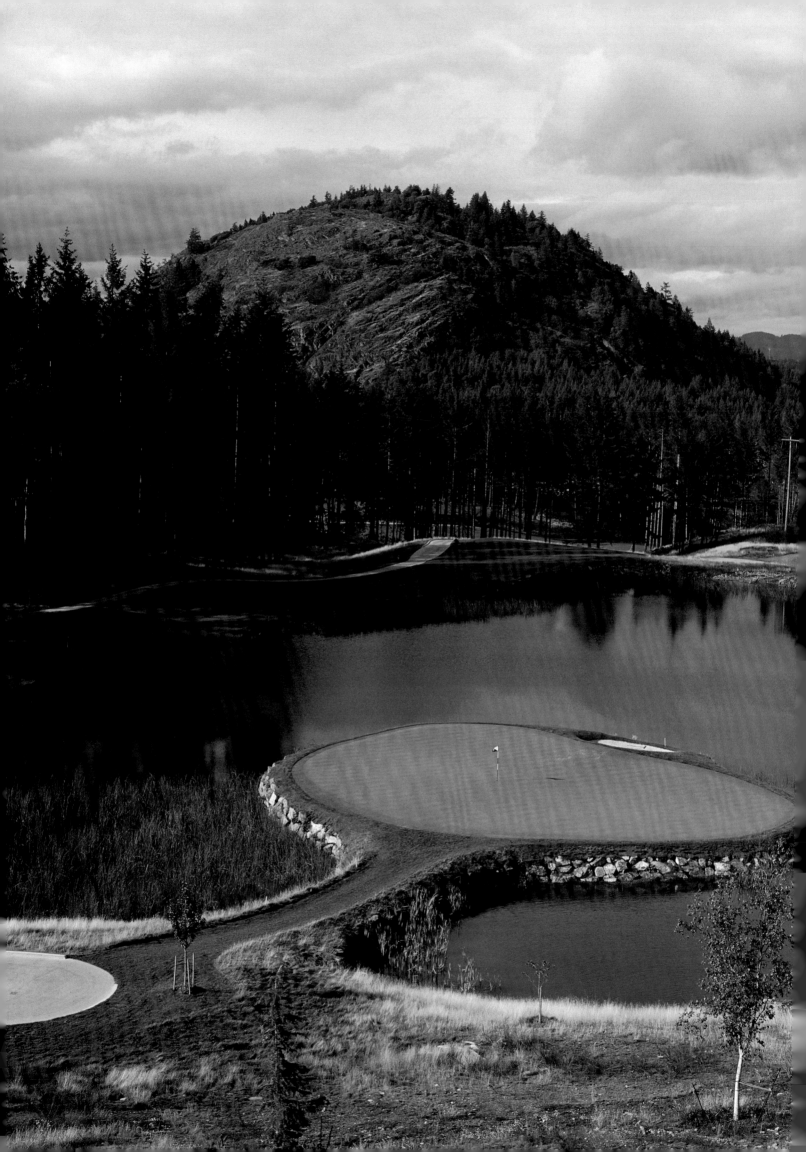

BEAR MOUNTAIN GOLF AND COUNTRY CLUB

Victoria, British Columbia

YOU GET AN INKLING THAT TWO GREAT CANADIAN SPORTS PASSIONS — HOCKEY AND GOLF — ARE intertwined when you discover that the director of golf at Bear Mountain is named Todd Mahovolich.

This golfing Mahovolich shares more than just a surname with Frank Mahovolich, the National Hockey League Hall of Famer turned Canadian senator. They are, in fact, related. Todd's great grandfather and Frank's grandfather were brothers, but the hockey connection played no part in the younger Mahovolich becoming one of the first employees at Bear Mountain which is owned by a consortium involving several past and present NHL players.

The Bear Mountain golf, residential and resort development was the brainchild of entrepreneur Len Barrie, a former professional hockey player who saw action in 184 NHL games and many more in the minors. He was hardnosed, racking up a total of 64 NHL points compared to 290 penalty minutes. That aggressive approach no doubt served him well when he turned his focus to business.

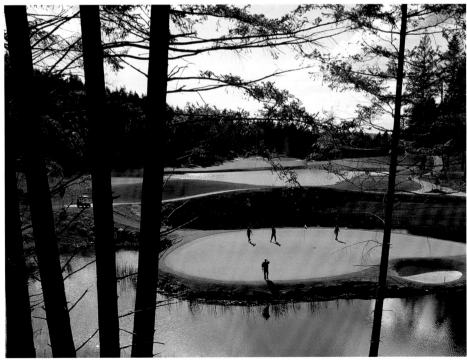

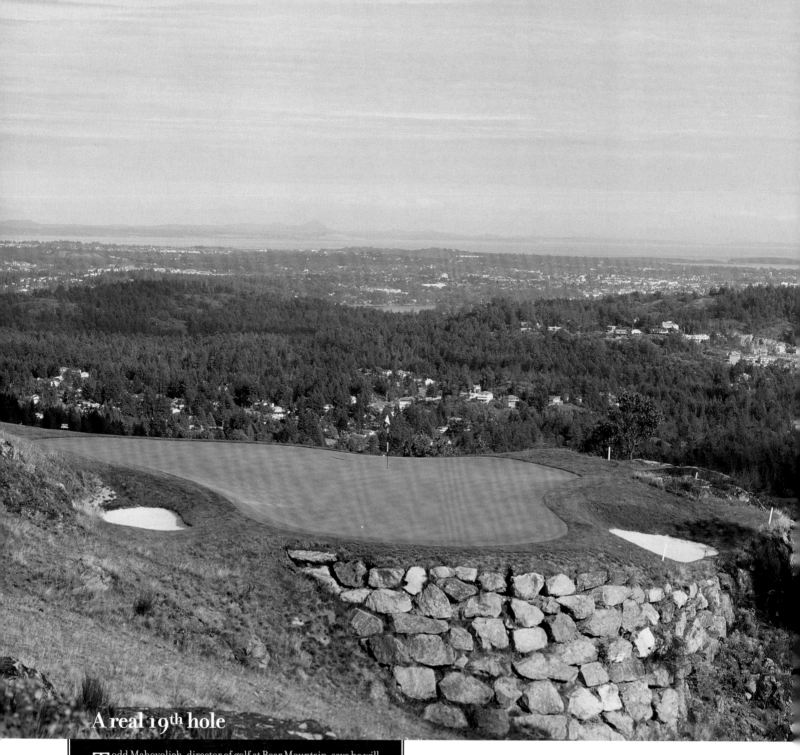

A real 19th hole

Todd Mahovolich, director of golf at Bear Mountain, says he will remember for the rest of his life walking around the property with course architects Jack and Steve Nicklaus. "It was awesome. We talked about a lot of things, they asked a lot of questions about playability and so forth."

One unique aspect that came from that conversation was the creation of an extra hole not in the original plans. The 141-yard 19th hole lies between the 14th and 15th, and it is truly a "roof of the world" setting. It offers a panoramic view of the Strait of Juan de Fuca, the Olympic Mountains, and the historic city of Victoria, the provincial capital.

While unique, the 19th is just another of Bear Mountain's superb par 3s which begin with the outstanding fourth hole. The 11th, for example, is only 124 yards but the wind can adversely affect the short iron shot needed to hit its picturesque island green. A coin-operated gumball machine filled with golf balls sits at the tee for those who require more ammunition.

(Opposite) A panoramic look at two of Bear Mountain's terrific holes: On the right, the tough uphill par-5 14th and, in the left foreground, the xxxx

Barrie recruited Mike Vernon, who played goal for the Calgary Flames and Detroit Red Wings, and project manager Kory Gronnestad. Together, they assembled a score of investors, including NHL players such as Ryan Smith, Gary Roberts, Rob Neidermeyer, Scott Mellanby, Sean Burke, and Joe Nieuwendyk. "Like hockey, you win by having a great team," Barrie says of his approach to business.

Not content with such a star-studded cast, Barrie obtained the services of Nicklaus Design to lay out what eventually will be 36 holes when the second course is completed in 2008.

That second course will have high expectations to fulfill, based on the splendid existing course, which opened under the signatures of Jack Nicklaus and his son Steve.

Just a few minutes outside the beautiful city of Victoria, on British Columbia's Vancouver Island, Bear Mountain provides unparalleled scenery and a rewarding golf experience for all handicap levels, provided they play from the appropriate tees. The severe terrain, lined by deep forest and craggy rock outcrops, can make for a long day for those who overestimate their ability and miss the landing areas.

The course plays 7,200 yards from the back tees — 7,350, if you play all 19 holes (see sidebar) — down to 5,000 yards at the front. The course rating from the back is 75.1 with a Slope of 152, so average male players would benefit from the middle deck of 6,350 where the course rating is 71 and the Slope 133.

While the mountainous terrain can make Bear Mountain visually terrifying at times, the landing areas are generous and the greens are hospitable. The layout opens in a very fair manner: The first hole is a dogleg-left par 5 with an elevated tee and a pond in front of the green. It is followed by a couple of enjoy-

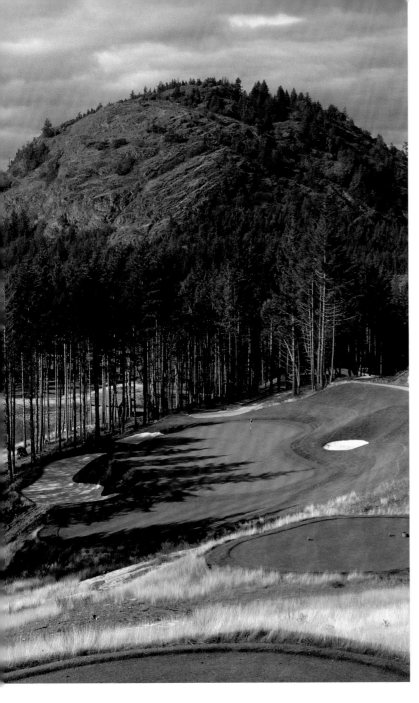

From the elevated tee, the par-3 16th (above) looks relatively benign, but deep bunkers on the left can easily produce a bogey or worse. Pocked with bunkers and guarded by a rocky hill on the left, the split fairway of the par-5 14th is fraught with danger.

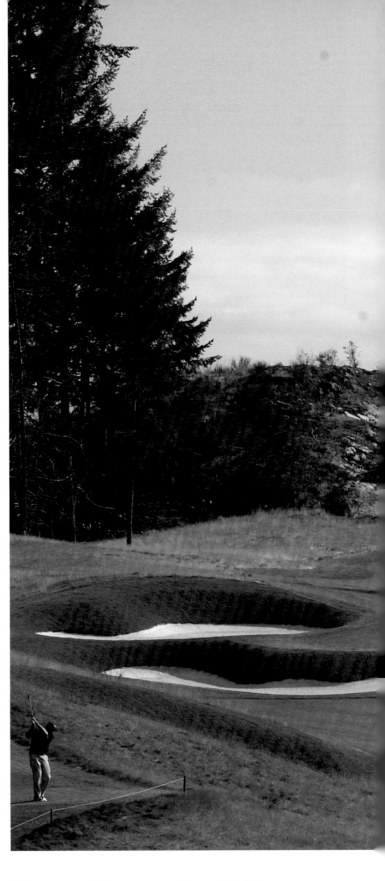

able par 4s, and then a memorable par 3 which gives you a taste of what the day will hold.

"The fourth is one very special hole that everyone enjoys," says Todd Mahovolich. "It sums up what this area is: Big trees, rugged terrain, rock outcroppings, bunkers." The sum is indeed tremendous. At 195 from the back, 150 from the middle, the fourth makes it tough to swing with total focus, as you will be overwhelmed with its beauty and challenge. It resembles nothing more than an oversized bonsai garden with its wind-twisted trees, terraces, stone-faced bunkers, deer grazing in

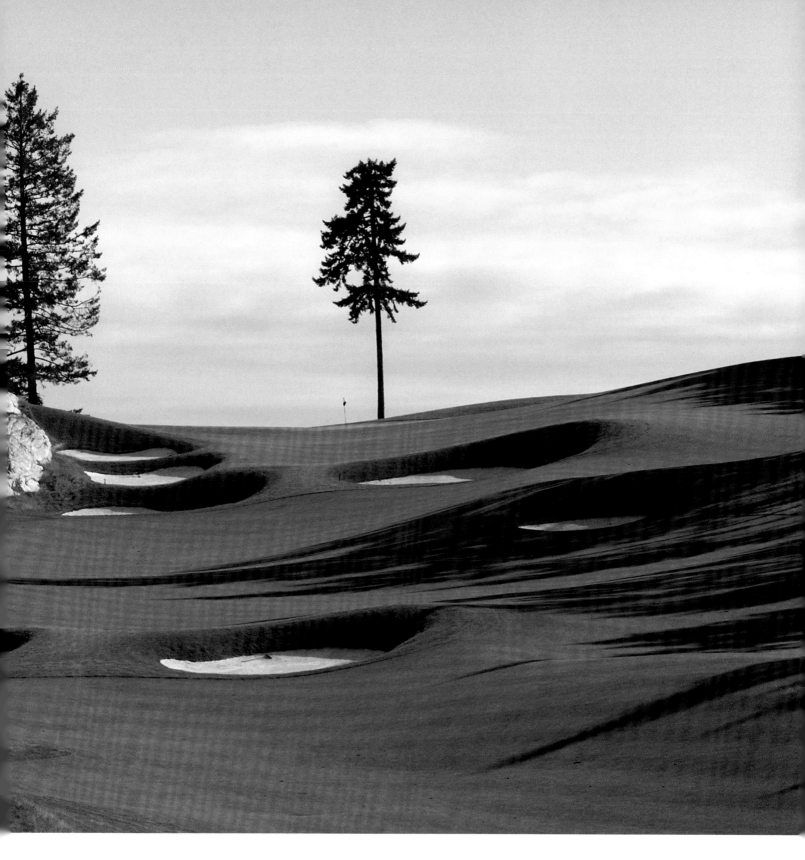

the forest which edges both sides, and nothingness behind the green. Very Zen-like.

Mahovolich also points to the 14th as a hole upon which a match could turn. While not long for a par 5 at 523 yards, the 14th plays directly uphill and offers a split fairway on the way to a green set in a bowl from which you can view Mt. Baker to the east as well as Victoria, and Port Angeles in neighbouring Washington State.

A personal favourite is the 17th, a drivable par 4, where sinking a three-foot eagle putt made the author eager for the 18th.

However, if the 17th is a pushover, the 18th is anything but. Water guards the left side of the fairway before cutting across it, and then curling back in front of the green.

"The 18th is an awesome finishing hole," Mahovolich says, "603 yards from the back, finishes over water to a relatively shallow green that puts premium on distance control. There are two bunkers behind the green, two short, water in front. It doesn't get any better than this hole. If you're going to flinch, it will be here."

BIGWIN ISLAND GOLF CLUB

Norway Point, Ontario

IN 2002, WHEN BIGWIN ISLAND GOLF CLUB WAS NAMED THE BEST NEW course in Canada by Golf Digest, it was the latest milestone in the resort's fascinating 90-year history.

In 1915, buoyed by the burgeoning tourist trade in the region, local tycoon C.O. Shaw purchased Bigwin Island, a heavily treed and rocky dot in Muskoka's Lake of Bays about a half hour northeast of Bracebridge, Ontario. Soon thereafter followed construction of an imposing rotunda, an eclectic architectural melange of Mediterranean, Tudor, Victorian, Moorish, and classical styles.

From just about every one of Bigwin Island's superb holes, like the par-4 sixth (far left), you have a view of Central Ontario's spectacular Lake of Bays. Placid whitetail deer (left) wander the course, frequently leaving their delicate hoofprints in the 75 bunkers, like these on the serpentine ninth (right).

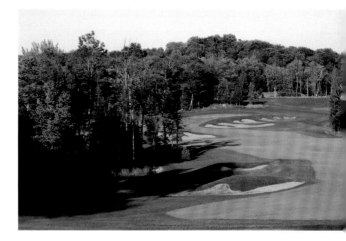

This lavish resort, with its beaches, water sports, and elegant entertainment, attracted the era's elite. All that was required to complete the recreational smorgasbord was a golf course. To that end, Shaw hired the legendary Canadian architect Stanley Thompson, who built a short, tight and tricky 18-hole layout.

In its heyday, the Bigwin Inn played host to many luminaries such as Clark Gable and Carole Lombard, Ernest Hemingway, and the Rockefellers. But Shaw's death in 1942 signalled a downturn for its fortunes which would not be reversed until Alan Peters and partner Jack Wadsworth purchased the faded lady in 1986.

Bigwin's rejuvenation included the construction of a new golf course, in the grand, classical style. To their credit, the owners selected Doug Carrick of Toronto, a Thompson disciple, to design it.

"It is a great natural setting,' says Carrick, "plus it has that historical ambiance associated with the old resort. It's quite a unique experience at Bigwin, starting when you take the boat across the lake from the mainland to the island to play golf."

Carrick had first seen the property a few years before Peters and Wadsworth bought the island, and his reaction was, "Wow! This is fantastic!" When he finally got his hands on the property, he realized his mandate was not to fashion a difficult test of golf, but to create 18 holes that reflected the ambiance of the resort.

"We wanted to open up the course, to reveal the vistas of the Lake of Bays, to showcase the rock, and to use the trees to frame the holes. They don't really come into play unless you hit it pretty crooked."

The result is a spectacular golf course, as evidenced by the Golf Digest honour, but one that heavily emphasizes playability, in contrast to the defunct Thompson layout. Although he denies experiencing the ghost of Thompson when he was routing Bigwin, Carrick mentions that there are lingering signs of illustrious predecessor's work.

"The routing doesn't resemble the original course, but some of the cleared areas were used to form part of the new course. For example, the third green is the only site we used where there was a previous green. When we were working on it, we would walk back into the woods and you could see the faint signs of where there were former tees and greens. The new 18th hole is actually the site of the old first and 18th holes, so you can see how narrow the Thompson course was."

The new rendition doesn't suffer from that pinched feeling. Generous rolling fairways and welcoming greens make the course hospitable for any

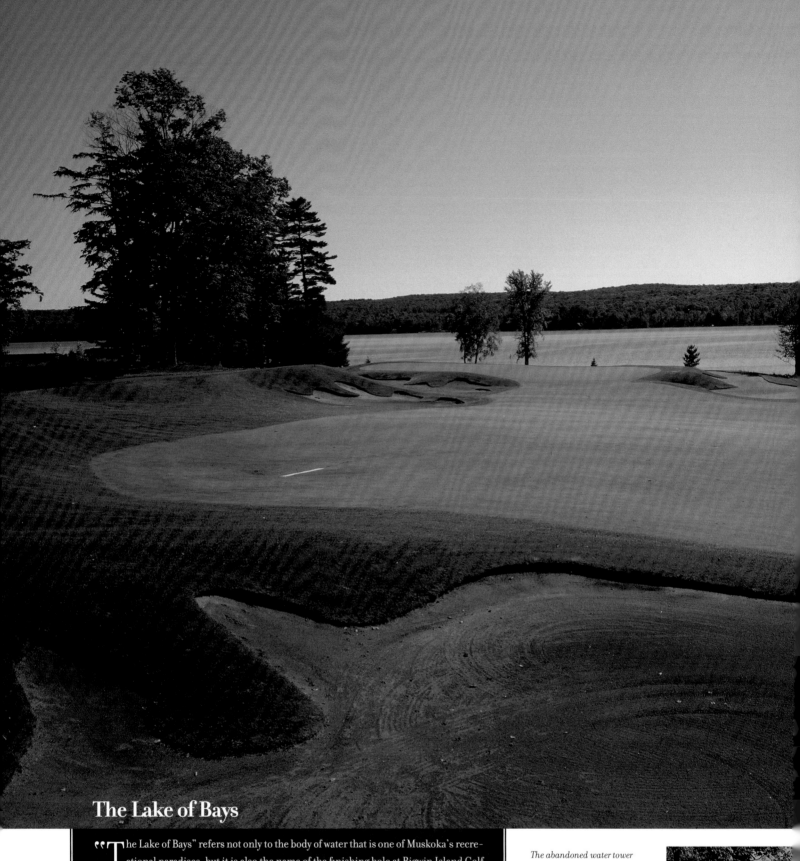

The Lake of Bays

"The Lake of Bays" refers not only to the body of water that is one of Muskoka's recreational paradises, but it is also the name of the finishing hole at Bigwin Island Golf Club. Although the card puts the distance from the back tees at 574 yards, the elevated tee shot shortens that considerably. You must, however, ignore on your opening shot what is a fairly common distraction at Bigwin: A few docile white-tailed deer may form a sedate gallery by poking their heads out of the trees. Assuming a solid tee shot, those bold enough to go for the green in two will be faced with a daunting challenge. "This is such a spectacular tee shot, and being the last tee shot of the day, you desperately want to hit a good one," says general manager Jonathan Gee, also a Canadian PGA pro. "I aim at the first fairway bunker on the right, because being on the fairway or short rough on that side shortens the second shot by perhaps 60 yards. The tricky part is that you are now over water for the most part on the next shot, but making birdie or even eagle on this hole is an unbelievable thrill. It's one of the most spectacular finishing holes anywhere in the world."

The abandoned water tower in the landing area of the par-4 fifth (previous page) provides a panoramic view of the lake and of the entire Bigwin Island. Dense forest lines many of the holes, like the sixth (lower right), and architect Doug Carrick has performed some magic with his bunkering around the elevated greens, like on the ninth (far right).

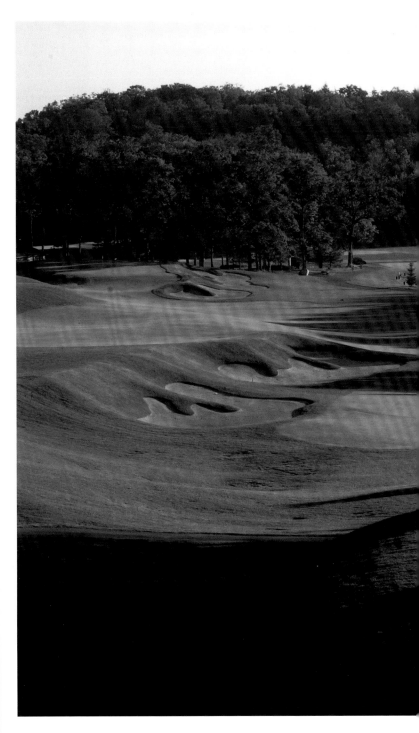

handicap level, with four tee decks stretching from 5,346 yards up to 7,166. The 75 bunkers are filled not with the glistening white sand so popular these days, but with a golden-hued silica that harks back to Bigwin's glory years.

"This golf course lends itself to sheer enjoyability because it allows you to hit the driver," says general manager Jonathan Gee. "The other fun thing about this course is the great shot values going into the greens, with the deep, deep bunkers. I've played most of the great courses in North America and I don't think any one of them matches our total experience, right from coming over by boat to the island, the great course, fabulous vistas…It's a complete day in every way. The challenge, even if you're a golf psycho, is to stay focussed on your game with all those distractions."

BLACKHAWK
GOLF CLUB

Edmonton, Alberta

IT IS FAIR TO SAY THAT ONLY A HANDFUL OF HARDCORE GOLF AFICIONADOS had ever heard of Rod Whitman before he created Wolf Creek Golf Resort in his hometown of Ponoka, Alberta, in 1983. Shame on the rest of you; more so if this is the first time you became aware of him.

Whitman's tale is as idiosyncratic as the man himself; as remarkable as the courses he designs and the way he builds them.

He followed his childhood pal, Ryan Vold, to Sam Houston State University in Texas in the late 1970s. Both dreamed of careers in golf: Vold as a PGA Tour star, Whitman, well, he wasn't quite sure. Both quickly gauged the caliber of their compe-

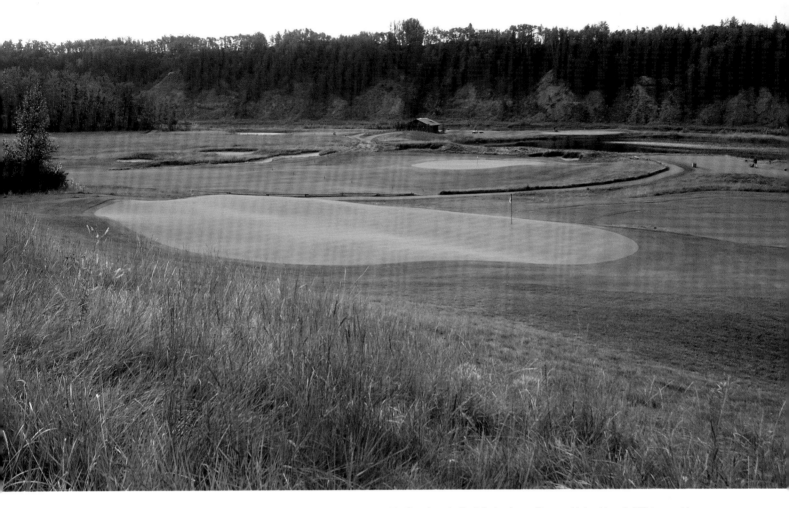

The flats along the North Saskatchewan River provided architect Rod Whitman with a palette to create a links-style layout in central Alberta. The photo above reveals the 18th green in the foreground, with the 15th and 16th holes in the distance.

tition on the school's golf team and made their life-changing decisions. Vold would become a club pro; Whitman a course architect.

That they each made the correct choice is evident. Vold visualized his family's ranch as a golf destination and Whitman, thanks in large part to a chance meeting in Texas with budding designer Bill Coore, directed his energy and talent into massaging raw property into the stuff of golfers' dreams.

That Whitman went on to apprentice under the legendary Pete Dye didn't hurt when Vold put his course development plan into action. Whitman moved tons and tons of dirt at Wolf Creek to create what looks and feels as natural a links-style course as you can imagine in Western Canada. Almost 20 years later, when Vold was involved in a development called Blackhawk just outside Edmonton, the first call he made was to his old pal.

Blackhawk was a different creature than Wolf Creek. The dynamic property snapped up and down around hills and valleys, the most stimulating of which was the huge chasm created by the North Saskatchewan River. It was the eroded and rugged edges of that topographical feature that Whitman focused on as the inspiration for the exceptional "Golden Age" bunkering that characterizes Blackhawk.

Whitman, a student of the game and its playing fields, had been directed by Coore to study the works of the masters of golf architecture's "Golden Age": Ross, Mackenzie, Tillinghast, Macdonald, Maxwell, and others.

Eventually, Coore would partner with Hall of Famer Ben Crenshaw to create a design firm whose hallmark was, in Coore's words, "admiration and respect for the classic courses...based

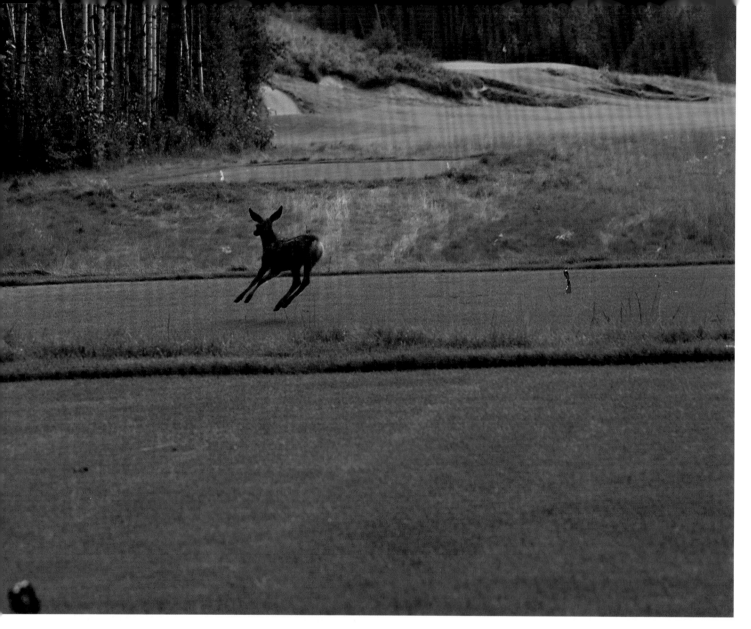

As deer frolic at Blackhawk (top left), golfers can be perplexed by the multitude of "blow-out" bunkers edged with tall fescue, like these on No. 7 (bottom left). (Above) The par-3 12th.

upon the shared philosophy that traditional, strategic golf is the most rewarding, and the creation of courses that present this concept with the greatest artistry is the ultimate goal."

Whitman not only read what Coore told him to, he took on that time-honoured credo as his own, honing it while working with Coore and Crenshaw on numerous projects such as Friars Head on New York's Long Island and Club de Medoc in France.

But when the time came for Vold to introduce Whitman to the other Blackhawk investors, there were some eyebrows raised over the architect's methods. He walked the property until he knew it intimately, he sketched hole layouts and green complexes on bar napkins and scraps of paper, he wanted to pepper the course with bunkers with raggedy edges bearded with long, drooping grasses.

While they were, in fact, modern interpretations of the way bunkers were built a century ago, he chose to point Blackhawk's principals to recent examples built by Coore and Crenshaw.

"I have to admit I had my doubts, but Ryan [Vold] kept telling me to be patient; that the end would justify the means," recalls Al Prokop, Blackhawk's managing partner. "What I really had reservations about were the bunkers, but then I had a chance to go to a Coore-Crenshaw course called Cuscowilla in Georgia. That's when I really got the gist of what [Whitman] was trying to create, those jagged, chopped out, natural pits."

The bunkers were a resounding success, as was everything else about Blackhawk, says Prokop. "Everybody loves it. Obviously the property has a big part to play in their overall

Bunker Mentality

experience here, but they love the bunkers and the variety of the golf holes and the interesting elevation changes, the fact that it looks like it's been here for years."

Another throwback design element is evident in the small, detailed green complexes. "You can take what is a 6,700-yard course and if the greens are running fast, those 6,700 yards will really test the scratch player," says Prokop. "That's the testament of a great course, that you don't need length all the time."

Whitman, who says "I'd rather run a backhoe than talk to people," not only designed Blackhawk, he built it. Literally. Other than the limited amount of bulk dirt moving, the rough-hewn, reclusive Albertan shaped every bunker, green, and most fairways himself.

At Blackhawk, not only the bunkering is a throwback to an earlier, almost forgotten era.

When a fellow writing a book about golf courses gets to play a round with the course architect, it's a treat. When it's Blackhawk and Rod Whitman, it's an extremely rare treat.

Such was the case on a sunny late-summer day in 2004. Despite his protestations of mediocrity, Whitman proved to be a proficient golfer, and a genial and entertaining host.

Blackhawk has several blind shots, as do many revered courses, although that design facet has had trouble gaining acceptance with the North American golfer. Knowing where the trouble is data gained over several rounds, so Whitman represented a fount of knowledge for the author, a first-time visitor.

"A lot of people complain about the bunker in the middle of the 15th fairway, but there's lots of room on both sides, so I don't see what they're mad about," he said as he hit his tee shot which landed, predictably, in that very pit. His second shot drove the ball into the face, his third rebounded and hit him, for a two-stroke penalty, and his third was a sideways explosion.

"I did that on purpose," he said with a broad smile, "just to make those other folks that hit it in here feel better."

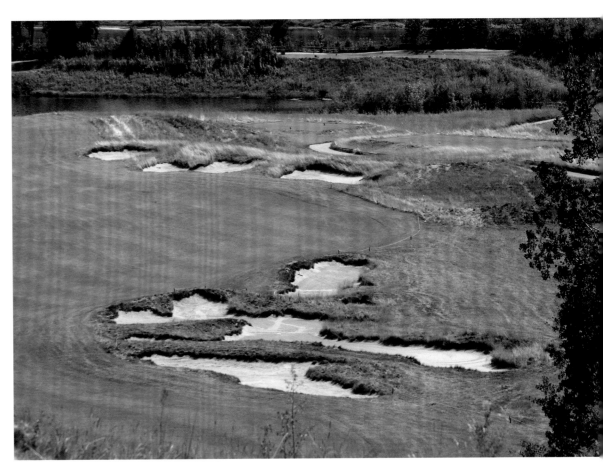

(Above) This overview of the par-5 11ᵗʰ at Blackhawk provides an excellent perspective on Whitman's remarkable bunkering, a throwback to golf's Golden Age.

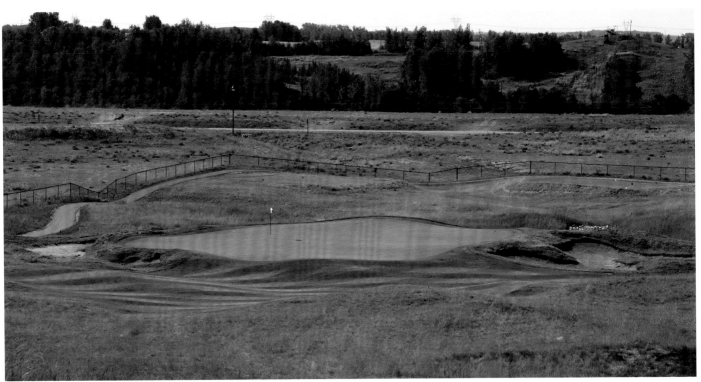

The challenge in designing Dakota Dunes was to route the course as naturally as possible through the glacial dunesland. That the architects, Wayne Carleton and Graham Cooke, successfully met that challenge is obvious from the result.

DAKOTA DUNES GOLF LINKS

Saskatoon, Saskatchewan

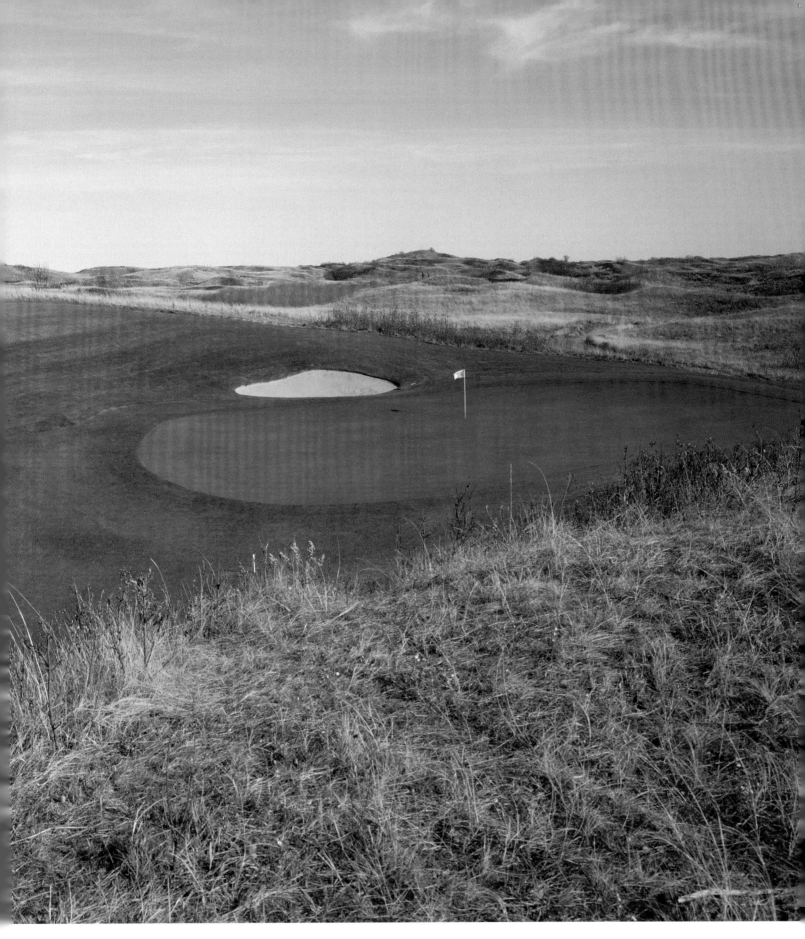

Geographically, Dakota Dunes Golf Links, which opened in 2004 to rave reviews, is just a short jaunt down Highway 219 from Saskatoon, Saskatchewan.

Philosophically, it's closer to revered courses 6,000 kilometres and a century away.

Wayne Carleton, who co-designed the layout with Graham Cooke of Montreal, calls Dakota Dunes "the opportunity of a lifetime.

"It doesn't look as if it belongs in Canada, or even North America," says the Delta, B.C.-based architect. "The challenge was to rout the course to have minimal disturbance to the fabulous natural features."

Located on the Whitecap Dakota First Nation Reserve, Dakota Dunes wends its way over a remote, isolated and – for golfers – exhilarating landscape. The dunes began their existence as a

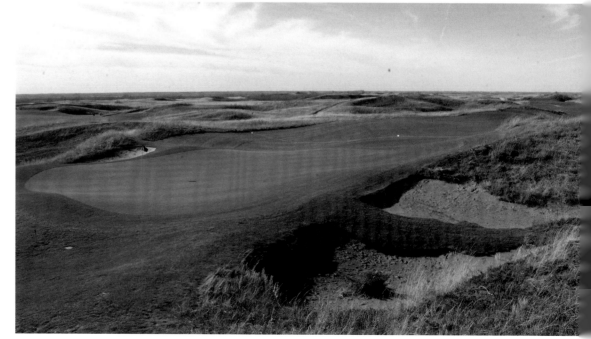

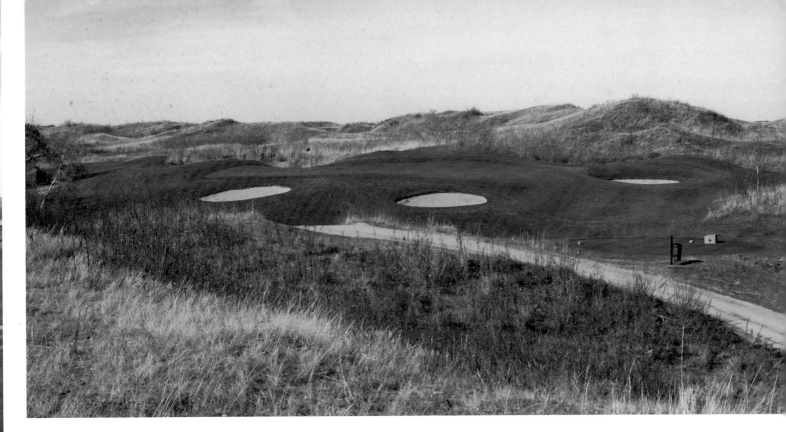

(Left) The green at the par-3 15th is nestled in a natural bowl, but like that of the short sixth (above), is well protected by bunkers. Like its old-style bunkering, the push-up greens are also built in the traditional manner.

flat delta where the Saskatchewan River flowed into glacial Lake Saskatchewan some 12,000 years ago, and then were whipped into towering sandy hills by fierce post-glacial winds.

"We preserved and accentuated the natural forms of the site, such as the high stabilized dunes, some of which are 20 to 25 feet high, small dune depressions and hollows or wind pits and the older blow-out dune complexes to form the course," says Carleton.

"The hollows and blow-out areas were both preserved and utilized to create pot bunkers and what I like to call blow-out bunkers. These bunkers were simply cut out with a mini-excavator and the edges were left rough and the surrounding needle-and-thread grasses and fescues were preserved to give the rugged natural look."

The term "blow-out bunkers" is a throwback to the earliest days of golf, where sand traps were formed when sheep would nestle against the dunes, eliminating the vegetation, allowing the wind to carve into the sand hills. "They look like someone dropped a bomb, and 'Bang!', there was a bunker," explains Carleton. "The edges are ragged and they add something special to the look and playability."

The result of this Carleton-Cooke collaboration is an inland links course featuring more than 100 pot bunkers and an additional 40 sandy natural areas and blow-outs. Some of those pots are blind to the golfer, as are several shots, again in the spirit of those ancient links. Played from the tips, the course stretches to 7,300 yards, but four tee decks can diminish that to 5,900.

The natural grasses are reminiscent of the fescues of Great Britain and the heather and gorse over there are replaced here by native shrubs such as wind-dwarfed junipers and cottonwoods. Wildflowers are in abundance and prickly pear and purple cacti serve as an occasional reminder that you are, indeed, in Saskatchewan. Kentucky bluegrass carpets the fairways and tees, while creeping bentgrass was the choice for the greens.

Combined with the almost ever-present prairie wind, which can gust as high as 90 kilometres an hour, there is no question that Dakota Dunes conveys a very similar golf experience to the original links of Scotland and Ireland. Those courses were routed through the natural terrain, utilizing existing hazards. Green and tee sites were selected on their natural suitability. Nothing was manufactured, nothing artificial was imposed on the land.

If you get the opportunity to play this unique course and agree with that assessment, then Carleton says his mission was accomplished.

"The form of the course was essentially in place and preserving and enhancing the natural look was probably the most important design philosophy we instilled to the shapers," says the architect, his pride in the finished product evident. "A great amount of time was spent onsite making daily decisions, marking the corridors of the holes and bunker outlines and working constantly with the shaper to achieve the final look. We told them this was not just another job, not just another paycheque. This was their chance to do something special, a highlight of their careers."

True to its links heritage, Dakota Dunes features greens that are simply pushed-up mounds of the existing sand. Peat was mixed into the top six inches to improve the growing medium,

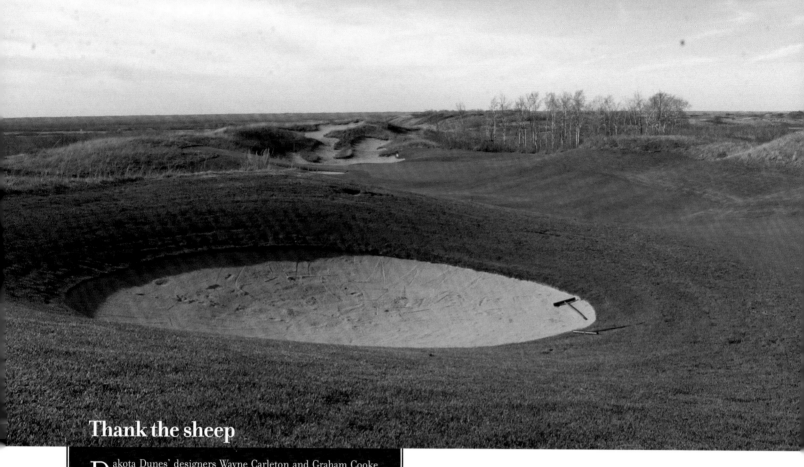

Thank the sheep

akota Dunes' designers Wayne Carleton and Graham Cooke should be congratulated for reviving a bunker style that harks back to golf's earliest days. These blow-out bunkers, a trademark of minimalist design, owe their origin to a most unlikely, four-legged, wooly creator.

"Sheep seeking shelter in hollows or behind hillocks would wear down the turf," according to Geoffrey Cornish and Ron Whitten in their authoritative book The Golf Course. "The nests and holes of small game would collapse into pits. Wind and water would then erode the topsoil from these areas, revealing the sandy base beneath. Such sandy wastelands, sand and pot bunkers dotted the landscape of a links and menaced many a golf shot."

The resulting bunkers are anathema to the modern trend of meticulously designed and geometrically shaped traps, and hopefully signal a return to golf's roots in more ways than one. Perhaps the end is in sight to the "Augusta Syndrome" where golfers expect acres of pristine, emerald golf course, shaved to the minimum and then over-watered? We can only hope.

and no drainage was installed. One visitor said the fairways looked "alive," with their incessant dips, rolls, and knobs. The result is that a level lie is an abnormality, in contrast to most modern courses, where fairways looks like emerald highways.

If this doesn't persuade you that Dakota Dunes is, like Nebraska's Sandhills, a modern interpretation of traditional links design in an inland setting, take this test:

Show these photos to any golf enthusiast and ask them to guess where this course is. Better yet, put a wager on the table. After a few sessions, you will have enough cash to fund a trip to Dakota Dunes. It's well worthwhile.

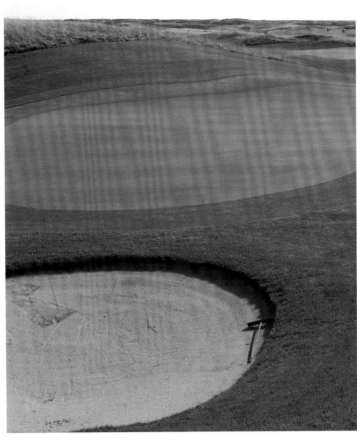

Wide-open expanses of Saskatchewan sky contrast with waving fescue and emerald fairways typify Dakota Dunes, right from the opening hole, a 424-yard par-4 (below).

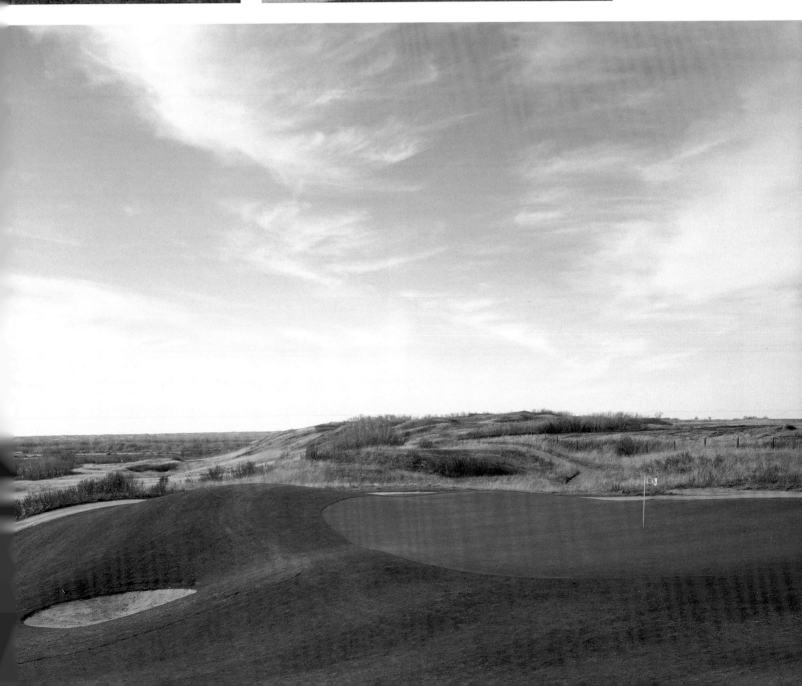

DUNDARAVE

Montague, Prince Edward Island

WHEN JASON STRAKA ARRIVED ON PRINCE EDWARD ISLAND, HE WAS told the tiny Atlantic province's goal was to become "the Myrtle Beach of Canada. They wanted a course that would make people want to fly here to play, and spend money on the Island."

That Straka, senior course architect for the renowned Ohio firm of Hurdzan-Fry, achieved that goal with the brawny Dundarave was evident when Golf Digest commanded its millions of readers to "plan your next vacation around it."

The task was not without challenges. Many Island residents were concerned that the stablemate for the picturesque Links at Crowbush Cove, which opened five years before Dundarave arrived in 1999, would be too costly for them to play. Other political hurdles faced the public-private development arrangement as well.

At Dundarave, the purest test of golf on Prince Edward Island, architect Jason Straka took into account the frailties of the average golfer while shrewdly anticipating the challenges desired by tournament players. Generous landing areas and greens combine with excellent bunker design and placement to please every golfer, as here on the 13th (left) and the eighth (above).

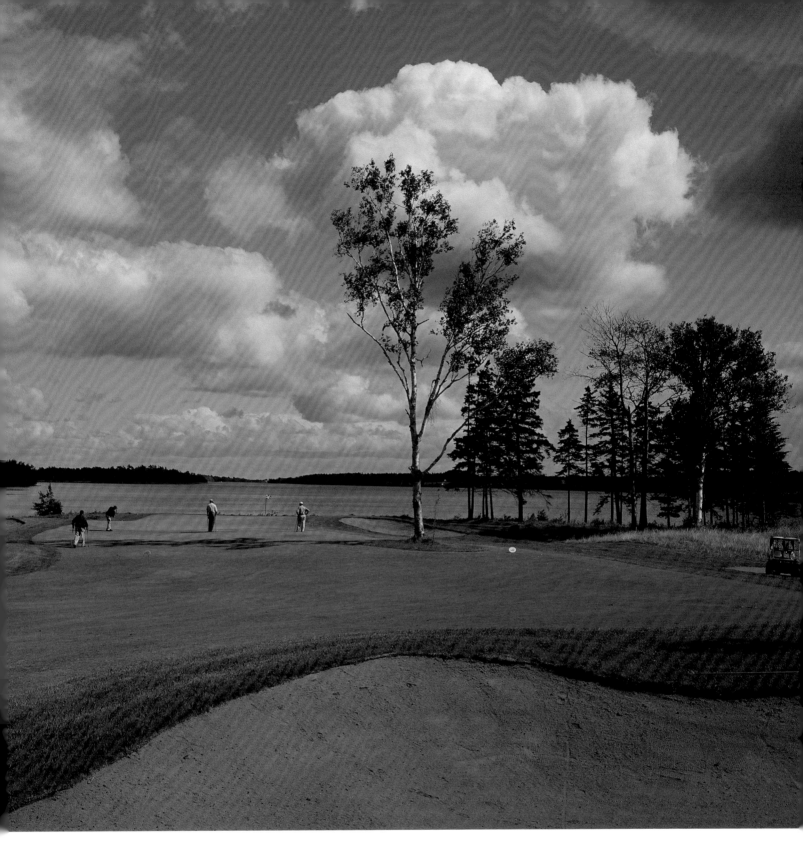

But all were overcome and the result is as muscular and straightforward layout as you will see anywhere, characterized by large greens and wide fairways. Straka and his bosses, Michael Hurdzan and Dana Fry, put together a track that provides a challenging but enjoyable and scenic test for vacationers, who represent 99 per cent of the itinerant players. As far as the tournament players, well, they are in for a surprise if they think the course is set up strictly for resort play.

"Being able to challenge both types of players can usually be handled by the number of tees, the size of the play areas, the location of hazards," Straka says. "You always have to remember that the average golfer struggles to keep it on some semblance

of turf. Then for the plus-handicap players, typically you provide intricate greens for tough pin positions, and I believe the play areas can still be wide. Narrowing fairways is not the way to go. If you have to, narrow them at 300 to 320 yards, pinching them there with bunkers or whatever hazards.

"When it's [the fairway] wider you can set some really tough angles into the greens. For example, the best angle to a particular pin might only be from the right-hand side 10 yards of the fairway so who cares if the fairway is 60 yards wide? For the professional, if it's a narrow green and he's on the left-hand side of the fairway, then he's got a difficult shot. But if the average player is over there, he's tickled pink that he's on the short

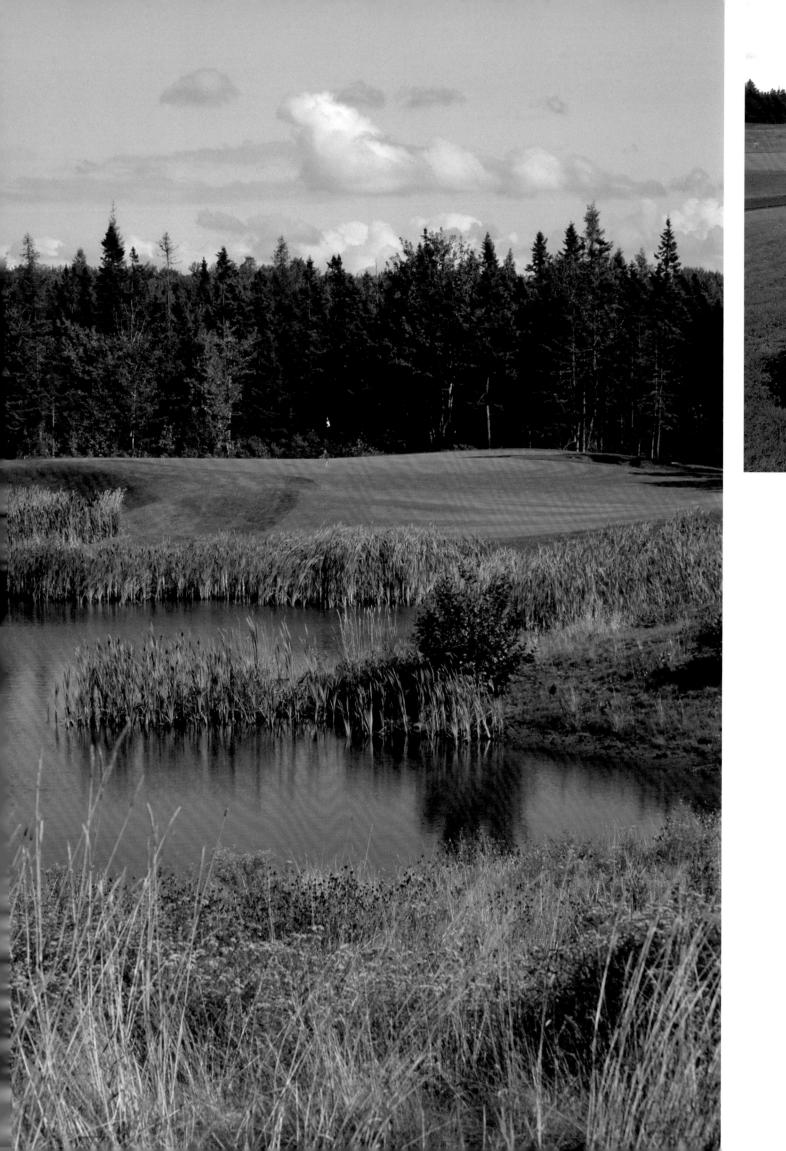

grass. The trend to narrowing fairways really precludes a lot of people from enjoying the golf course."

Greg Dukart, general manager of Golf Links PEI, says Dundarave is "pure golf; there are no tricks here." Although there is not a lot of elevation change, Straka used classic parkland design and remarkable bunkering to enhance the expansive 220 acres of red sandstone skirting the Brudenell River and the older golf course of the same name.

"It's a player's course," says Dukart. "It's strong and unrelenting. You can bite off as much as you think you can chew, from almost 7,500 yards down to 5,800. From the back, it will test all dimensions of your game, but if you play the middle tees, you can have fun with some driveable par 4s, and reachable par 5s."

One of those potentially driveable holes is the eighth which like any good short par 4 (see sidebar) offers several options off the tee. If the wind is not favourable, the smart shot is to lay up to the 150-yard marker and then try to knock your approach stiff. If the wind is behind you, driving the green means carrying the ball about 260 yards while avoiding a sandy stretch of seven bunkers.

The eighth, ninth and 10th holes represent Dundarave's ver-

sion of Augusta National's revered Amen Corner. The ninth is a slight dogleg right with water all the way down the left side. Driver might not be the wise choice off the tee because a controlled shot to the landing area leaves a full shot to the target green. On the 10th, the tee shot must clear a small quarry and a good drive will tempt the player to go for the green in two shots. However, a miss will leave the ball either in a gully or in a huge bunker to the left.

Dundarave complements the existing older course at the four-star Brudenell Resort, which ScoreGolf Magazine picked as one of the top six golf resorts in Canada. As well, the resort and conference centre offers the Canadian Golf Academy, also designed by Hurdzan-Fry. Sitting on 75 acres, it has a nine-hole, par-30 short course, a 475-yard double-ended range, 10 covered all-weather hitting stations, two short game centres with 20,000 square feet of greens, 25,000 square feet of practice putting greens, a bunker and uneven-lie area with 12,000 square feet of target green, and an indoor teaching facility.

Length is Over-rated

Many architects admit that they get the most challenge and enjoyment out of designing a cunning short par 4. Jason Straka, senior course architect for Hurdzan-Fry, is among them.

"I especially like the 16th because there's that low area along the right-hand side which is nothing but a sea of bunkers and fescue. Then there's an approach of about 20 yards short of the green where you're given enough space that if you did hit a driver, you could actually carry all the bunkers and carry it through and stop it on the green or the green surrounds. Then there's a huge fairway that goes out to the left, so you can hit two 7-irons if you chose to do so. But if you do that, then the angle of the green is blocked off and it's really shallow from that side.

"So what my concept was, was to test different play characteristics. Is it two 7-irons, is it a 3-iron and a wedge, or is it a driver and a putter? There's just not one single right way to play it. Virtually anyone can play it, since there's four or five different ways to approach the hole."

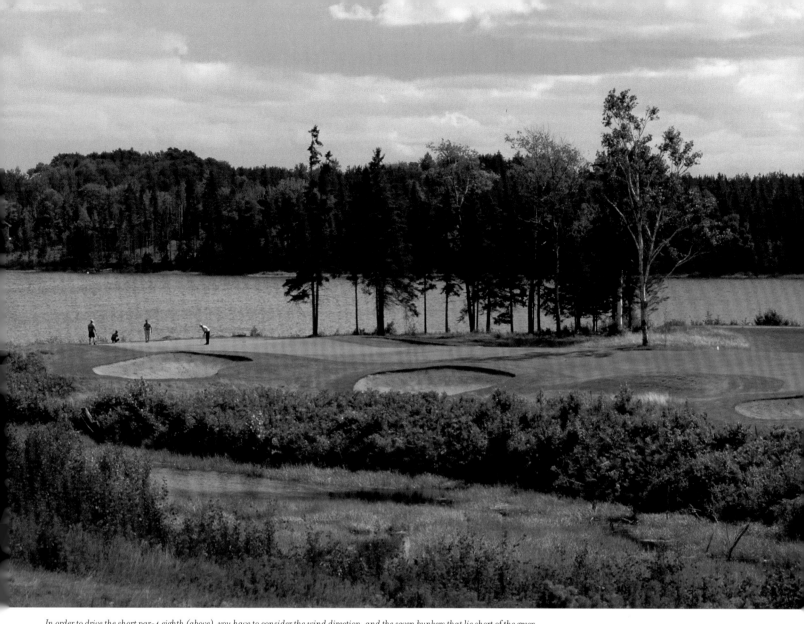

In order to drive the short par-4 eighth (above), you have to consider the wind direction, and the seven bunkers that lie short of the green.

Almost 100 sodwall bunkers, fescue roughs, fast fairways and tricky greens make Eagles Nest a worthy North American interpretation of links golf. (Right) Anything hit short of the green at the 242-yard par-3 15th will likely end up in these pot bunkers.

EAGLES NEST GOLF CLUB

Maple, Ontario

TORONTO COURSE ARCHITECT DOUG CARRICK IS A QUIET, UNASSUMING person, the kind of man the phrase, "nice guy," was coined for, but you would have trouble believing that if you took Eagles Nest Golf Club as an indication of his personality.

Eagles Nest, just north of Toronto, is a snarling, duplicitous, unyielding brute – and a total joy to play. "This course will kick the daylights out of you, especially if you play the wrong tees," says Director of Golf Euan Dougal. "But everyone seems to want to come back anyhow. That's how good it is."

Stretching almost 7,500 yards from the furthest back of its five tee decks, Eagles Nest is as faithful a reproduction of links golf as

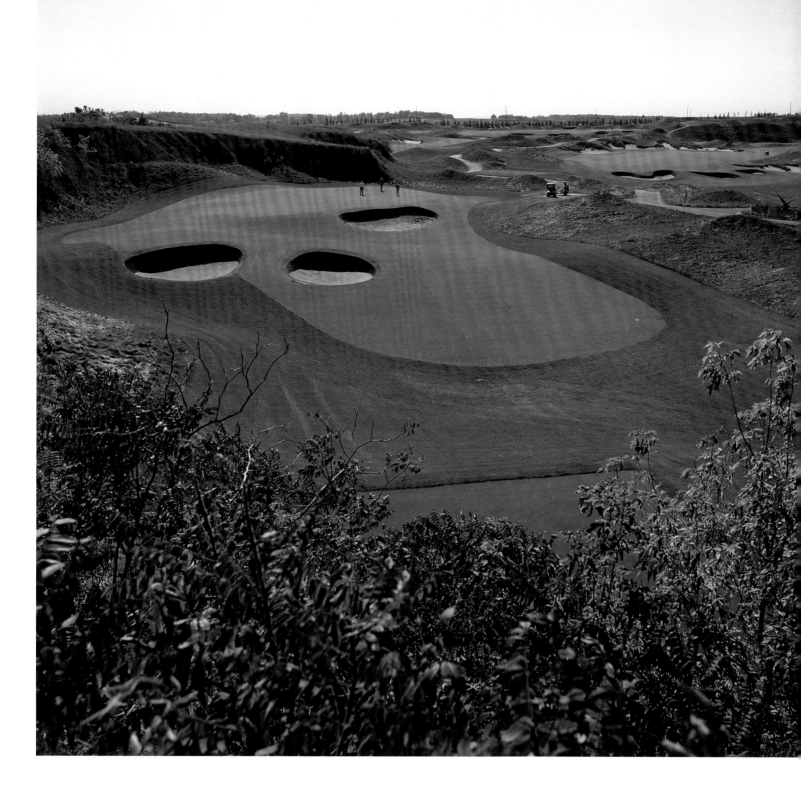

it is humanly possible to build on this side of the Atlantic. More than 90 sodwall bunkers and knee-high fescue siphon balls which a millisecond before appeared to come to rest in the fairway.

If anyone knows links golf, it is Carrick. He's built some good approximations in Canada, but Eagles Nest is the distillation of his many playing visits to Britain's famous links. As an endorsement of his ability, he is in the process of constructing a course on the shore of Loch Lomond in Scotland, due to open in 2006.

If you are skeptical about the authenticity, you would have had good company in Dougal. Born on Scotland's East Coast, he learned his game at Dunbar and played most of the famous

links. "I was chatting with Doug before the course opened, and he told me he was building a links course here. I raised my eyebrows and nodded, thinking, 'Yeah, I've heard that before about links courses on this side of the pond.' But when I played it, there were certain areas where you would hit it and get nothing out of your drive, but if you hit it where you were supposed to, the drive would go forever. That's part of links golf. This has potential for bump-and-run shots on just about every hole, and the wind is a huge factor because we're so high up. You definitely play every club in the bag, and just about every kind of shot. It's not North American target golf by any means."

(Left) The seventh is a dogleg right that demands a long and accurate drive favouring the left side, while the tee shot on the par-4 second gets lots of hang time from a highly elevated ridge.

Built on 230 acres, most of which was an abandoned sand and gravel pit, Eagles Nest offers more elevation changes than usually associated with links golf. For that reason, travelling golfers say it reminds them of more Irish courses than Scottish, although there are hints of Gullane, Gleneagles or Loch Lomond. The north end of the property formerly was a ski area.

"I liked rugged landscape," recalls Carrick. 'It looked linksy to us, and the owners wanted us to carry that theme through. The challenge is to make it look like it had always been there, so I had to tell the shapers not to make things the usual neat way, but to make a nice mound, and then take a bite out of it, gouge it, like it had been eroded over years and years by the wind and rain."

Dougal says that mission was accomplished. "I know they moved a lot of earth [1.4 million cubic yards, to be exact] but the result is that the course feels like it just fell from the sky ready-made. It plays and feels like a links course. I've gone from a skeptic to a believer.'

The result may be jarring to the eye of golfers who are fed a steady diet of manicured North American courses, but that's their problem. While the conditioning is excellent, the course is the first in the country to feature velvet bentgrass, a drought-resistant strain that plays hard and fast over the fairways that have been capped with a foot of sand to encourage the ball to run. The resulting playability is superb.

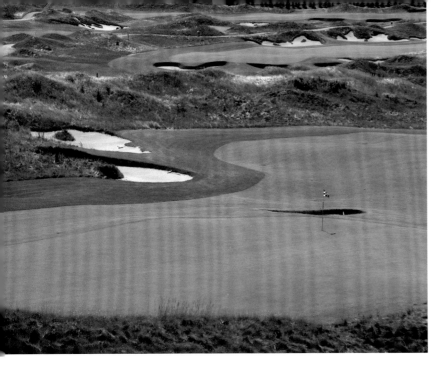

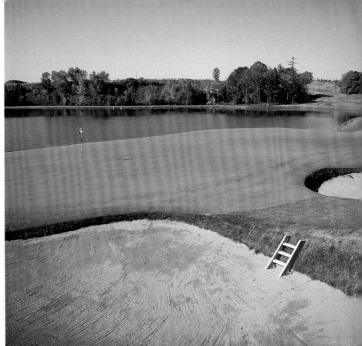

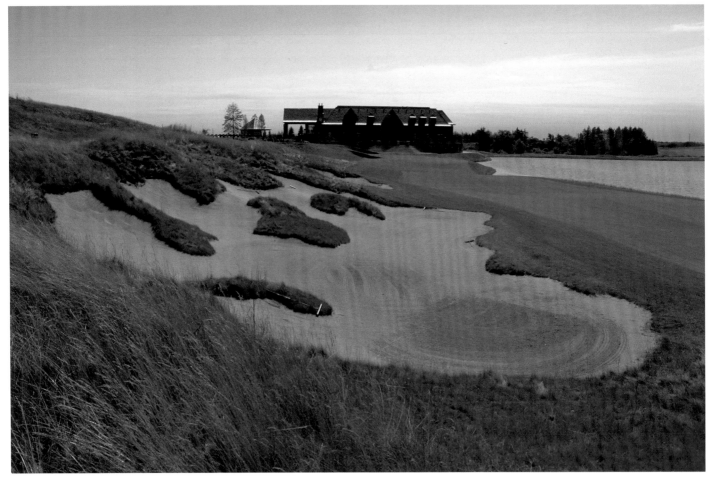

Like many courses, Eagles Nest has a definite rhythm. The opening hole, 565 from the back, is relatively innocuous and could provide a birdie chance if you are hitting the ball well. From there, you gradually go uphill, and then down into the valley holes where, depending on the pin positions, you could make the turn in good shape. The 11th, a seemingly innocent mid-length par 4, plays as the toughest hole, largely because of an excruciatingly difficult tee shot. Anything short of the plateau landing area will kick right into a collection area or worse. The green is tucked into a mound, flanked by bunkers, and has a false front that rejects any short shots.

Eagles Nest's talons come out in earnest on the final four holes. A 242-yard par 3 is followed by back-to-back par 5s of 559 and 643 yards, then you are faced with the 484-yard par-4 18th. "You stand on that 18th tee and just say, 'Oh, come on!,'" says Dougal.

First-time visitors are advised to visit the course's Web site where they can plug in their average driving distance to establish which tees suit their individual game. Playing the wrong tees brings those sodwall bunkers, waste areas and fescue into play. You will, as Dougal says, "get the daylights kicked out of you." But you'll still come back.

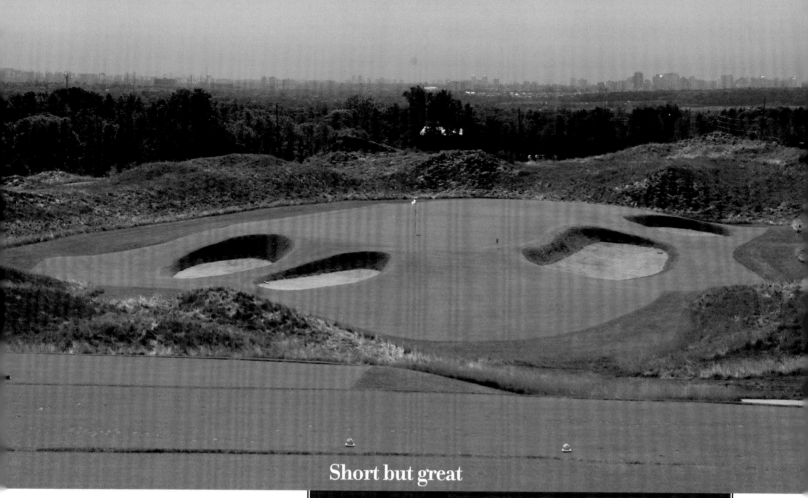

Short but great

Architect Doug Carrick designed Eagles Nest to build to a stirring conclusion. The 17th (top left) is the second of two consecutive par-5s, while the par-4 18th (top left, left, and bottom right) is a classic risk-reward par-5 of almost 500 yards

E agles Nest architect Doug Carrick takes some inspiration from Canadian golf icon Stanley Thompson of Toronto, who was renowned for his par 3s. It's obvious here. The one-shot holes play anywhere from 164 yards to 242, and length does not necessarily reflect challenge. In fact, says Director of Golf Euan Dougal, the shortest of the four par 3s, the eighth, is his favourite. "You walk up onto the tee out of the valley and have a view all the way to downtown Toronto. Really amazing, and there's always wind. It's a shortish hole, but that green is one of the toughest I've ever come across. I still haven't figured it out. There are six sodwall bunkers, and an elevated platform green. It's a bit reminiscent of the Postage Stamp at Troon. I think the par 3s here are the strongest part of the course from a shotmaking perspective."

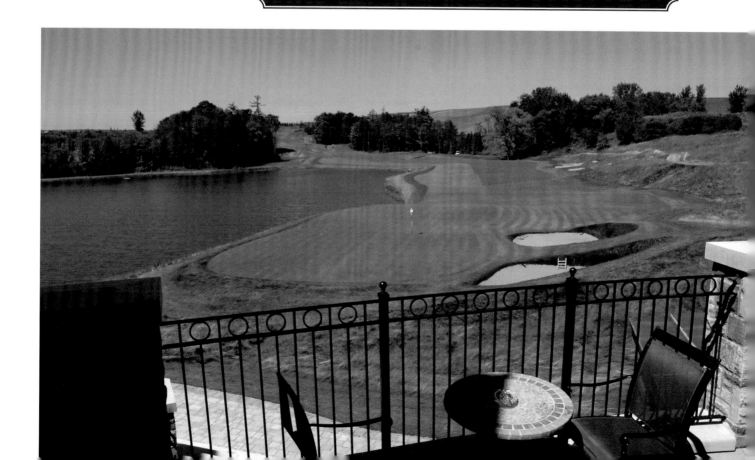

CLUB DE GOLF LE FONTAINEBLEAU

Blainville, Quebec

ALTHOUGH IT WOULD TAKE 20 YEARS FROM THE TIME HE FIRST SET EYES on the property, Graham Cooke knew that the site 30 minutes from Montreal would eventually be a golf course.

Cooke had even gone so far as to lay out a routing for 36 holes, "hoping that someone would buy and develop the land." In the intervening years, the booming housing market reduced the amount of available land but that didn't mean Cooke wasn't prepared when the new owner came calling.

That owner was ClubLink Corporation, the country's largest developer, owner and operator of golf facilities. "ClubLink saw

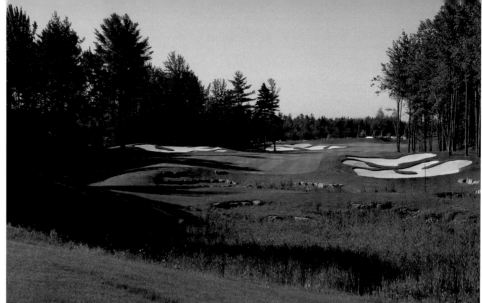
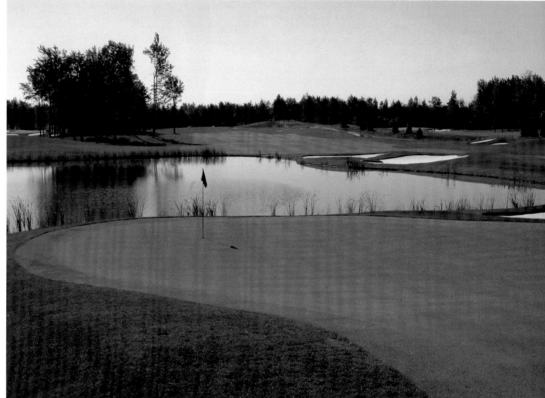

Faced with a flat property, architects Graham Cooke and Darrell Huxham massaged the earth, even elevating the clubhouse site six metres. The 15ᵗʰ (top right) and the 12ᵗʰ (above) holes became excellent tests of strategy and shotmaking with the creation of water hazards and prolific bunkering.

it as a great opportunity to have a showcase course down from Tremblant, closer to Montreal," Cooke says.

The relatively flat nature of the land also didn't daunt the experienced architect. "Not only did we have to move a lot of earth, but we had to work around residential components. The result is a big, sweeping course that, even though my associate Darrell Huxham was more involved, still carries on my design philosophy: Playable, visual, memorable."

Huxham, who has since parted company with Cooke, was indeed an integral part of this and other award-winning projects such as

Le Maitre de Mont-Tremblant and The Lynx at Kingswood Park in New Brunswick. This course, however presented some serious challenges, which taxed even his imagination.

"This is the one that kept me up nights," Huxham recalls. "It was desperately flat but what I'm really proud of is that I created dimensions there, the ups and the downs, and made the land feel as if it was moving. The holes were placed in natural corridors and swales. We dug down and lowered the fairways below the trees so it looked like they are in natural little valleys. It comes across as a really pleasing, naturally flowing golf course.

A wood even for the best

When Phil Mickelson, John Daly, Vijay Singh and Hank Kuehne showed up at Fontainebleau for the 2004 Telus Skins Game, they were presented immediately with a challenge, since much of the difficulty is found in the early going, as exemplified by the par-3 sixth hole.

"The sixth is 225 yards from the back tees to a very tough, two-tiered green," says Eric Lamarre, director of golf at Le Fontainebleau. "A lot of times the wind is coming from the right, and into your face. Phil Mickelson hit a 3-wood here during the Skins Game. He went just over the green, but it still was a fairway wood. If you miss left, you're in the bunkers, and the two tiers are about four feet in difference, so you've got to make sure you're on the right tier. On the right is deep rough and over the back, well, you're pretty much dead."

Mickelson, one of the great short-game players of this or any other era, went on to make par, as did Daly, carrying over the skin. Eventually, the left-handed Mickelson would win the event with a total of eight skins, worth Cdn $165,000.

Le Fontainebleau opens with bang. If you get through the opening six holes at even par, you feel like you're two-under. Here, the sixth (top) and the par-3 fourth (above). The 14th (top left) stretches 585 yards and, like the fifth, at almost 600 yards, should be played as a three-shot hole.

The land looks like it has lots of natural movement to it when in reality there might be a metre of natural grade slope from one end of the property to the other."

The clubhouse site was raised six metres, but graded out up to 200 metres in every direction, so the 15,000 square-foot, neo-classical edifice looks like it is sitting on a natural knoll, rather than perched on an artificial podium.

Director of Golf Eric Lamarre came to Le Fontainebleau from Le Maitre even before it opened in 2001. "I arrived during the construction and as soon as I went around it once, I knew there was something awesome going on here. One thing that caught my eye was that 12,000 square-foot green on No. 12 with its two tiers, and I thought that if the pin was at the bottom there, well, it would be a tough par. I didn't know then that I would see Phil Mickelson hit it close from out of the left bunker during the Skins Game, but it takes a special player with a lot of guts to do that."

Lamarre says you have to be patient if you are hunting for birdies at Le Fontainebleau. The challenge comes early in the round, so make full use of the practice facility before you tee off.

"I would say three through six is the tough stretch here. If you

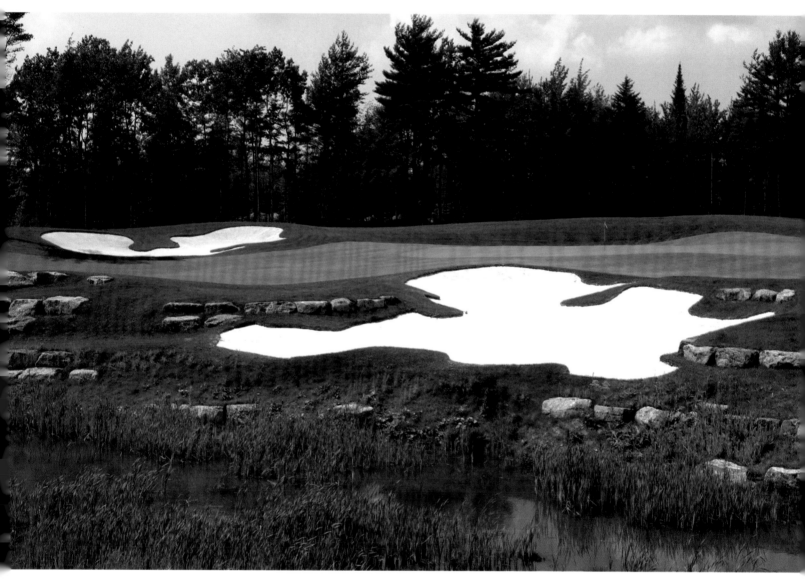

get through there at even par, count your blessings. As a matter of fact, if you get to the seventh tee at even par, you'll likely feel like you're two under. It's just damage control on the front nine, really, because it's tougher than the back."

The third is a 445-yard, slight dogleg right par 4 where a tee shot to just in front of the left fairway bunker is ideal. A good drive will leave a mid-iron into a narrow but deep green.

"The fourth is a par 3 that isn't all that long but when the pin is on the left side, you want to bail out right to avoid the huge bunker that protects that pin position," Lamarre advises. "If

you land just past the bunker, it lands on the down slope and it will run right through into the rough."

The fifth is a 595-yard par 5 that should be played as a three-shotter, says Lamarre. "The hardest shot is the drive, but if you hit the fairway, then your second shot is pretty wide open. The driving area is narrow with a bunker and woods, and it's a really tough driving hole. It's very intimidating to hit driver, and why would you if you can't get there in two?"

As some of the world's best players have found out, the sixth is no pushover, either. (see sidebar)

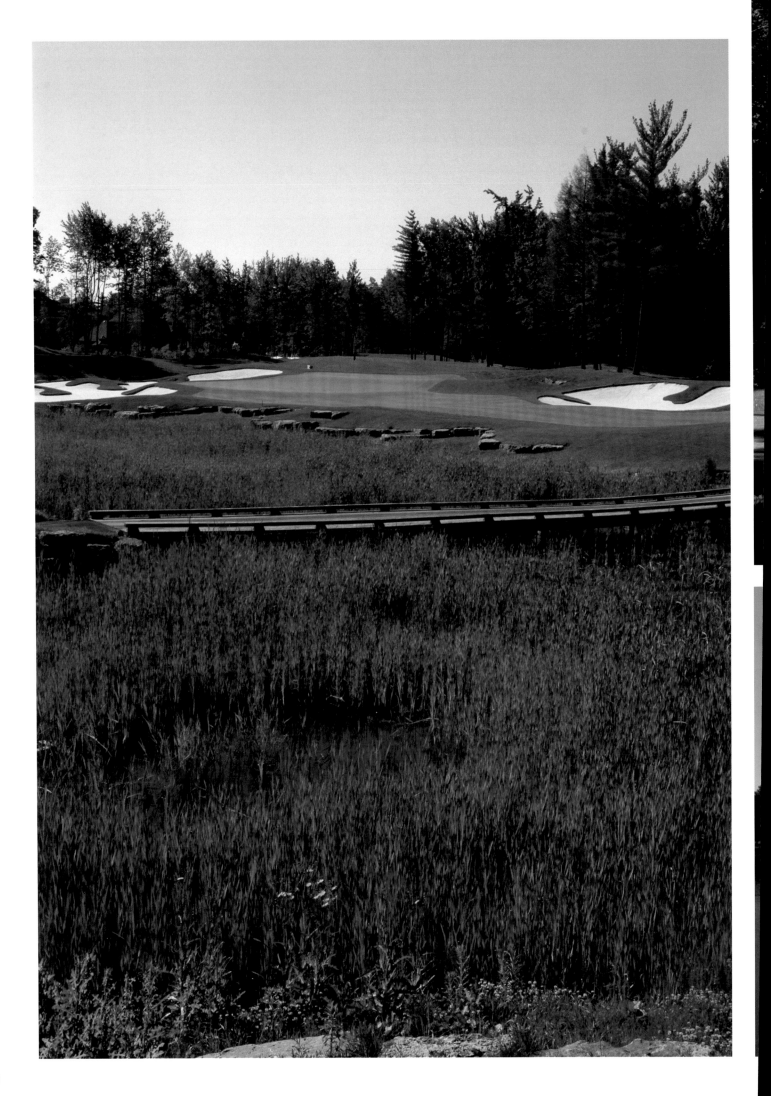

The 170-yard 17th (left)

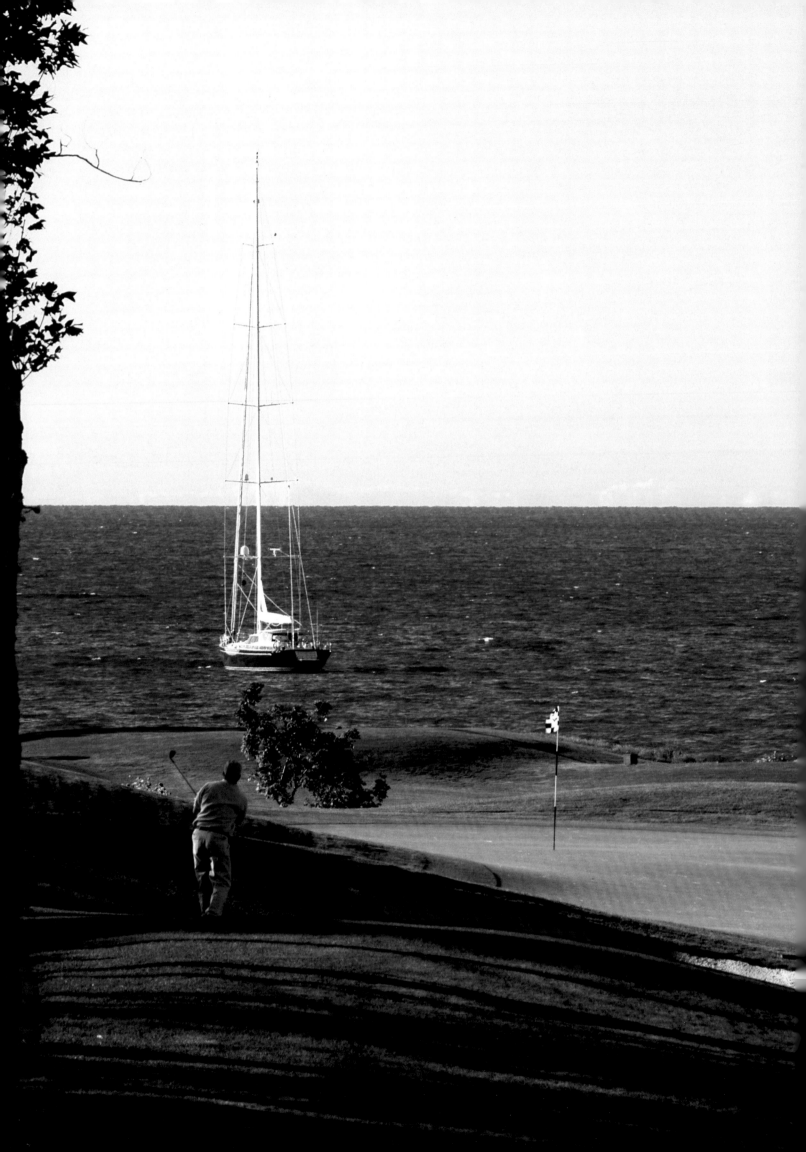

FOX HARB'R

Wallace, Nova Scotia

THE FIRST HINT THAT FOX HARB'R IS SOMETHING OUT OF THE ORDINARY comes just after you enter the gates and see a sign beside the lush fairway which reads: "Attention. Watch for approaching aircraft."

Make no mistake, though. You are not on the flight path of some international airport. Instead, says course architect Graham Cooke, you are on a remote parcel of 1,000 acres on the north coast of Nova Scotia owned by billionaire Ron Joyce, the co-founder of Tim Hortons, the huge coffee-and-donut chain.

The back nine at Fox Harb'r is set on one of the most breathtaking properties anywhere. Distractions abound, including luxurious sailboats in the Northumberland Strait, as here on No. 11 (far left). A timber-reinforced sodwall bunder provides an aesthetic addition to No. 5 (left) while water provides a scenic and very real hazard on the seventh (above).

Joyce, who sold Tim Hortons 10 years ago, came late to the game of golf, but when he bought this coastal peninsula, he knew it was begging for a prestigious course to be the centrepiece of the exclusive recreational enclave he envisioned for the rich and famous.

"It was an intriguing, powerful site," says Cooke, "with the harbour on one side and the ocean, the Northumberland Strait, on the other with its red rocky cliffs that are typical of the region. It's a very special place, charming, isolated, tranquil, with seals in the ocean and spectacular sunsets."

Only a couple of hours' drive from Halifax, should you choose not to arrive in style by private jet or helicopter, Fox Harb'r is an amalgam of two very distinct styles. The front nine is a traditional parkland setting, reminiscent in places of the Carolinas, with generous bunkering, water hazards and stands of coniferous trees. The back nine brings the

While the fact that the 18th (left) cuts inland provides an anticlimactic finish to the round, there is no denying its status as a great golf hole. At shadowy dusk (right), the genius of Graham Cooke's attention to shaping detail is undeniable.

Monterey Peninsula to mind, with five holes playing on the edge of the ocean.

For Cooke, whose other marquee work includes the restoration of the iconic Stanley Thompson creation, Highlands Links on Nova Scotia's Cape Breton Island, it was a rare opportunity to work with an open-ended budget on a once-in-a-lifetime site. His mandate included not only creating a course that would garner worldwide attention, but incorporating every other aspect of the resort into his plan. Those aspects included residential units, the aforementioned runway and hangars, and recreational amenities such as tennis and skeet shooting.

Based on the results, there can be no question that the course was the priority. Thousands of yards of earth were relocated to create the elevation changes and other features on the front nine, where hundreds of scrubby trees were removed and replaced with bunkers and water hazards.

"We were given a unique palette at Fox Harb'r and I think we made the most of it," Cooke says. "While we used a variety of styles and forms, it isn't confusing and it isn't constantly over-powering the golfer. There are spots, especially on the back nine, where there is great excitement, but you have to have that excitement ebb and flow, otherwise you either exhaust the golfer or he becomes used to it."

His mandate called for a layout that was breathtaking aesthetically but which provided an enjoyable round for recreational golfers while offering, through length and green design, a challenge for tournament players.

As a result, the fairways are generous, especially on the front nine which, while an excellent example of classic parkland design, pales in comparison to the back where the water is always in sight, if not always in play.

The Northumberland Strait plays as a backdrop to the 10th green while the 14th plays close to not only the water again, but also Joyce's mansion and its marina. It is the par-4 16th, however, that most players will be talking about as they leave. The back tee is built out into the water on a small rocky promontory, calling for a relatively short forced carry over the ocean on the left, with the craggy cliffs threatening errant balls.

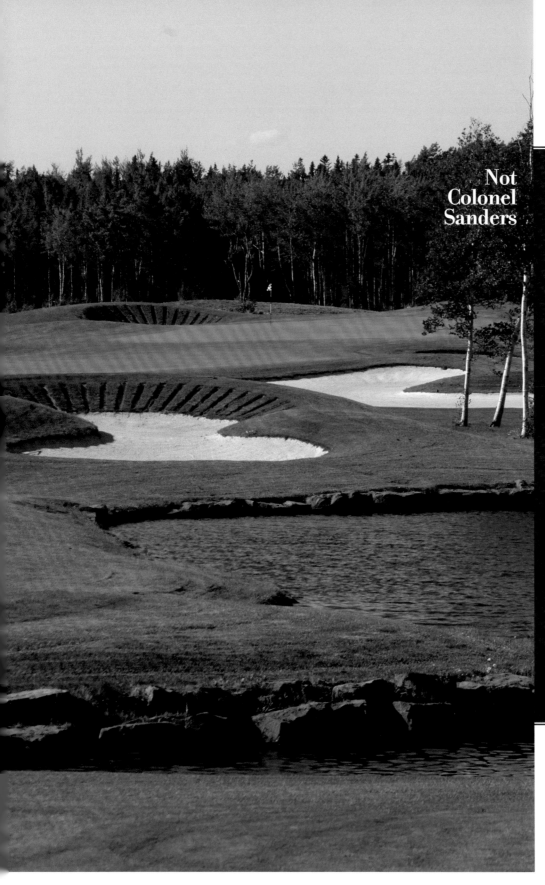

Not Colonel Sanders

It's been said that believing that PGA Tour players actually design the courses they have their names on is like believing Colonel Sanders really fried all that chicken personally.

Not so with Graham Cooke, who, at the age of 58, remains one of Canada's most accomplished golfers as well as being one of its most respected architects. Winner of more than 50 amateur tournaments in his four decades of competitive golf, Cooke was twice runner-up in the Canadian Amateur and is the only man to have won the Canadian Mid-Amateur an astounding seven times, including 2000 and 2001, when he also won the national Senior Amateur title.

"Being a competitive golfer absolutely helps me to understand this game, how traumatizing it is and how difficult it is. Playing a lot of tournaments and seeing so many golf courses makes you realize that there are many ways to approach design." In his playing career, he has literally played around the globe, where he uses his architect's eye to examine other approaches to design.

"I'm the first one to say that I enjoy looking at other people's work, and if I find something I like, there's a comfort level that you can explore that theme or concepts or thoughts in your own work."

After the 17th, however, players may be dismayed by the fact that the finishing hole turns inland toward the sumptuous clubhouse. Somewhat mystifyingly, Cooke and Joyce decided to use the coastal land beyond the 17th green for a par-3 course, making the finishing hole anti-climatic.

Nonetheless, Fox Harb'r remains a great course, with every resort amenity commensurate with the caliber of Cooke's design.

(Bottom left). Fox Harb'r owes its genesis to Ron Joyce, co-founder of the ubiquitous Tim Horton's doughnut and coffee juggernaut, who retains a palatial home and adjacent marina here.

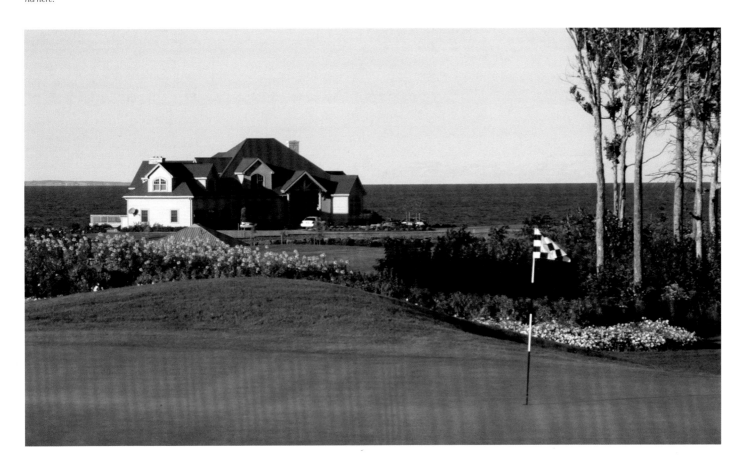

GEORGIAN BAY CLUB

Collingwood, Ontario

THERE ARE MANY MEMORABLE ASPECTS OF THE GEORGIAN BAY CLUB, too many to do justice to in these few words: Its setting on spectacular Georgian Bay, its proximity to the world's longest freshwater beach and surrounding ski hills, its stunning clubhouse and residential housing, its superb conditioning. The list goes on.

However, for the golf aficionado, it is the bunkering that punctuates its broad bentgrass fairways with repeated exclamation marks that will live on in a player's memory long after the score is forgotten.

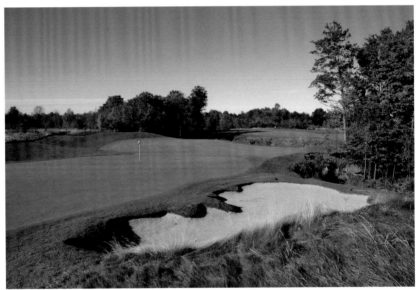

The splendid Georgian Bay clubhouse sits imperiously above the tricky par-5 18th hole (left). In the words of architect Jason Straka, "100 miles of open water" provides the backdrop (top), while the rolling topography and water-filled ravines provide strategic challenges as on No. 4 (above).

A century ago, iconic architects named Thomas, Tillinghast and Mackenzie concocted wild, freeform bunkers with raw edges draped in native grasses. That style fell out of fashion as surely as the hickory clubs with which the golfers of that era played. Although examples survived on the links of Scotland and Ireland, so-called "Golden Age bunkering" was all but non-existent in North America for decades.

Happily, that trend is slowly reversing and Jason Straka, senior course architect for Ohio-based Hurdzan-Fry, told the Georgian Bay Club ownership group that their site was ideal for this bunkering throwback.

"A couple of the guys thought it was outstanding, but some didn't like it at all because it was so different. They were more comfortable with the expanses of white sand that you see at 95 per cent of the courses built in the past 20 years. There's nothing wrong with that, but I wanted something unique for this unique site. I was paging through books, and came across pictures of those old-style bunkers and I though, 'Wouldn't this be interesting if we could do a real throwback?'"

After a couple of examples were built, the owners wholeheartedly agreed. But a re-education process was required for the course shapers who were unfamiliar with the antiquated style. A small bulldozer was used to dig the bunker and rough in the basic capes and bays, a random pattern that someone with a fanciful imagination might say used as a model the Georgian Bay waters and shorelines. Then a track hoe with a Twist-a-

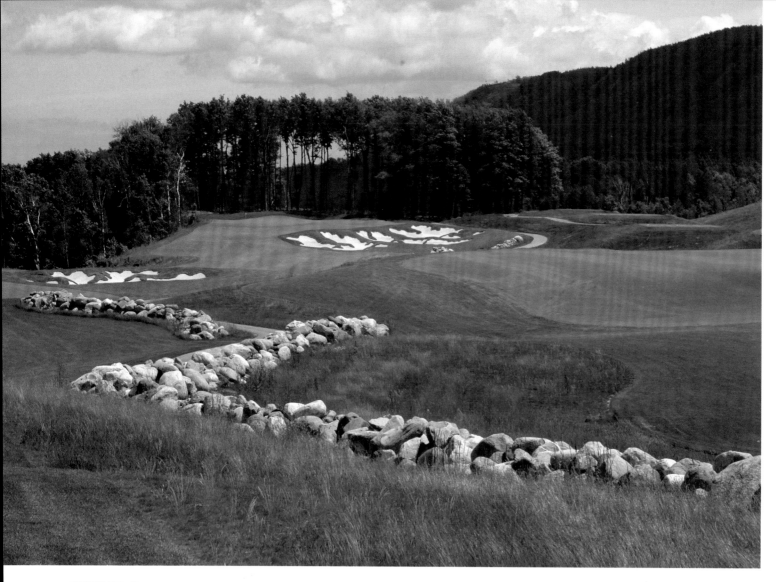

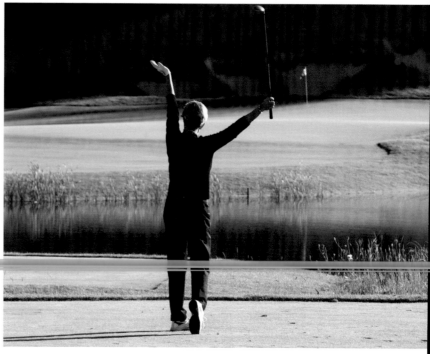

Wrist, or articulated pivoting bucket, was used to hammer in more noses and ridges, funky hollows and ridges.

A trademark of these Golden Age bunkers is the wispy yet tenacious fescue grass that grows down to their edges on the outside of the playing areas. "I told them that even where the grass comes into the bunkers, there's got to be lots of 3D move-

ment," says Straka. Even though some of the bunkers are taller than a man, a synthetic liner ensures the faces will never erode.

The Georgian Bay Club, where Straka's mandate also included a high member playability factor, has enormous fairways so the more cautious player can steer their ball around the trade-mark bunkers easily. The key to scoring here, however, is to

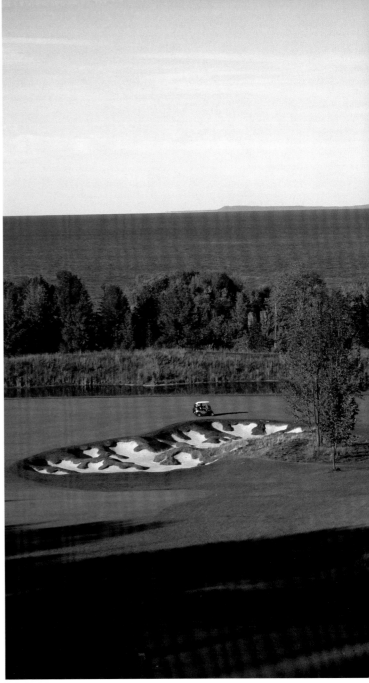

(Top left) Laboriously built stone walls and cunningly designed Golden Age bunkers make the Georgian Bay Club a special experience, as exemplified on the par-5 13th. (Far left) Jason Straka did a fabulous job of designing the layout under the supervision of architectural genius Michael Hurdzan (to Straka's right). (Left) Much of the charm of the Georgian Bay Club is the joy it brings to all levels of golfers. (Above left) Stands of trees provide a backdrop to the 14th and 18th fairways while Straka's sensational blow-out bunkers (left) are a trademark of this course. The tee shot on the par-4 14th (above) is threatened by a nest of savage bunkers in the crook of the dog-leg, and a pond for those who err too far on the side of caution.

tempt fate by using the bunkers as aiming marks. Frequently, the closer to the bunker, the better the line to the green.

"There was a very conscious effort to study the angles of tee shots in relation to the ravines and bunkers to create a thinking person's golf course," Straka says. "The goal was to create holes in which there are several ways to play it depending on your skill set and bravado. The mandate by the owners was to create a course that would be player friendly to its members and it is. However, to shoot low scores one will have to take some risks and that is where the dynamic character of the course shines."

Straka's mentor, Michael Hurdzan, the renowned architect who founded Hurdzan-Fry, is regarded as one of the leading

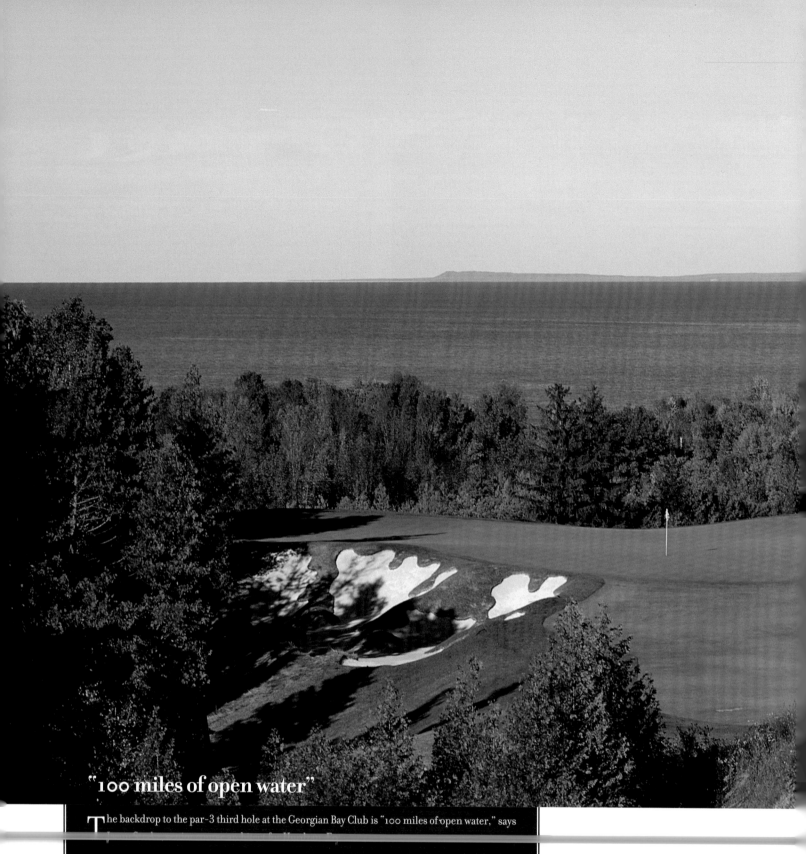

"100 miles of open water"

The backdrop to the par-3 third hole at the Georgian Bay Club is "100 miles of open water," says

From the elevated tee of the 217-yarder, the eye is drawn to the seemingly endless waves of Lake Huron's Georgian Bay seen over the back of the green. The hole, built in a former sand and gravel pit, features a green that falls away on three sides, but the fairway is sloped to funnel shots hit short and right onto the front of the putting surface. Assuming players can tear themselves away from the spectacular view, club selection is next to impossible due to the elevation change and the ever-present wind off the bay.

Straka spent two days a week here during construction and would end each day with a tour of the property. As he stood on the roughed-in third green on a summer evening admiring a fantastic sunset across the bay, he got a call on his cell phone from his father, Ron.

"I told him, 'Dad, one day when this course opens, you have to come up here and then you will understand the awe and peacefulness of what I'm looking at. This is the most spectacular par 3 I've ever built and perhaps that the company has ever designed, and one of the best I've ever seen in the world."

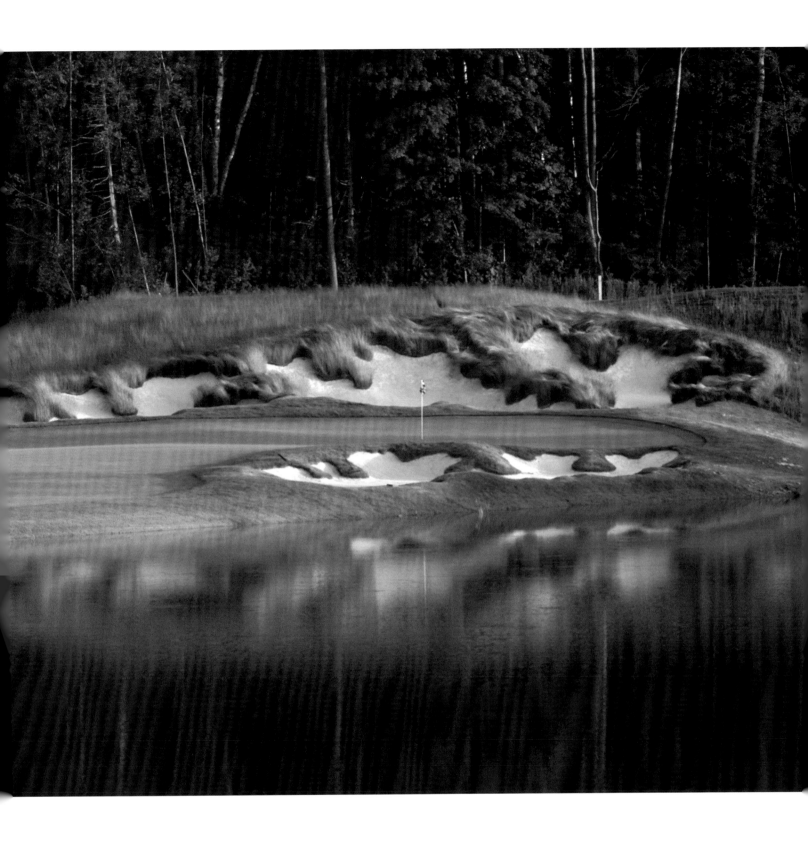

lights in his profession when it comes to environmental stewardship. That expertise came in handy at the Georgian Bay Club, where three deep ravines necessitated some serious routing and environmental considerations.

"Several of the holes were previously abandoned sand and gravel quarries directly adjacent salmon bearing streams," Straka explains. "The holes were carefully routed through these areas to re-establish the land and eliminate erosion into the streams." In addition to preserving these waterways, other wetland areas were created, and specific habitat construction ensured that recently released wild turkeys would feel at home.

The Georgian Bay Club, with all its natural attributes, would have been an exceptional course even with the standard bunkering style. Straka's revival of the sandy hallmarks of golf's Golden Age ensures it will take its place among the best playing experiences in Canada.

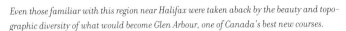

Even those familiar with this region near Halifax were taken aback by the beauty and topographic diversity of what would become Glen Arbour, one of Canada's best new courses.

GLEN ARBOUR GOLF COURSE

Hammonds Plains, Nova Scotia

EVEN MICHAEL DEYOUNG, WHO GREW UP NOT FAR FROM GLEN ARBOUR, was taken aback when he drove through the golf course gates for the first time back in 1998.

DeYoung, who manages the course, was expecting the relatively flat topography typical of the region, which is generally dotted with scrubby spruce and other unremarkable flora.

"My immediate reaction was, 'Wow! Where did this come from?'" he recalls. "The property was hilly, rolling, with these beautiful pristine lakes and gorgeous trees."

Architect Graham Cooke had much the same reaction sometime earlier when he arrived to lay out the 6,800-yard course. "It was a feast for the eye, an ideal site in so many ways. There were some excellent stands of trees, crystal-clear lakes, a wonderful natural feel about it."

Even though the plans included residential development, the owners were savvy enough to entrust Cooke with the responsibility of routing the course first and then weaving the housing around it, a job he did seamlessly. "The golf course was their priority all along, which is rare, so we could lay the course out the way we wanted. The holes saddle along the lakes, which then buffer the houses from the course."

As a result, Glen Arbour remains "a feast for the eye," although Cooke incorporated some architectural trompes de l'oeil that date back philosophically to the great Alister Mackenzie. Mackenzie, creator of such monuments as Augusta National and Cypress Point, worked with the British Royal Engineers to develop camouflage techniques during the First World War. Later, he

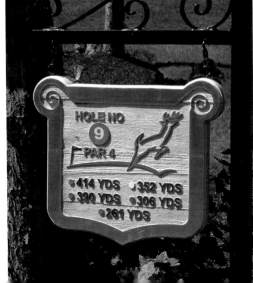

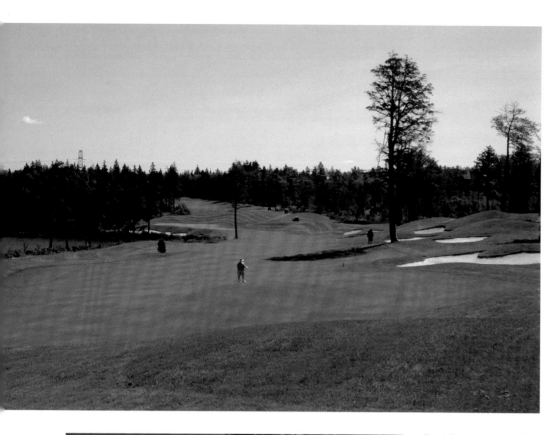

Glen Arbour is a treat, visually and strategically. On the 13th (below) and 14th (above), the landing areas are cunningly devised to appear smaller than their actual size. (Right) The comfortably understated club-house overlooking the 18th green is usually full of golf-mad players, eager to share a story and a pint.

would incorporate that knowledge into his course designs not only to make his manmade features blend in with the natural topography, but to confound and perplex those who played his creations.

In Glen Arbour's case, Cooke took a page from Mackenzie's book to produce a course that, to the first-timer, looks visually intimidating, especially from the tee. However, what appear to be lengthy forced carries are in fact easily conquered, even by higher-handicappers. On numerous occasions, what may appear from the tee box as a sliver of landing area reveals itself to be very generous. So generous, in fact, that DeYoung says, "you have to hit a pretty poor shot to be in the trees or even off

the turfed area of the golf course. This course plays much bigger than it looks." In general, visitors are pleasantly surprised when they total their score after a round here.

Not long by modern standards, Glen Arbour's real test comes once you reach the putting surfaces, where Cooke has concocted some very complex contours. When the 2005 Canadian Women's Open is played here (see sidebar), the players would be well advised to stay below the hole on their approaches. While DeYoung says the layout favours a straight hitter who is a good, imaginative putter, the three reachable par 5s on the back nine could give the edge to a longball hitter.

In general, Glen Arbour is characterized by downhill tee shots, always a crowd pleaser, but the approaches are frequently back uphill, which makes club selection problematic.

While the first 11 holes are pleasant, even DeYoung admits that the "real" course starts on the 12th tee. This hole, a 544-yard par 5 from the back tees, plays across Bottle Lake before heading for a green cut into a hillside cluttered with bunkers and grassy hollows.

Aside from 12, there are two more par 5s remaining on the back, an unusual but interesting design feature. The 504-yard 14th is perhaps Glen Arbour's most memorable hole, following

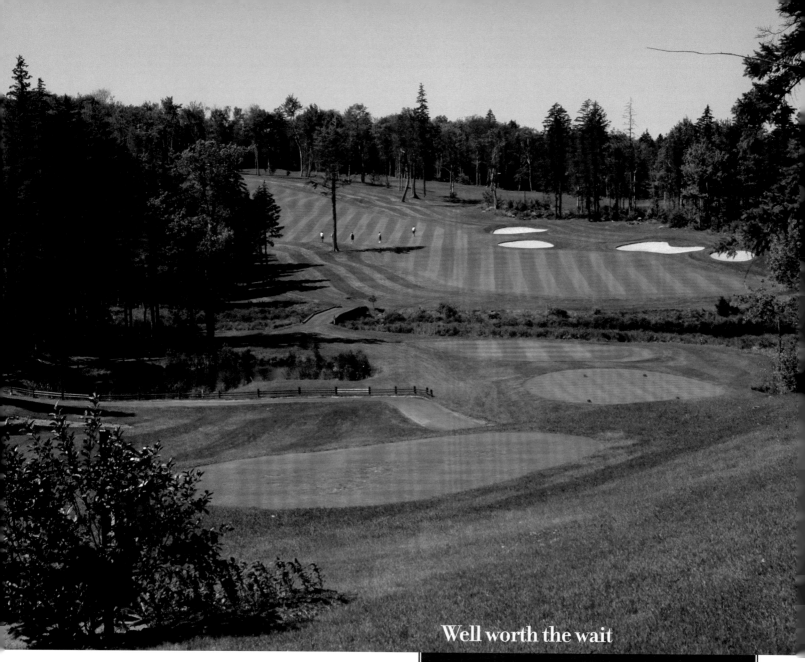

Well worth the wait

as it does the right shoreline of Bottle Lake from tee to green. The 18th, at 560 yards the longest of the trio, features a fairway which descends to a green guarded on the right by Sandy Lake and the clubhouse on the left.

Whether you are a world-class pro or a recreational hacker, Glen Arbour provides a scenic and enjoyable round. In many ways, its unusual setting is reminiscent of Ontario's Muskoka region, without its distinctive (and oftentimes annoying) rock outcroppings. Attractive stands of pines and white birches delineate fairways that are among the best conditioned in Eastern Canada.

In 1939, when Harold (Jug) McSpaden walked off New Brunswick's Riverside course as the winner of that year's Canadian Open, golf fans had no way of knowing that it would be 66 years before a national professional championship would return to Atlantic Canada.

From July 14-17, 2005, Glen Arbour played host to the Canadian Women's Open, an event that created great excitement not only among the 400,000 residents of the Halifax Regional Municipality, but throughout the Atlantic provinces of Nova Scotia, New Brunswick and Prince Edward Island.

The world's best female golfers tackled a gorgeous course that tested all their abilities, especially on the greens. Glen Arbour set up nicely for the women, and its three par 5s in the final seven holes set the scene for last-minute heroics.

LPGA rookie Meena Lee, 23, posted her second straight 3-under 69 in the final round to claim the victory. Her nine-under-par 279 was one better than Katherine Hull.

Lorie Kane of Prince Edward Island and British Columbia's Dawn Coe-Jones tied as the low Canadian finishers at 1-over- par 289.

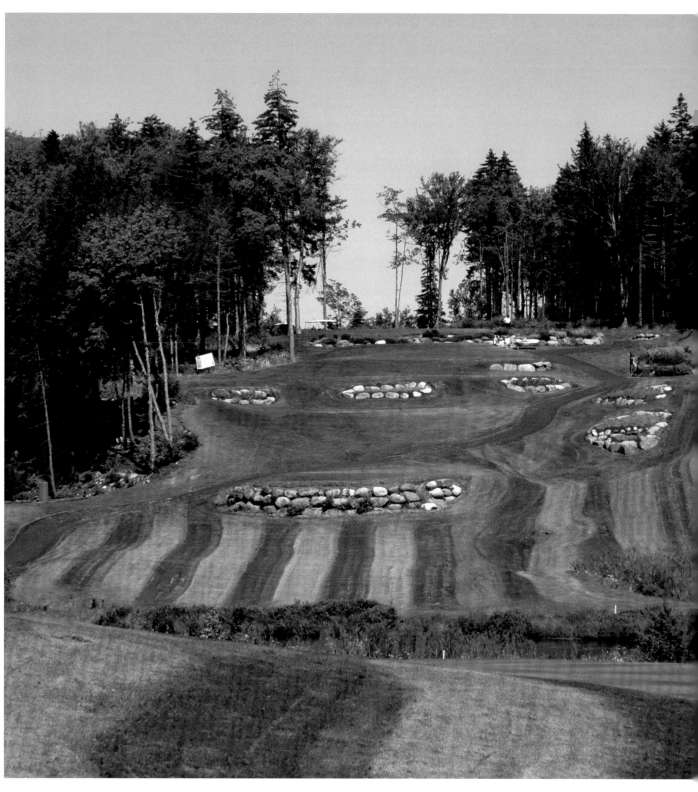

A feast for the eye? That cliché sells the par-4 fourth hole at Glen Arbour far too short.
A spectacular view from the green awaits those who negotiate the fairway and the
inlet from nearby Beaver Lake.

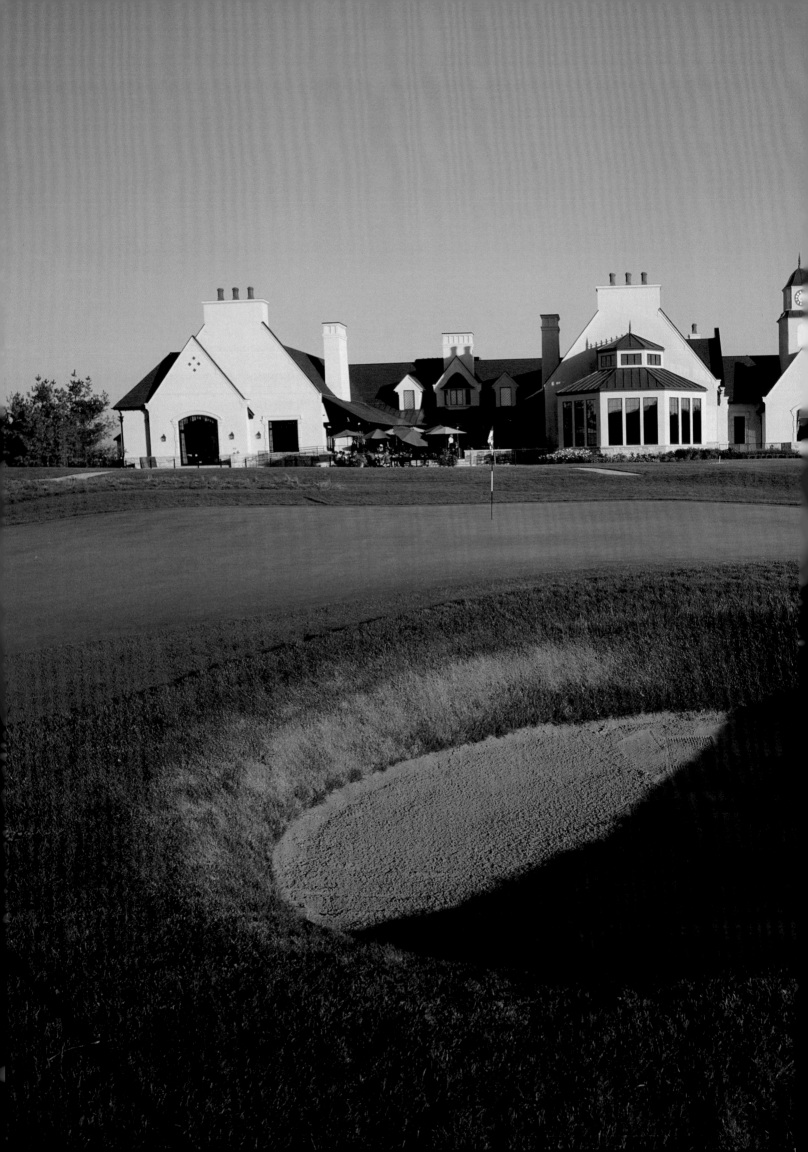

The vision of several men including Robert Poile, Scott Kirby, Bruce Simmonds, Tom McBroom, Edge Caravaggio, and John Finlayson led to the reality of Glencairn, in many ways a reasonable facsimile of traditional Scottish golf, right down to the bunkers and clubhouse.

GLENCAIRN GOLF CLUB
Halton Hills, Ontario

How do you transplant the traditional Scottish golf experience to Southern Ontario? It takes a strange recipe, with various ingredients including chutzpah, pizza, frequent-flyer miles, fescue, a risk-taking owner, and two men who relished tackling that risk.

"This was an adventure for all of us," says Scott Kirby, who was executive director of golf development for owner ClubLink Corporation when Glencairn was conceived and built. "We'd never done anything like this. It was a fantastic learning experience. We had a pizza night with all the shapers and all the foremen and we passed around books about all the great courses over there [Britain], with pictures of the bunkers, different land-forms, and everything else. It was amazingly productive, and it gelled the whole team."

The resulting interpretation of an inland links or heathland course has its roots in two of the most revered examples, says architect Thomas McBroom. "Muirfield is a reasonable analogy for the north and south nines where the gentle roll in the land is very reminiscent of that area. On the northeast nine, it gets very dramatic, along the lines of Gleneagles."

All 190 bunkers are sodwalled, but are not vicious sand pits. Again, they are on the Muirfield model, with soft classical shapes, and filled with traditional brown-hued sand, not the familiar white silica. The fairways take their cue from there as well, offering receptive landing areas.

There are other signs that this is not your average lush North American track.

"There is no bluegrass rough," says McBroom, "so you don't see that typical North American stark contrast between the rich green of the bluegrass rough to the lighter green of the bentgrass fairways. We wanted to emulate that duller Scottish look. The primary roughs are fine fescue and outer roughs are tall fescue. It's very brown and wispy, and that may shock some people at first. I love it."

The site offered some challenges, most of which were met successfully. A railway line running through the property was spanned with a 61-metre bridge. In fact, the

railway adds authenticity, a la Carnoustie or Prestwick. Water was not plentiful, so a 3o-acre lake was dug to receive runoff. Ninety per cent of the course was sub-drained to collect rain, which is directed into the lake. Remaining true to the course's context, the lake does not come into play because "that wouldn't be Scottish," says McBroom. Instead, it is hidden from sight by dunes and mounds. The only jarring note, a concession to the despised golf cart, are paved paths, although a sincere effort has been made to camouflage them behind mounds as well. Having said that, Glencairn is eminently walkable, like its renowned forebears.

"The contouring on real linksland makes your head spin," marvels McBroom. "It's astounding how Mother Nature can be so staggering beautiful. It is very hard to replicate. The tendency is to machine it and shape it too much. The way

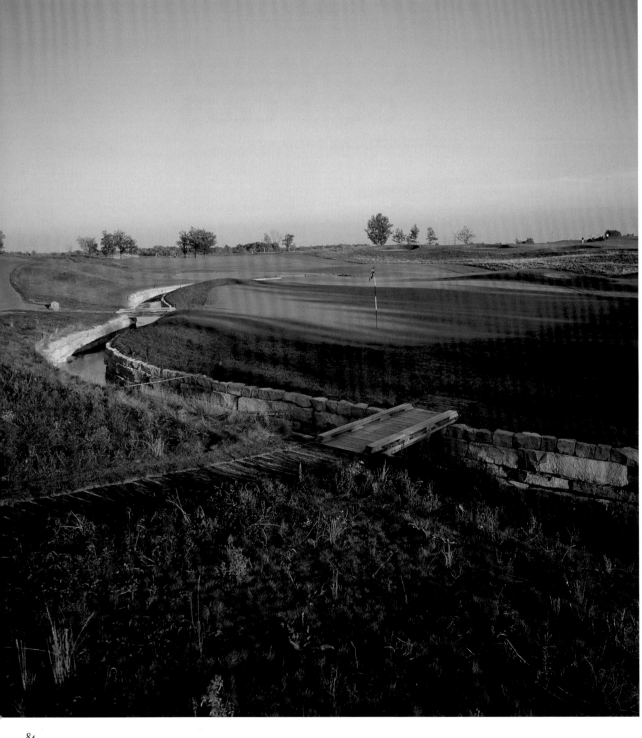

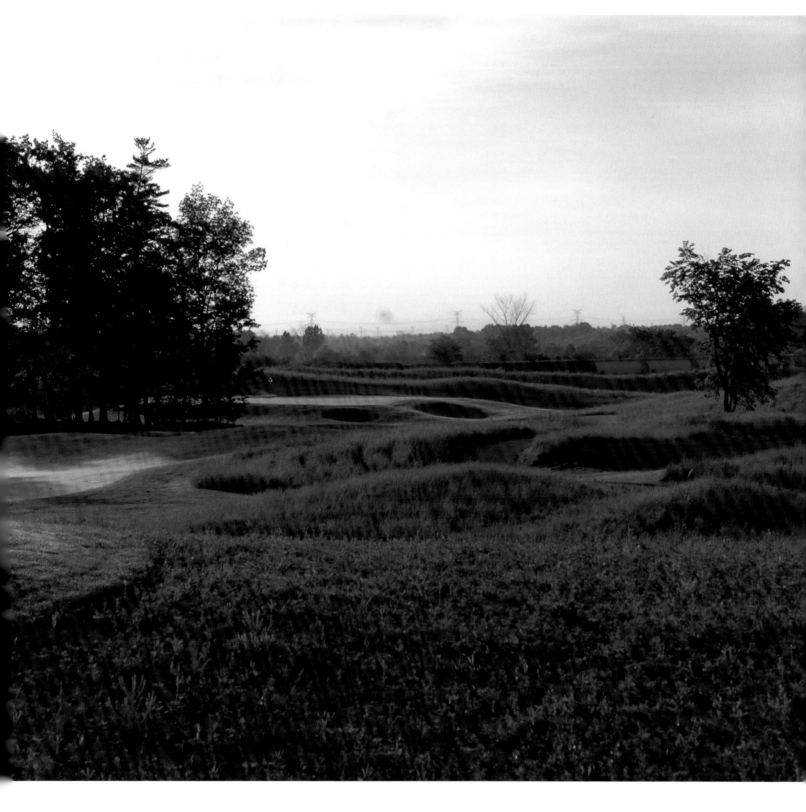

A wee stone-braced burn, tufts of fescue, natural mounding, and deftly shaped bunkers on Leithfield's ninth hole (left) and on its opening hole (above) define the Glencairn experience.

to do it is to not machine it, not force it, and just let things happen. For some of the mounding at Glencairn, we just dumped dirt off the back of trucks, where it ended up in piles. I said, 'Leave it.'"

Some, like "Wee Tricky," a short but demanding par 5, are obvious. Others, says Kirby, represent more than what first meets the eye. "Old Tom," for example, refers primarily to Old Tom Morris, winner of four Open Championships in the 19th Century. "But it's also a bit of a shot at our Tom [McBroom]," chuckles Kirby.

Not lost in translation

ClubLink Corporation wanted their new course, Glencairn, to be as authentic a replication of a Scottish golf experience as possible. To that end, they sent architect Thomas McBroom and Scott Kirby, then ClubLink's executive director of golf development, to Scotland to research what would be involved in achieving that goal. It was not the first trip over there for either man, both of whom are aficionados of the iconic links and heathlands courses. "We both thought we knew how to recreate a links-style course, but we wanted to understand all the nuances," says McBroom. "We specifically examined Muirfield. This land reminded me of that, relatively treeless, not close to the water. Topographically, the contours were fairly soft, not dramatic dunes. Even the bunkering style came from there. The idea wasn't to copy a particular course but to take inspiration from one of the greatest." Not content with taking inspiration from the course alone, Kirby and ClubLink created an impressive clubhouse that emulates the famous Greywalls Hotel at Muirfield, complete with a pub.

Both the par-4 fourth (top right) and the par-5 fifth (bottom right) holes on the Leithfield nine are dotted with pot bunkers. The absence of bluegrass rough, a standard on North American courses, adds to the Scottish look.

The rumpled, crinkly landscape offers several standout holes. A manmade burn, or brook, comes into play on four holes, including the first on the Speyside nine, making it one of the architect's favourite holes. "It is like the first at St. Andrews with the burn cutting right in front of the green. It figures into the ninth as well, which is a long par 4 with the burn running parallel to the green. It's a very difficult par 4, obviously, and you're forced to think twice about your second shot. On the Scotch Block nine, the ninth is a very reachable par 5, only 515 from the tips, but the burn parallels the hole from tee to green, then comes hard to the right-hand side of the green. Combine that with the rock wall we put there and you've got a great risk-reward hole."

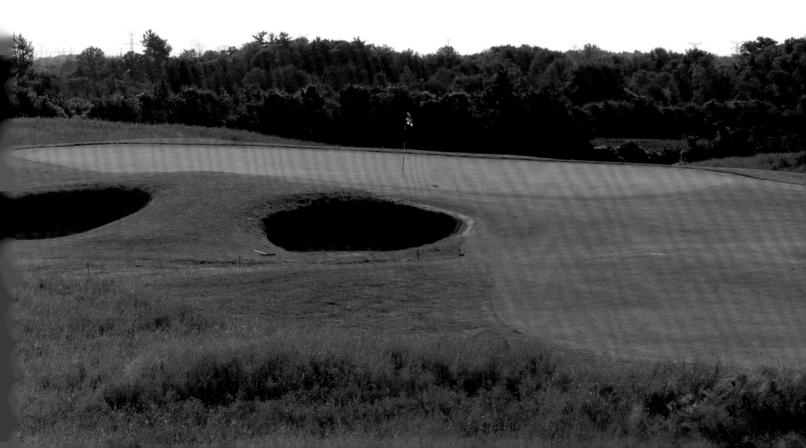

GRANDVIEW GOLF CLUB

Huntsville, Ontario

WHILE MARK O'MEARA, WHO MADE HIS DESIGN DEBUT AT GRANDVIEW Golf Club in 2001, has caused little controversy during his illustrious PGA Tour career, the same cannot be said for the course he created.

Even Simon Bevan, the director of golf here, says he understands that the first taste of Grandview could be a touch bitter, but that initial impressions are not always correct.

"I have to be honest and say that the first time I played it, was the worst," says Bevan, who has been here since the course opened. "Just about everyone who plays it more than once says that they like it more and more each time."

Much of the criticism is caused, he says, because the up-and-down layout winding through, over and around the craggy Canadian Shield makes it absolutely essential that players take an honest look at their ability and play from the appropriate tees. Not doing so means that tee shots will not carry to the correct landing zone, leaving the hapless hacker with blind approaches to greens.

"Growing up in England, I don't have a big thing about blind shots because that's the way golf is over there, and in Scotland

Grandview typifies Muskoka golf with its unique combination of granite outcroppings, ancient forest, and wetlands. (Above) Looking to the 17th fairway from the 18th, the split landing area on No. 4 (bottom left) and looking back from the fifth green.

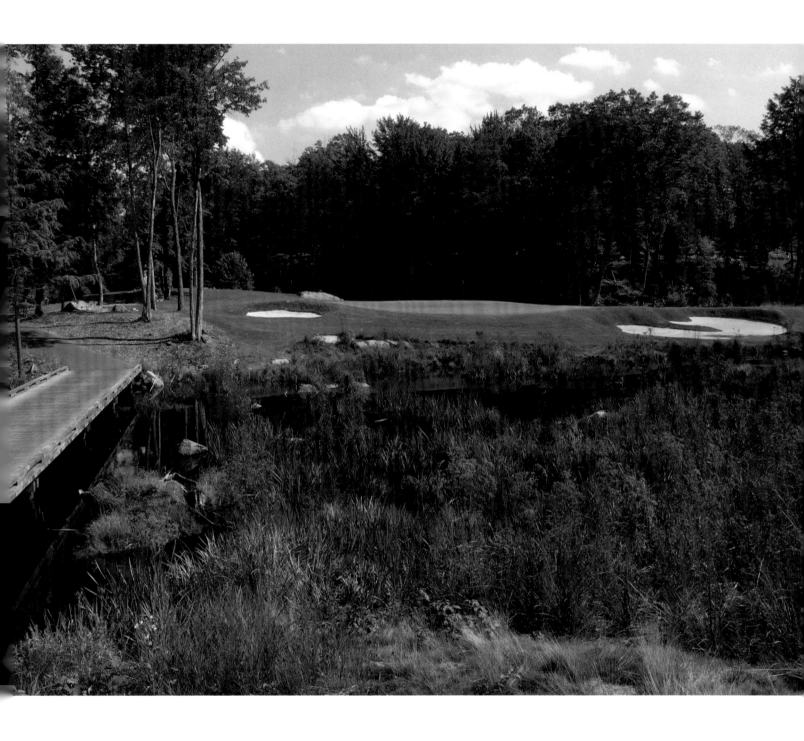

and Ireland. It's a North American thing, I guess, hating blind shots just on principle. But especially up here in Muskoka, it's almost impossible to avoid at least a couple of blind shots because of the topography and all the rock. You could blast it all away, but then you would lose the character, and everything that makes playing golf up here unique in the world."

Having said that, one first impression that is accurate is the feeling that you are in for something special when you drive up the winding road, flanked by towering rock walls, to the imposing clubhouse built of locally quarried rock.

That anticipation is multiplied when you get to the first tee, a real golf gut-check which sets the tone for the rest of the round. (See sidebar.)

After negotiating the first, which is much tamer from a playability standpoint than it appears, you get to the first of Grandview's par 5s, the four holes that Bevan says truly define the course, which O'Meara co-designed with Brit Stenson.

"The second hole is called Rollercoaster for a reason. You're up and down but if you hit a good tee shot from the right tees, you can get home in two. It's a good example of what I was saying in

The first cut is the deepest

Few courses come to mind – maybe Devil's Pulpit in Caledon, Ontario, would be another – where the opening hole can be called the "signature" or the most distinctive hole. While the term "signature hole" has come under significant, and justifiable, disdain because of its devalued meaning, it may be applied to the first hole at Grandview because it sets the tone for the round in several ways.

Set in the shadow of the imposing stone clubhouse, the tee blocks for this 420-yard par 4 are separated from the fairway by what appears to the first-time player to be a 300-yard-wide jungle-filled chasm.

In fact, says Director of Golf Simon Bevan, the carry is 140 yards over a river valley from the blue tees. As a result, many overly aggressive (or terrified) first-timers overswing and pump their tee shots through the fairway of the dogleg-right hole. Most others dunk their shot into the swamp. In reality, a decent left-to-right tee shot will leave about 150 yards into a well-bunkered green guarded by the hazard on the right.

"To my mind, it's the most amazingly dynamic opening hole I've ever seen," says Bevan. "It also helps convince players who may want to play from the blue tees but really don't have the game to move up to the white tees."

From the 7,065-yard gold tees, the course rating is 74.6 with a Slope of 142. That diminishes slightly to 72.4/138 from the blues (6,635 yards), and then drops to 70.0/133 from the whites (6,140). The front tees play a manageable 4,750 yards.

As with every hole at Grandview, discretion off the first tee is the better part of valour. Your score card will thank you.

that the first time you play it, you think it's difficult or a bad hole, but once you understand it, you love it."

Like most of the fairways here, the second is spacious, allowing you to cut the corner of the dogleg-left as much as you dare. The better player will have 210 to 220 yards left on the second shot, assuming they have driven the ball to the top of the rock face.

Bevan's favourite hole is the 505-yard fifth, the shortest par 5 on the course. "It's a fairly easy hole but it can show its teeth if you don't drive the ball well. That's the key here. Even though the fairways are huge, you have to drive it on the right line to score well. You don't have to be long, but you have to be accurate."

In contrast to the fifth, the 12th is a virtually unreachable 595-yard monster. The finishing hole, an uphill 557-yarder, mirrors the first with its forced carry of about 170 yards over a cedar swamp, heading for an extremely elevated green. Only those confident of getting to the green in two should try, since anything hitting short will likely roll back to the 150-yard marker.

Although Grandview welcomes guest play, especially from the adjacent Delta Grandview Inn, it plays like a member's course where local knowledge can save several strokes. First-time visitors are advised to book at least two rounds so they can appreciate its nuances.

(Right) At 480 yards, the par-4 fifth hole is rated the toughest at Grandview.

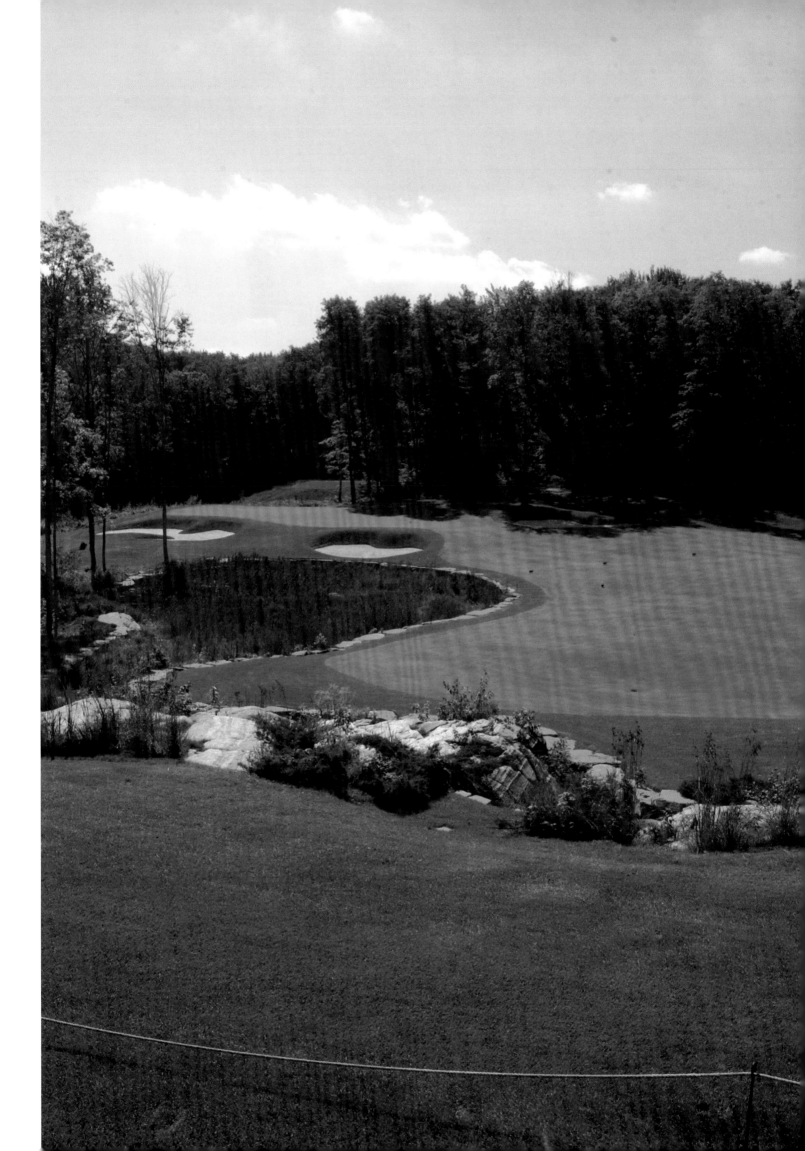

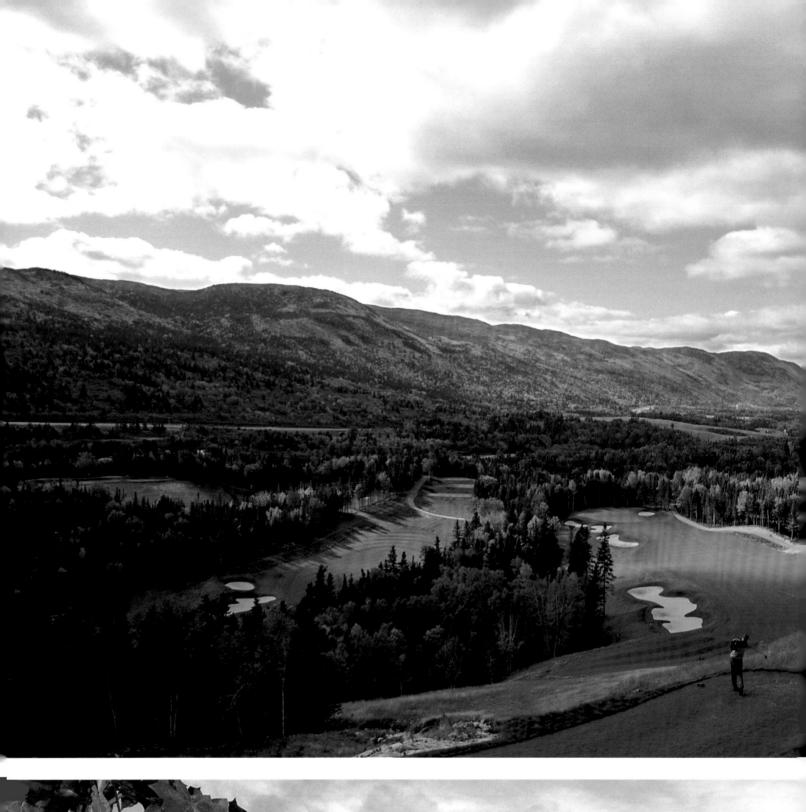
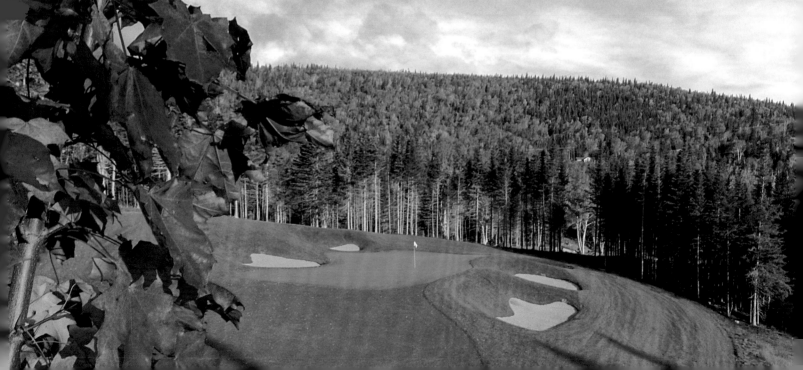

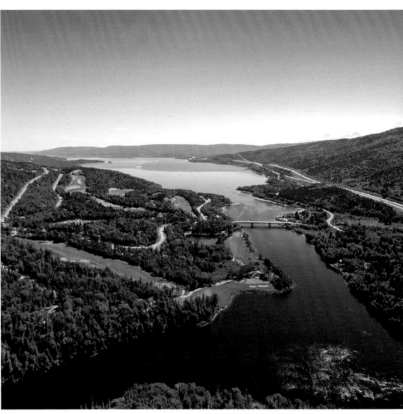

While the ill-informed consider Canada's most easterly province "The Rock," Humber Valley's phenomenal setting illustrates that there is a distinct possibility Newfoundland might just be the next great golf destination.

HUMBER VALLEY RESORT

Deer Lake, Newfoundland

WHEN AN ARCHITECT AND THE DIRECTOR OF GOLF BOTH TELL YOU THAT their new golf course looks like it should be in the Scottish Highlands, there is a certain amount of disbelief.

But that statement about Humber Valley gains significant credence when it comes from Doug Carrick, who has designed a course in Loch Lomond, and Wayne Allen, an Englishman who worked as a golf pro in Edinburgh.

"I lived in Scotland for four years, and the landscape is very similar to the Highlands," says Allen. "You've got the mountains and the small communities, and not much else. It's very natural, as is the golf course because it's cut through mature forest."

"It's rugged and mountainous like it is over there," agrees Carrick, "but it's wilder and there's more forest. But what makes it really special is the Newfoundland people. They're the most hospitable, wonderful people anywhere."

Much of the marketing for residential sales at Humber Valley Resort, which eventually will be a 1,000-home, Cdn $1-billion

Wending its way along the mighty Humber River, one of the world's best salmon-fishing destinations, this Doug Carrick creation features more than 300 feet of elevation change, towering forest, and cavernous valleys intersecting the property.

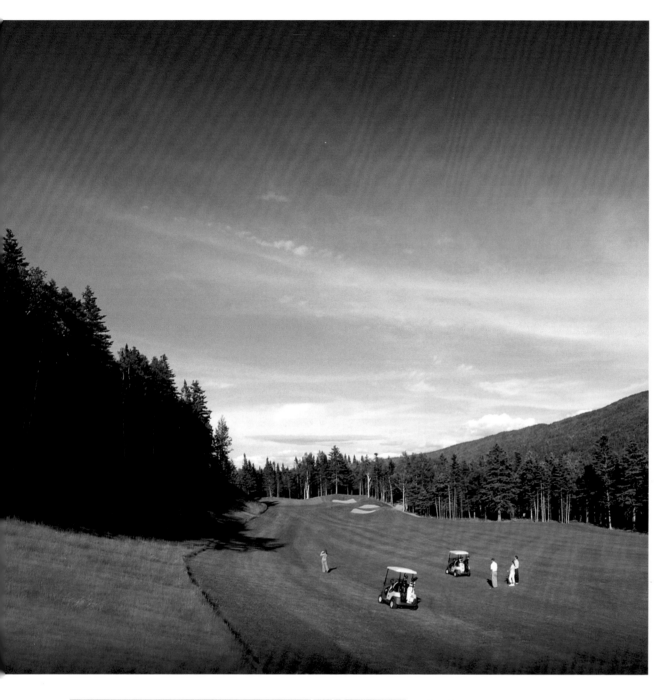

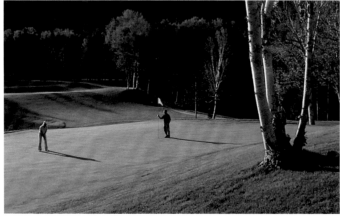

development, is aimed at Britain, Ireland, and Europe. In fact, Allen originally came here with an eye to buying a vacation home, but fell in love with the area. "You could tell it was going to be an amazing golf course and it turned out better than anyone ever expected. Playing it with the colours in the fall is especially stunning."

Carrick, who previously had done a renovation and nine-hole addition at Twin Rivers in Port Blandford, Newfoundland, says he was "astonished" by the site. Unlike many in the windswept, soil-deprived province, this property has excellent stands of spruce, fir, and birches.

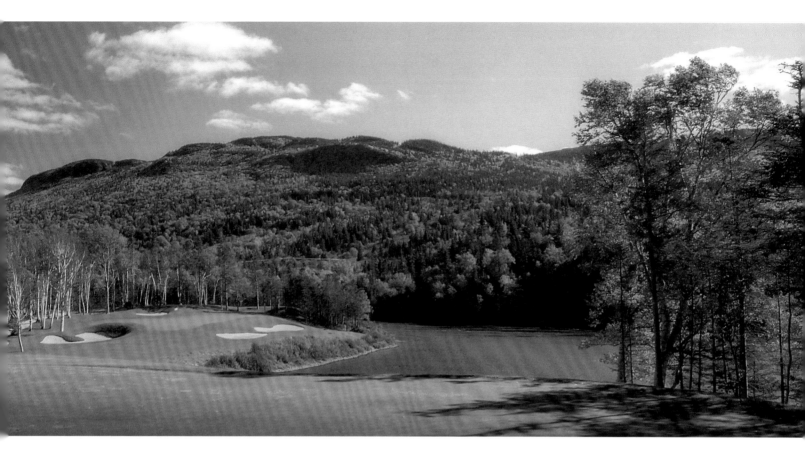

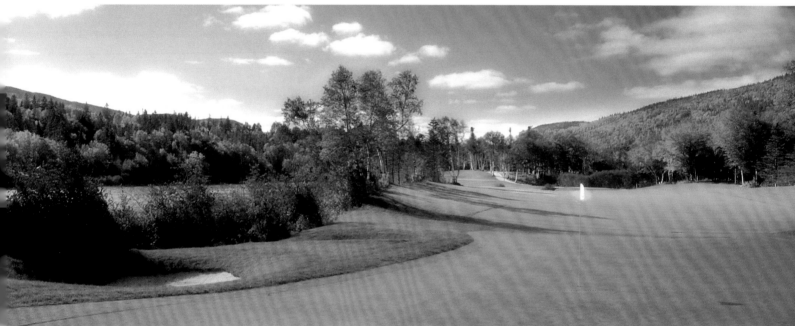

"It was an excellent site to work with. It was heavily wooded, and the west end was intersected by number of deep incised valleys. Surprisingly, there were not a lot of rock outcroppings, and as a result the only blasting was right in front of the tees on the first hole."

"Highlands" is the operative word when discussing Humber Valley, which features about 300 feet of elevation change. While the 10th hole represents the most dramatic and disputed drop (see sidebar), the adventure begins right at the first tee, which descends 30 feet to the fairway.

"The first four holes head downhill," says Carrick, while the par-3 fifth runs along the Humber River. "No. 2 drops about 40 to 50 feet, then No. 3 drops about 70-80 feet." That elevation is gradually regained in 20- to 30-foot increments before making the turn. At some point on every hole on the front nine, you can see Deer Lake.

Allen especially likes a stretch of three holes in the middle of the back nine, all of which feature the mighty Humber River, one of the world's great salmon-fishing venues. At 520 yards, the 13th is a reachable par 5, with a fairway that slopes down to the green. The 14th is a terrific par 3 of 176 yards with an elevated tee and green separated by an inlet from the river. The river

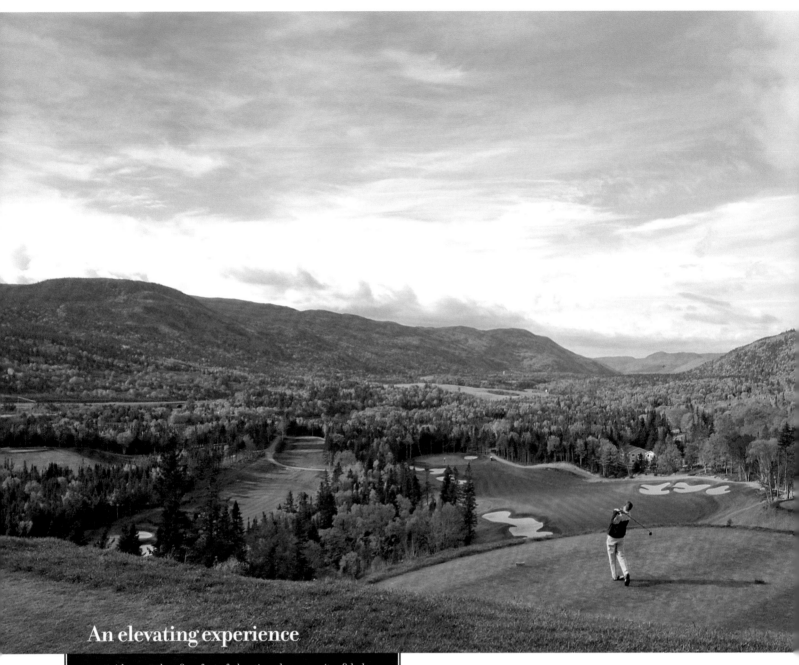

An elevating experience

With more than 300 feet of elevation change on its 18 holes, Humber Valley offers a number of elevated tee positions, but none more breathtaking than on the 10th.

Course architect Doug Carrick estimates that the drop from tee to landing area on the 439-yard par 4 is about 150 feet (although the course's Web site says it is 300 feet, or the equivalent of hitting a ball from the top of a 30-storey building).

While this would normally make for an easier than usual tee shot, Carrick says this assumption is incorrect when dealing with the opening hole of the back nine. "It's a deceptive tee shot because even though there's a big fairway, it's tough to align yourself. There's no real aiming point looking away down the Humber Valley with no point of reference. Having no backdrop really throws off your depth perception. Actually, it's a bit of a disadvantage to be that high."

Director of Golf Wayne Allen agrees. "The best shot off the tee is a slight draw, and then you might hit anything from a wedge on a calm day to a 2-iron in on a windy day. The wind is usually coming in your face and that makes it even harder."

While "Screech" may be the official alcoholic libation in Newfoundland, that sound can be heard emanating from the throats of every joyful golfer who is fortunate enough to stand on the tee at Humber Valley.

not only reaches into the 15th fairway but hugs three sides of the green meaning this 328-yard par 4 offers some serious course-management issues.

This is not to say that Humber Valley is too difficult for the average player. In his design, Carrick made allowances for the scratch player who wants to test his ability from the back, 7,200-yard tees. However, he realized the resort's bread will be buttered by the visiting recreational players, most of whom would be advised to play from the 6,200-yard tees and forward.

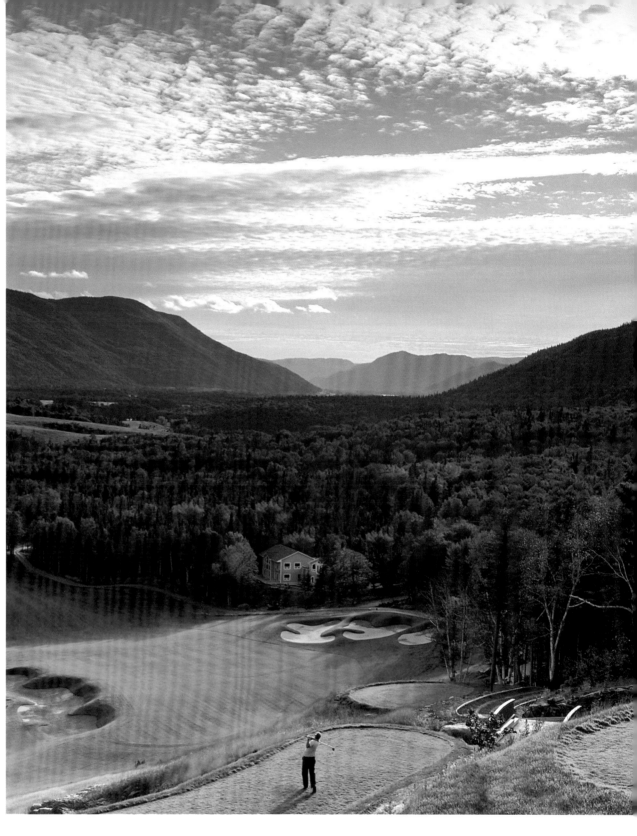

"The fairways are much wider than average," says Allen. "The rough is not severe and the underbrush is cleared. It's classic risk-reward, so good shots are rewarded and poor shots are punished, but that doesn't mean you lose your ball."

While creating a golf destination is essential, it is not the only facet of Humber Valley's four-season approach. Other summer activities include hiking, sea kayaking, mountain biking, sailing, windsurfing, river boat tours, caving, birdwatching, and, as Allen says, "not just fishing, but actually catching fish."

Other seasons offer alpine skiing, cat skiing, and snowboarding at nearby Marble Mountain, cross-country skiing, snowmobiling, snowshoeing, helicopter tours, and back-country adventures.

Recognition of its early success came in 2004, when it received awards from Bentley International Homes for "Best Canadian Development", "Best Canadian Property", "Best Winter Sports Development" and "Best Property Advertisement," winning from more than 250 resorts worldwide.

KING'S RIDING GOLF CLUB

Aurora, Ontario

A DOZEN YEARS AGO, THIS PROPERTY PLAYED HOST TO THE ONTARIO Amateur Championship, and the hills were alive with critics, from spectators and media to the players themselves, who wondered aloud who had designed the controversial layout and whether the plans were upside down during construction.

Five years ago, some of the best players not on the PGA Tour stopped by for the Canadian PGA Championship. Californian Chad Wright won with a 16-under-par total of 268 and, to an individual, everyone who set foot on the property sang its praises.

King's Riding, the result of a total redesign of an existing course by Tom McBroom, shows an encouraging return to shotmaking over today's trend of power golf. Narrow landing areas, small greens, and punitive bunkers are all factors on the 11th (above left), the 15th (top right) and the 16th (bottom right).

What happened in the intervening seven years? ClubLink Corporation and Tom McBroom, in that order. ClubLink, the country's largest owner, developer and operator of golf courses, spotted this ugly duckling on a very good piece of land not far from its corporate headquarters at King Valley Golf Club. After the deed changed hands, ClubLink asked Toronto architect McBroom to perform one of his trademark "nuke" jobs.

"That's the best word for what he did," says Director of Golf Peter Harris. "I guess you could say it was amateurishly designed. There were lots of blind tee shots, eight in total, I think, and some funky doglegs that didn't make a lot of sense."

Harris says the transformation was phenomenal, especially on the back nine which was almost totally bulldozed, except

The 213-yard par-3 11th (above) and the 440-yard 17th (right) are two of the architect's favourite holes.

where environmentally protected zones, such as cedar swamps, necessitated the retention of existing play corridors.

The front nine was extensively tweaked, rerouted, and had new tee decks and green sites created. The result was a well-conceived and executed mélange of parkland and heathland styles on a relatively meager 145 acres that plays from 5,100 to 6,500 yards.

"It's not killer length, to be sure," agrees McBroom, "but I have no problem whatsoever with that. I have never been a big fan of big length and big width. I like more traditional dimensions. King's Riding is a good example of those traditional dimensions, maybe even skinnied up a bit. It's got all the shot values and all the difficulty that the average member would want.

"It plays harder than the length indicates because it's relatively tight, the greens are relatively small, and the bunkers are relatively deep, so it has some tricks to it. You have to hit the shots to score."

Thus, King's Riding has many of the attributes of what used to be called a "member's course," in that it's not of Tour length and the emphasis is on placement, club selection and local knowledge rather than power. But to McBroom, it's more than that.

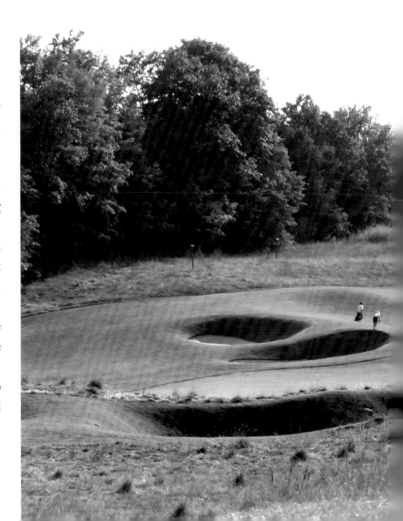

"I think it is a bellwether of where we need to go in this business. Everything's just getting too big, from balls and clubs and distance to the length of golf courses. The technology is having a dramatic effect on the whole game. How do you design for 340-yard drives? I don't think this can be allowed to continue.

"We've got to make sure people are enjoying the game and, I'll tell you, people enjoy King's Riding."

The 213-yard 11th hole which runs parallel to busy Bathurst Street is a favourite, with its elevated tee and watery carry, as is the cunning short par-4 13th.

"Everyone loves to hate the 13th because it's almost a driveable par 4, but the angle of the tee shot makes it difficult to get in there because there's a big hedgerow of trees all up the right side," says McBroom.

"It's a terrific hole because you have to hit a great drive to get into the green on the second shot. Many short par 4s are weak because they don't put a real premium on the drive. Take the 16th at the TPC at Scottsdale, for example. It may be exciting for TV, but you can skank a drive 150 yards and you have another easy shot into the green. That's a glaring weakness.

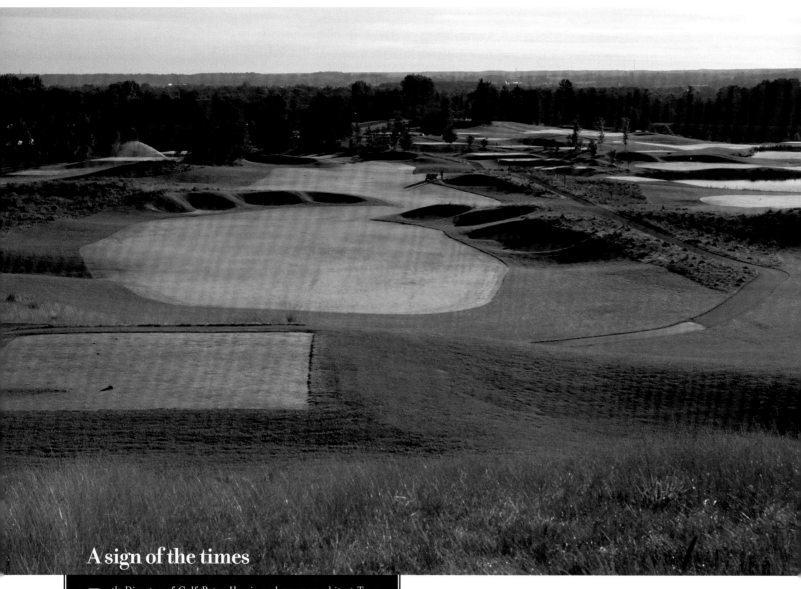

A sign of the times

Both Director of Golf Peter Harris and course architect Tom McBroom admire the two finishing holes at King's Riding, which are studies in contrast.

The 440-yard par-4 17th demands a huge drive over a nest of bunkers in the inside of the dogleg right to a steeply elevated green. There is a large bailout area to the left, but ending up there most likely means a 3-wood for your approach.

The 480-yard 18th is a reachable par 5 lined with fescue and bunkers, all of which are visible from the elevated tee, to a tiny 3,000-square-foot green, "one of the smallest I've ever done," says the architect.

The relatively miniscule putting surface is another indication of what McBroom mentioned about traditional dimensions.

Commonly these days, large greens are required to stay in scale with the rest of modern oversized courses, most of which are open to public play.

King's Riding is a welcome return to a more cerebral style of golf, both from the design and playing aspects of the game.

"Here, you can hit a 3-iron or 3-wood or driver but you can't hit a mid-iron and have the green opened up to you. You have to have the right combination of distance and accuracy.

"My honest feeling is that, as a breed, short par 4s are overrated because they can easily be weak, uninteresting holes. There needs to be a huge risk if you don't hit the right tee shot. That's one reason why the short 10th at Riviera is so famous because the angle of the green and the bunkering means you can't hit a mid-iron."

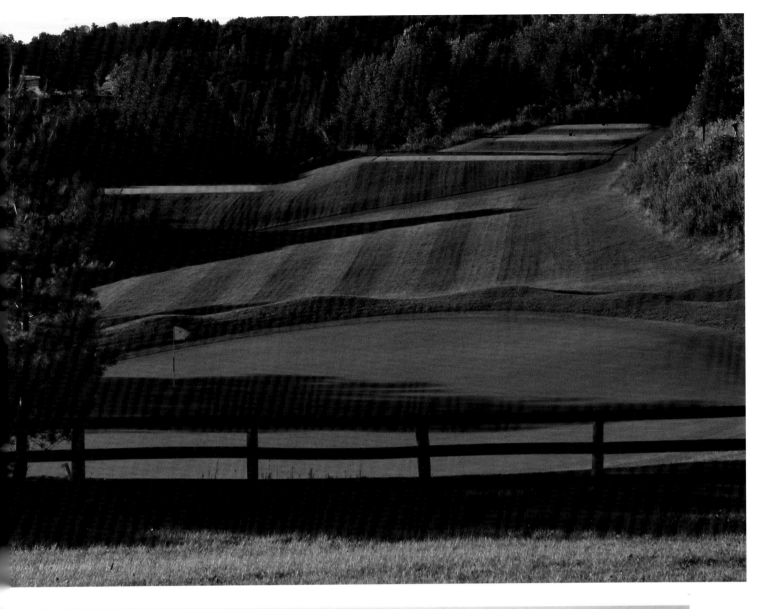

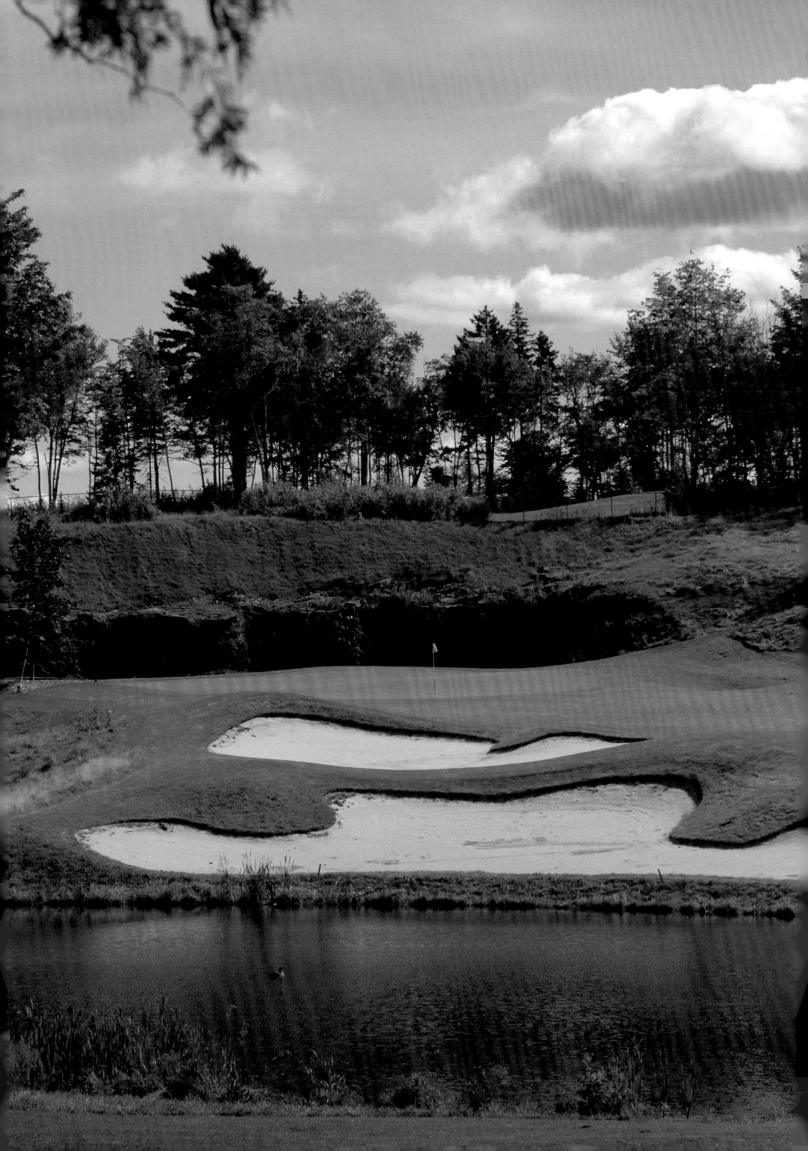

KINGSWOOD

Fredericton, New Brunswick

ALTHOUGH ITS BEGINNING WAS NOT NECESSARILY AUSPICIOUS, THE FINAL outcome was more than anyone could have hoped for Kingswood.

The developer told architect Graham Cooke that there was a slight possibility that a major highway extension might be routed through the back end of the property. In fact, that possibility came true, but not until after Cooke had already built a few holes, necessitating the acquisition of adjacent land and a rerouting of the layout.

"Actually, it turned out for the best," recalls Cooke. "We swapped some land, and then the highways department needed some rock for construction, so we did a deal where they would blast their rock from our site. They got their rock and we got some really nice rock faces and walls, which we used in our design for waterfalls and other features." The new land also offered some attractive ecological aspects, such as marshes and stands of tall white pines.

That it did turn out for the best was demonstrated when Golf Digest picked this relatively remote (although only a few minutes' drive from the provincial capital of Fredericton) and under-marketed course as its Best New Course for 2003. In 2005, the magazine ranked it 97th in its list of top 100 courses outside the U.S.

Aside from its unusual beginnings, this course is a few degrees off centre in other ways. It is the hub of an elaborate entertainment complex offering everything from bowling and

Here's a golf trivia question: Which course did the redoubtable rankers from Golf Digest magazine pick as the best new layout in Canada for 2003? How about this Graham Cooke design in New Brunswick? No, seriously, they did. And they were right!

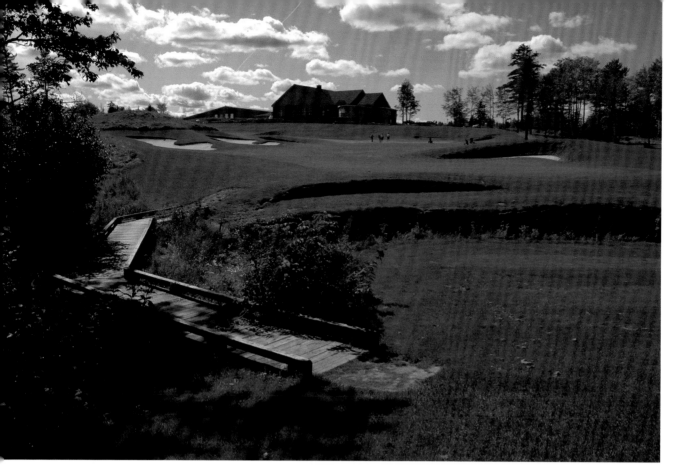

extreme laser tag to a gymnastics facility that served as the host training centre for the national gymnastics team during preparations for the 2000 Olympics.

The course itself offers the full bag of tricks with very few repetitive design themes.

The first hole, a 413-yard par 4, features an example of the rock walls Cooke mentions behind the green. The 516-yard par-5 second demands everyone carry at least part of an expansive lagoon, and the 432-yard third has a serpentine fairway demarcated by two ponds. The tee shot on the long par-3 fourth must

clear a waste area and the straightaway par-4 fifth has not only a lake on the left, but a green hugged by fescue-covered mounds.

The sixth hole is a nice example of a short risk-reward par 5. Going for the green in two shots calls for a fairway wood or a long iron over water. The faint of heart will want to steer to the left to avoid the lake. The 213-yard seventh is followed by a noteworthy par 4 of 415 yards which shares its broad fairway with the 15th hole, although the centre line is dotted with pot bunkers, some of which have steps to assist the entry and exit of those unfortunate enough to find them off the tee. The two-

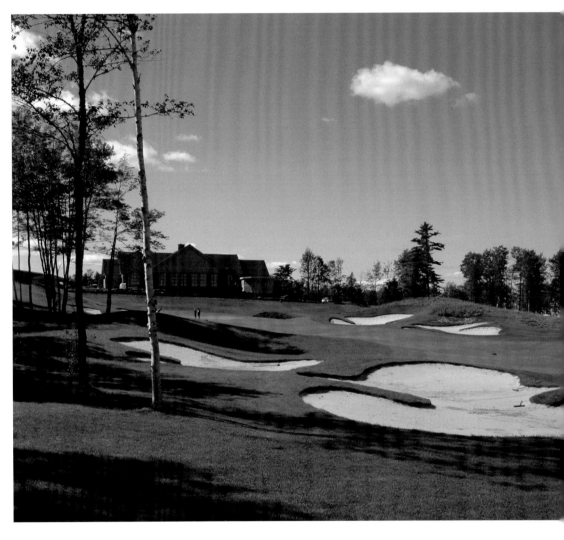

The ninth hole (right) wraps up the outward loop with a short par-4 with a multitude of bunkers and an environmentally protected area while the 18th (above) features contentious white birches in the landing area.

tiered green features a sodwall bunker. The front nine concludes with a short par 4 where the tee shot must carry an environmentally protected area to a fairway where bunkers march up each side.

The back nine starts with a par 5 of less than 500 yards where a solid drive over the bunkers should lead to an eagle putt on the elevated green. The par-3 11th, at 187 yards, is called the most deceptive hole at Kingswood because the tricky wind is almost impossible to judge from the tee. As well, the long but narrow green slants away from the tee, making the back right pin posi-

tion over the fronting bunkers a real test. Long is much preferable to short on the 11th.

On the 441-yard 12th, crushing a drive over the right-hand bunkers on this slight dogleg will set up a mid-iron to a small two-tiered green. The opposite tack is called for on the following hole, at 367 yards the shortest par 4 on the course. Distance control is everything, as a drive too close to the green will leave an awkward pitch to the narrow green. The 14th, the signature hole at Kingswood (see sidebar), is followed by a mid-length par 4 of which you have already had a glimpse, as it shares its

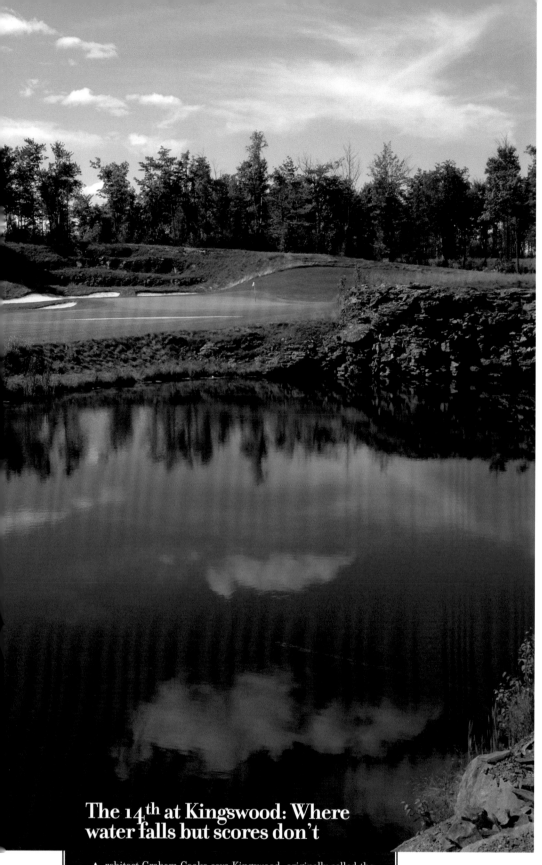

The 14th at Kingswood: Where water falls but scores don't

Architect Graham Cooke says Kingswood, originally called the Lynx at Kingswood Park, is one of the finest projects he and his associates have done to date, and his company dates back 30 years. Golf Digest rankers agreed, making this little known New Brunswick course the "best new course in Canada" a couple of years back. While the design variety impressed them, their memories were no doubt imprinted by the fabulous par-4 14th. While the slight dogleg right is a challenge design-wise, it is the visual distraction of the 30-foot waterfall in the greenside lake that is the real diversion. Ironically, none of the remarkable rock faces might have been possible here had not a late decision by the provincial government necessitated a rerouting of the original layout.

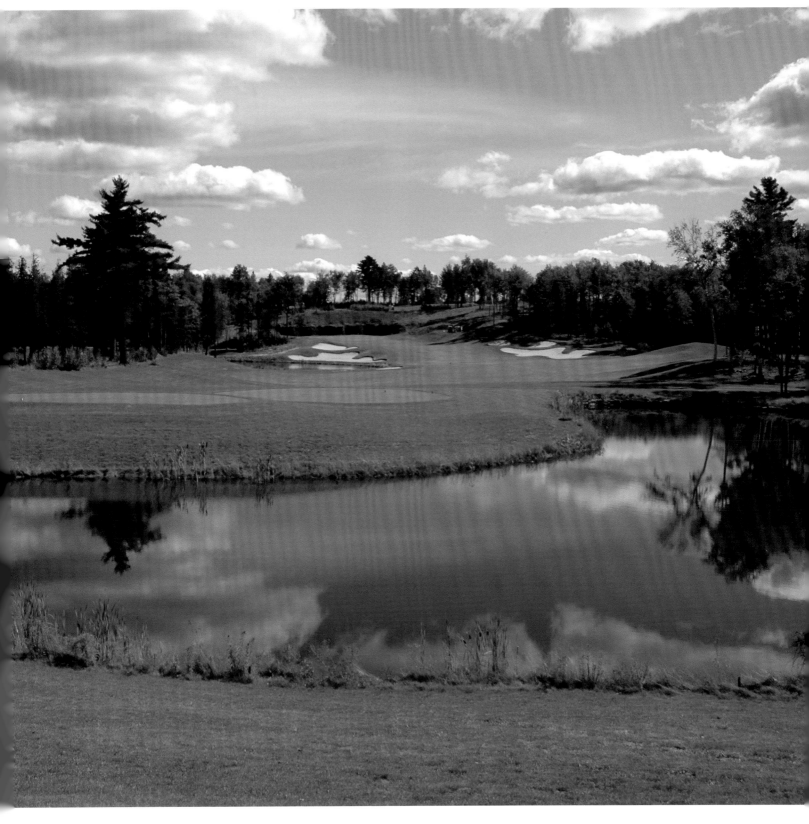

Never considered New Brunswick as golf destination? How about this as an opening hole? Changed your mind yet? Why not?

fairway with the eighth. The 16th starts an excellent finishing threesome with its classic risk-reward par-5 concept. The par-3 17th is 236 yards from the Claws or back tees, with a carry over a lake to a green surrounded by fields of waving fescue. Your birdie putt on 18 will come on the large green in front of the lodge, assuming you have avoided the sodwall bunker.

It used to be assumed that Atlantic Canada, with the possible exception of Prince Edward Island, had inadequate resources for the golf vacationer. Kingswood, by becoming the first New Brunswick course to claim Golf Digest's most prestigious award, has proven that assumption must change.

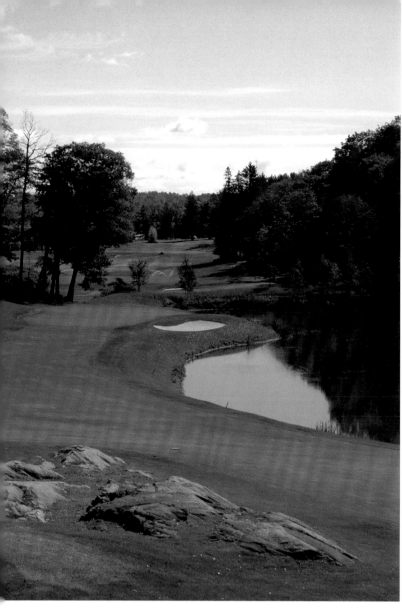

The Lake Joseph Club was architect Tom McBroom's first solo design in Muskoka and one which raised the bar for every subsequent course in one of the world's most scenic and exclusive vacation regions. The 18th hole (left) has all the features – water, rock, sand and forest – that makes Muskoka golf unique. Looking back from the 17th green (right) down a fairway framed by cerulean skies and vibrant autumn colours is a golfer's dream.

THE LAKE JOSEPH CLUB

Port Carling, Ontario

SECLUDED AMONG THE LAKES, GRANITE OUTCROPPINGS AND EMERALD forests in Ontario's spectacular Muskoka tourist region is the Lake Joseph Club, one of the superb stable of courses owned by ClubLink Corporation, Canada's largest owner and operator of golf facilities.

Like many of ClubLink's other properties, it was designed by renowned Canadian architect Thomas McBroom of Toronto.

"The Lake Joseph Club is characterized by magnificent trees, bold rock outcrops and the sensual and striking landscape of Muskoka," says McBroom. "My task here was not so much to create a theme but to let the beauty of the land itself speak out. The lines and the contours of the golf course therefore are relatively gentle and soft, and artificial contouring and highlighting are unnecessary."

McBroom accomplished that and more. Both Golf Digest and ScoreGolf Magazine selected Lake Joseph as the best new course in Canada in 1997. Integral to those honours was the recognition by the rankers that the architect had integrated the

very elements that make a course in this rugged region of Canada unique in the world of golf.

"In laying out the fairways and green sites, I tried very hard to seek out natural bowls, valleys and draws upon which the fairways and greens could be developed without undue grading or manipulation of the land," McBroom recalls. "I wanted there to be a feeling of naturalness and receptivity such that individual holes fit upon the landscape, rather than lying forcefully imposed upon it. I wanted the golf holes to appear as

if they had always been there, while showing off the spectacular beauty of Muskoka.

"The granite cliff which forms the backdrop of the par-3 eighth hole, or the magnificent view from the 16th tee, or the utilization of the wetland on No. 11 as a natural hazard are just a few examples of where the land and the golf course are in perfect harmony."

That underlying principle of restraint applied to the style of the bunkers and greens. In contrast to some of McBroom's con-

Not only does ClubLink, Canada's largest developer, owner and operator of golf facilities, lavish
special attention on their courses, but they manage to build clubhouses that not only are the
envy of the rest of the world, but also are architecturally remarkable and functional as well.

"The Perfect, Extraspecial Muskoka Experience"

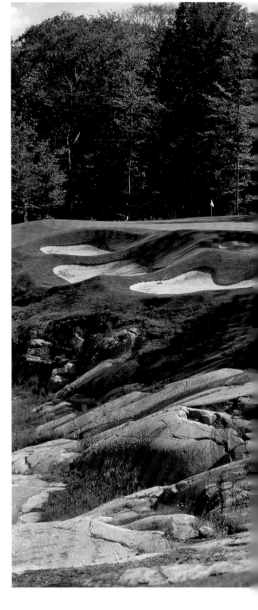

Measuring only 158 yards from the back tees, the par-3 eighth hole at the Lake Joseph Club appears benign on the two-dimensional scorecard, but the 3D, real-life experience is far different.

Director of Operations Greg Macmillan calls this hole "the perfect, extra-special Muskoka experience," because it falls some 75 feet from the tee to a green surrounded by rock faces, towering trees, and bunkers.

Much like the storied 12th hole at Augusta National, site of The Masters, this hole bedevils players because the wind direction on the tee may be 180 degrees different from that at the green. The reason, says Macmillan, is that the breeze at the green is funneled down an adjacent valley.

His advice is to factor in the wind, take an extra club to better control your distance, and hope to hit the centre of the green. The putting surface, which is tilted back to front, and angled away from the tee from left to right, is protected by a deep-faced bunker at the front right, and middle-left by a smaller trap. A miss right leaves a tricky chip back to the elevated green, and overclubbing usually means hitting the rock face or ending up in the trees.

"The best miss is to be short," says Macmillan. "The toughest pin is back right, because you don't only have to worry about how far to hit it, but you have to carry the bunker. Short-siding your shot leaves a really difficult chip."

troversial earlier work, the greens are straightforward in form and contour. These gentle putting surfaces contrast with the complexity of the surrounding landscape, providing balance and relief. Difficulty on the putting surfaces was not a design prerequisite, since the challenges at Lake Joseph appear elsewhere.

In many cases, the bunkers play a more important role than mere penal hazards. In fact, the bunkers can often work for the golfer rather than against him. They provide artistic accent where appropriate and as a line of play guideline. They highlight attractive features such as the magnificent white pine adjacent to the 18th green or the massive rock outcropping near the landing area on the ninth fairway. Bunkers are intended only as hazards where a degree of difficulty is important to the strategy of the hole.

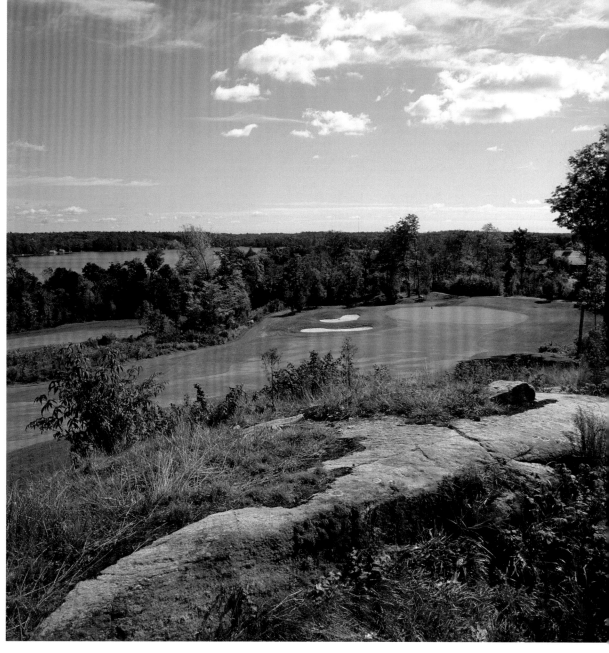

The ninth hole at The Lake Joseph Club demands a tee shot that avoids the rock outcroppings on the right before determining the correct club for the downhill approach to a green protected by bunkers and tall native grasses.

The true difficulty here is not so much focussed on one particular facet of the course, but rather is a sum of the parts. Any time there are 18 holes carved through dense mixed forest and routed over severe and rocky terrain, there is inherent difficulty. McBroom understood he did not have to contrive any monumental golf challenges with this outstanding property because nature had beaten him to it.

Although the Lake Joseph course can be visually intimidating, McBroom says he went to great lengths to ensure "a high level of challenge, fairness, and pleasure for golfers of all skill levels" – popularly known as "playability." McBroom says it is tougher to create a truly playable course than it is to build a severely difficult brute of a layout.

"To achieve playability, four different sets of tees have been designed with tremendous length and approach angle variation between them. The principle is to equalize golfers of vastly different skill levels by placing them on the appropriate tee from which they can hit the specific target, given a reasonable drive."

Not content with the superb 18 full-length holes, ClubLink commissioned McBroom to design a nine-hole short course on the site of the teaching academy adjacent to the main course.

"The short course is one of the important amenities of a true destination resort and caters to families – beginners, seniors, children or parents who want to play with their children," the architect says. "The beauty of the short course is that it is variable in length, allowing everything from a 2-iron to a wedge. With the same overall yardage as the short course at Augusta National, players can hit every iron in their bag, while enjoying a leisurely round."

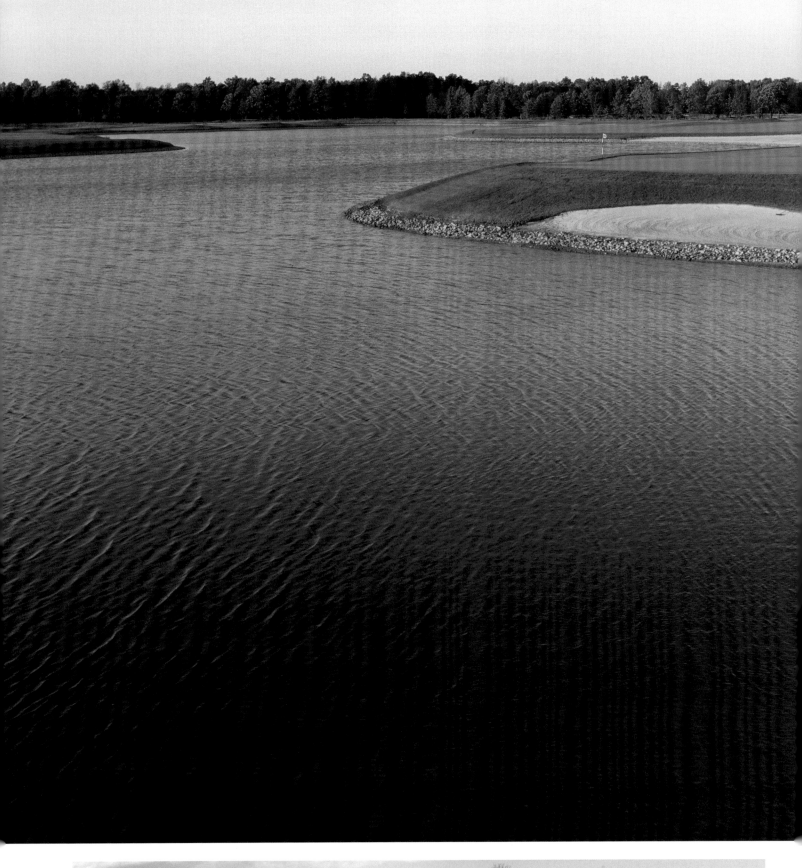

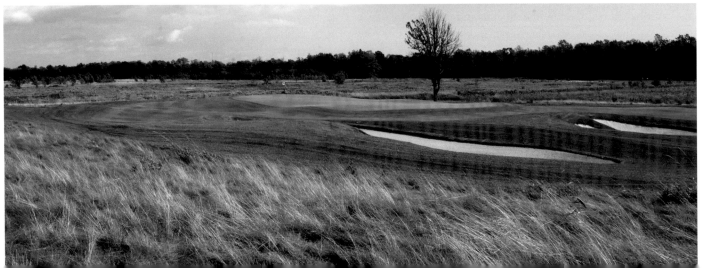

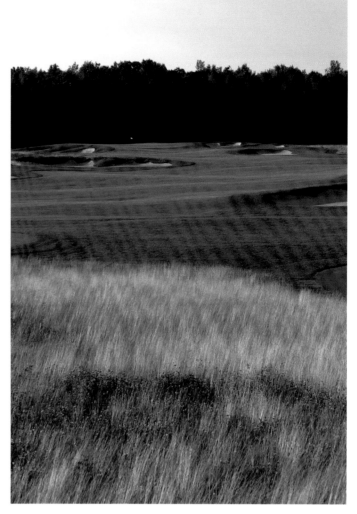

An uninspired 700 acres of clay was transformed into 36 holes of terrific golf thanks to the efforts of Canada's best-known architects, Doug Carrick and Tom McBroom. Their separate but equal results produced Ussher's Creek and Battlefield, the latter the site of the 2004 Canadian Women's Open, an LPGA event.

LEGENDS ON THE NIAGARA

Niagara Falls, Ontario

WHILE CALLING THESE TWO OUTSTANDING COURSES "LEGENDS" MAY BE hyperbole, there is no question that their origins are replete with interesting tales.

Toronto architects Doug Carrick and Thomas McBroom, Canada's two best-known designers, were hired by the Niagara Parks Commission in June 1999 to build a world-class golf complex just across Niagara River Parkway from the waterway of the same name. The 700-acre site was only a few kilometres from the world-famous thundering falls and the Canada-U.S. border.

Each architect was assigned to design their own 18-hole championship course, then combine their talents on a nine-hole short course and a unique practice facility featuring an 18-hole putting course and a 360-degree range covering 45 acres.

McBroom and Carrick, while thrilled with the challenge, were slightly daunted by the nature of the property, which was basically a flat expanse of clay. The heavy nature of the soil created huge headaches for drainage and other technical aspects, but these were eventually overcome.

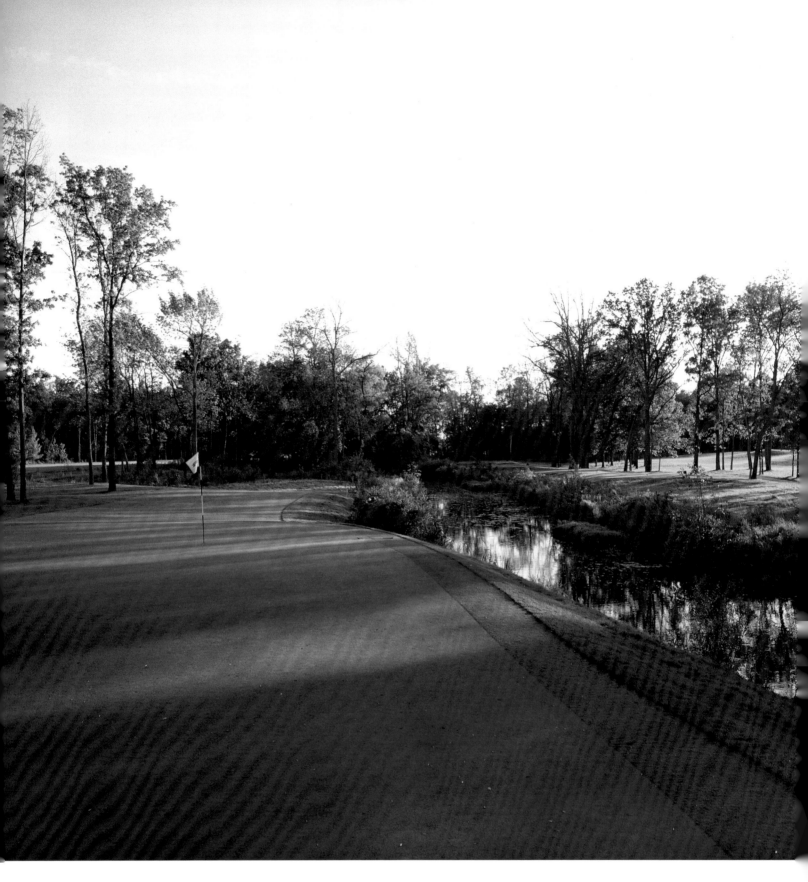

Another challenge was for the two architects, like the rest of their breed not lacking in ego, to come up with an equitable manner in which to choose the parcel of land upon which to build their respective course.

"We literally flipped a coin," chuckles Carrick, "but I think it worked out the way we each secretly hoped it would." The coin flip resulted in McBroom choosing acreage which featured the meandering Ussher's Creek, from whence the course would get its name.

As for Carrick, he received a parcel in the north end of the property which was slightly more wooded. This would eventually become Battlefield, named in commemoration of the Battle of Chippewa, which took place during the War of 1812 adjacent to the course.

"We both got the parcels we wanted in the end," Carrick says. "We worked together almost continuously. In the early stages we did our own routing and then we consulted on things like where the clubhouse should be located, entrance points, that kind of thing."

While McBroom calls the Ussher's Creek site "topographi-

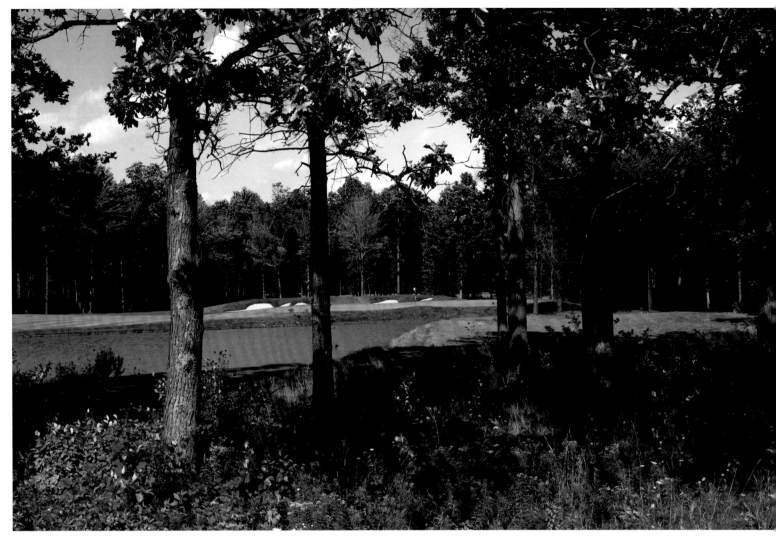

The 205-yard 17th on Carrick's Battlefield (above), with its carry over water to a well-bunkered green, was a tough test for the world's best women during the 2004 Canadian Open. (Left) The 178-yard third hole on Ussher's Creek is one of architect Tom McBroom's favourites.

The 2004 Bank of Montreal Women's Canadian Open

Meg Mallon came to Battlefield, the Doug Carrick-designed course at Legends on the Niagara, fresh from winning the U.S. Open. At the age of 40, few expected her to become the first woman to win the national opens of both countries in the same year. But Mallon, in her 18th year on the LPGA, swept around the course in a record 65 strokes on the first day, the same number she had posted in the final round of the U.S. Open. She would match that score in the third round on her way to a Women's Canadian Open record-tying 18-under winning score. Her closest pursuer was the defending champion, 47-year-old Beth Daniel, but she could get no closer than four shots. A record seven Canadians made the cut, with Dawn Coe-Jones and Lorie Kane tying for fifth. No Canadian has won her native open since Jocelyne Bourassa won the inaugural event in Montreal in 1973.

cally challenged" (that's architect-speak for "flat"), that negative was compensated for by "some beautiful big trees, especially oaks, shagbark hickories and other unusual species."

Despite the inherent environmental challenges, McBroom managed to incorporate the creek into play on eight holes. Overall, Ussher's Creek is generous off the tee, but could bare its fangs when played from the back tees and with tucked flags.

Asked about favourite holes, the architect singles out the third, a mid-length par 3 with an angled tee shot that must carry the creek, and the sixth, a big par 4 across the corner of the lake.

He also takes a perverse delight in the eighth, a 472-yard par 4 – "It's such a killer par 4 that many people think I got confused and it should be a par 5." The front concludes with a 553-yard par 5 that appears reachable but a layup in front of the sliver of a green protected by the creek is the smart play. The final hole at Ussher's Creek is a man-size par 4 where the creek again cuts in front of the putting surface.

In tribute to Carrick's design and the aggressive marketing of the Niagara Parks Commission, Battlefield was selected by the LPGA and Royal Canadian Golf Association as the site of the

2004 Bank of Montreal Women's Canadian Open. To say it came through with flying colours would be an understatement, as the world's best women golfers uniformly complimented the course, and singling out the greens as the best they had played all season.

Like Ussher's Creek, where four sets of tees stretch from 5,400 to 7,200 yards, Battlefield can be as hospitable (5,500 yards) or as hard (7,300 yards) as you want.

The centrepiece, literally, is a huge 19-acre lake created when fill was removed to build contouring on the gently flat property. This lake provides the venue for several of Battlefield's most memorable holes, such as the 449-yard par-4 fourth, the 541-yard fifth, the 190-yard eighth, and the 472-yard ninth, the top-rated stroke hole. On the back nine, the lake provides an attention-grabbing hazard on the 205-yard 17th and the 556-yard 18th, creating a spectacularly challenging finish to your round.

Spacious landing areas are bracketed with enormous fairway bunkers which serve more as aiming marks rather than hazards for all but the most wayward shots. More punitive are the smaller bunkers which protect the contoured greens, many of which are elevated.

In all, Legends on the Niagara is a tribute not only to architects Carrick and McBroom but to the visionaries at the Niagara Parks Commission.

Legends on the Niagara not only boasts two championship courses, but also a terrific practice facility, including an 18-hole putting course (above). Ussher's Creek makes its appearance on several holes, including the short but tricky par-5 18th (right).

"Magna" sums it up. At this Doug Carrick course, nothing succeeds like excess. From the clubhouse to the fairway landing areas to the greens, everything is oversized.

MAGNA GOLF CLUB
Aurora, Ontario

WHEN DOUG CARRICK, THE ARCHITECT OF MAGNA GOLF CLUB, SAYS EVERYTHING here is on a "grand scale," you have to picture him with his arms spread as wide as they can go. That's still not wide enough, however.

From the expansive fairways down to the oversized lockers in the imposing chateau that serves as the clubhouse, every aspect at Magna was intended to be not just bigger, but better, than anything else in Canadian golf.

"There were no barriers to excellence here. We wanted to create a real-life version of what people dream about." Executive Director David Kaufman admits he's a touch biased but the fortunate few members and their lucky guests are sure to agree. Only about 250 golfers have ponied up the $125,000 entrance fee to play this former horse farm, and annual dues are "north of $10,000," says Kaufman. Guest play constitutes about 4,000 of the paltry 15,000 rounds each season.

"Instead of trying to out-do our competitors as is usually the case in business, we decided not to have any competitors. We would do whatever it took to excel beyond anyone else in both the product and the service for a small membership willing to pay whatever it took to achieve that. The last thing we want is for our members to come to their club and have something less than what they already have at home. We want them to feel indulged every time they set foot here.

"We never spent money just for the sake of spending it," says Kaufman. "We tried to accomplish the perfect fusion of form and function."

Owned by auto parts magnate Frank Stronach, Magna is a tribute to an unlimited budget. Architect Doug Carrick was judicious with his open chequebook, creating a layout that while spacious, also presents a challenge for those players who want to walk away with an enviable score.

When auto-parts magnate Frank Stronach, a non-golfing horse-racing aficionado, wanted to create a centrepiece for his 750-acre Magna International campus just north of Toronto, he contacted Carrick to design 18 holes that would delight members and their guests while retaining the potential to challenge the best players in the world. Neither faction would be disappointed.

Even the hapless hacker will notice the differences at Magna. Just like on the PGA Tour, the inside of every cup is painted white,

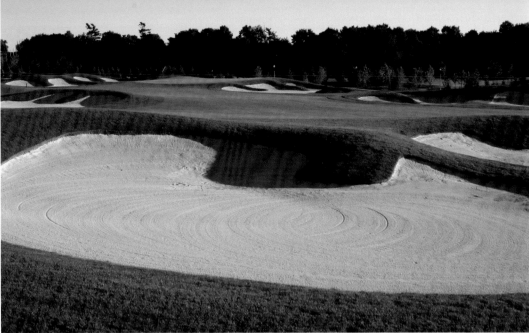

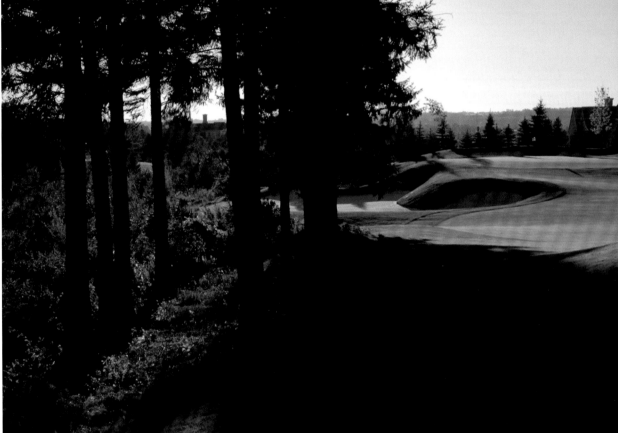

and every maintenance worker is off the course by the time the first player of the day hits his opening tee shot. Exact yardages are posted on every par-3 tee box, and the yardage guide is a work of art. Conditioning brings to mind that overused term "manicured," but the brash Kaufman goes further.

"I've been around the world and I've never seen better conditioning – ever. Augusta is in the shape you see it during the Masters for maybe 12 days. Our course is in shape for 200 days in a row."

The keys to a successful round at Magna are driving the ball to the right position on the generous fairways, knowing where to miss the greens, and getting through the punishing first five holes at even par.

If you're fortunate enough to be invited inside the gates, all the excitement and all the length are in the par 4s, and you are immediately aware of that right from the first hole.

At 473 yards from the pro tees and 440 from the middle deck, the first is a dogleg-right down a hill with water on the right and

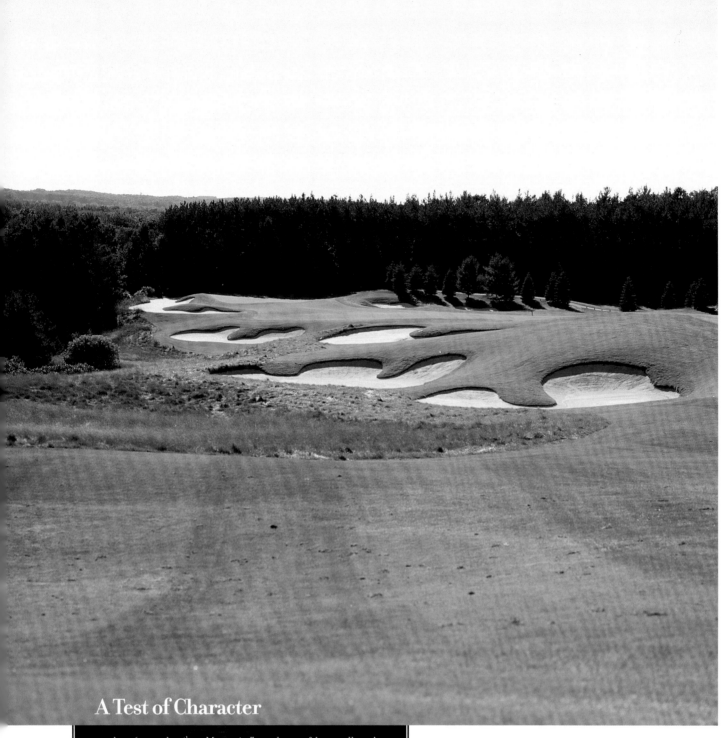

A Test of Character

The 560-yard 14th at Magna is "a real test of how well you're playing that day," says Executive Director David Kaufman. "It's visually stimulating and intimidating because all you see when you stand on the tee is bunkers and fescue. It's a perfect risk-reward hole because if you play it as a three-shot hole, it's an easy five. But if you try to cut the corner, you can hit the downslope and get another 65 yards of roll, but then you take the risk of hitting it into the bunkers or, much worse, into the fescue from which it's almost impossible to extricate yourself. But if you hit it down the extreme left side of the fairway and get that extra roll, then it's only a mid-iron to the green. What's so great about either route is that the green has a row of pines behind it, and bunkers to the left, and there's a pitching area on the right. So, if you're long, you're "x-ed" because you'll never see the ball again. If you're left or right, you've got a very delicate shot to what isn't a very big green. Two good shots and you're rewarded with an eagle putt, but one bad shot and you might not finish the hole."

forest on the left. Taking an aggressive line over the correct aiming bunker reveals that the landing area is much larger than it appears from the tee, a Carrick trademark. "This green is protected, as are many here, by deep bunkers on one side and thick rough on the other, and the back of the green slopes away to a water hazard," Kaufman notes. Other greens are guarded by bunkers on one side and tricky Pinehurst-style collection areas

on the other; often the bunkers are a better place to miss the green if you hope to get up and down.

Level par as you stand on the sixth tee may be a lofty goal if you're playing from the back tees, he says. "You're probably looking at a 4-iron in on No. 1, No. 2 is 210 yards over water so that's probably another 4-iron, you have to thread the needle off the tee on No. 3, on No. 4, you're probably hitting a 3-wood onto the green, and No. 5 is a short hole with a really tough

green, which is another Carrick characteristic. Then you can breathe."

While Magna received some criticism for its wide-open fairways when it opened, its ongoing evolution includes recontoured landing areas to penalize poor shots and reward good ones, and 400 yards of additional length. But unless you're a member or lucky enough to know one, you'll just have to take our word for it.

LE MAÎTRE DE MONT TREMBLANT

St. Jovite, Quebec

LIKE THE PGA TOUR STAR UNDER WHOSE SIGNATURE LE MAÎTRE WAS designed, this course in Quebec's gorgeous Mont Tremblant region of the Laurentian Mountains offers far more depth than one might expect at first glance.

ClubLink Corporation, the country's largest owner, operator and developer of golf facilities, hired 1992 Masters champion Fred Couples to work as a design consultant. The intent was that Couples' vast experience would complement the expertise of

Gene Bates of Couples-Bates Design, and that of local architects Graham Cooke and Darrell Huxham.

Cooke and Huxham, based in Beaconsfield, Quebec, handled just about all the onsite details. "We talked to Freddy before we started the process, and his own company provided a part of the equation," recalls Cooke. "But basically it was Freddy saying, 'Okay, since you guys are right there, here's the kind of golf course I want. I want to flash the bunkers, I want

With the fabled ski destination of Mont Tremblant as a background and PGA Tour legend Fred Couples as its design consultant, it is no wonder Le Maitre is one of this country's most interesting courses. An abundance of sand and water hazards, including a waterfall on the finishing hole, provides the ultimate resort golf experience.

to make sure the greens are approachable and puttable. I want it to be resort-ish in its look.

"So we sent him routings and he was happy with them, and although we met with his group along the way during their site visits, Freddy really just went along with making sure we understood his philosophy. Gentle guidance, you might say."

That Cooke and Huxham understood Couples' subtle suggestions was evident when Cooke, one of Canada's all-time outstanding amateur golfers, played with the Tour standout during Le Maitre's grand opening in 2001. "As we went through the holes, he said he was very pleased, that he appreciated the work, and that it was representative of what we had discussed all along."

Couples, having been involved in many courses worldwide both as a player and a design consultant, no doubt appreciated the process as much as the end result. The property that was destined to become Le Maitre had a multiple personality when Cooke and

The 425-yard, par-4 sixth at Le Maitre (above), the 14th (right) and the 400-yard second hole are perfect examples of the shotmaking expertise required to score well at this sprawling ClubLink layout.

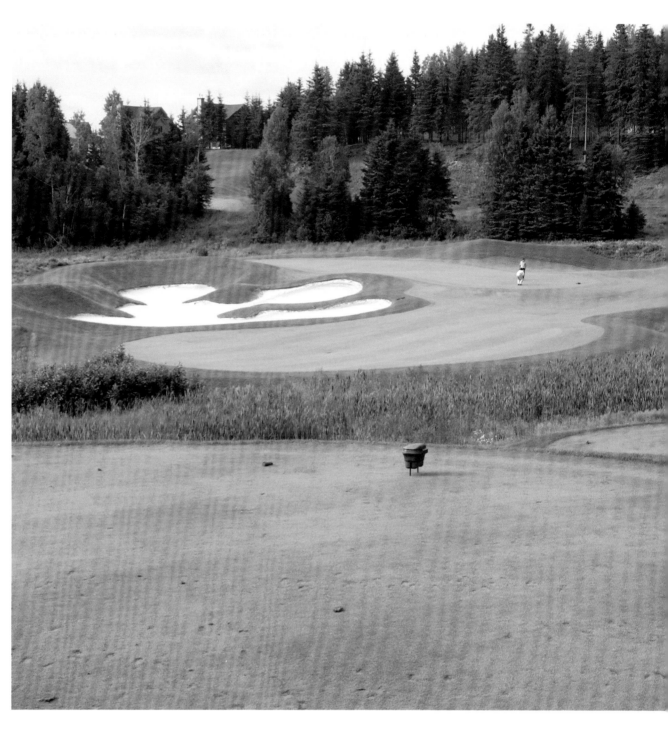

Huxham first laid eyes on it. While parts were open and rolling, there were valleys and marches, and stands of thick forest.

Cooke likens the site to slices of pie, or spokes of a wheel. "It was kind of tough to get your head around at the start because it was going off in different directions. It was broken into regions by some elevation changes and strong forests so the challenge was to make all these areas and features blend together and play as one."

But what could have been a curse was turned into a blessing by the joint input of all concerned, says Eric Lamarre, who was the head professional at Le Maitre when it opened.

"It's really fun to play because it's like three separate courses. The first six holes are in the woods and can be tough to play. No. 5, for example, is 605 yards. I never saw anyone get there in two, because of the two creeks, and the wind never seems to be at your back.

"The next six are pretty much open, but with lots of water and bunkers and hills. There you can hit it as hard as you can. The last six, it seems like they're almost surrounded by water. It's a really classic resort experience."

That experience is enhanced by the cozy clubhouse where, as in all ClubLink facilities, no corners were cut. Although only

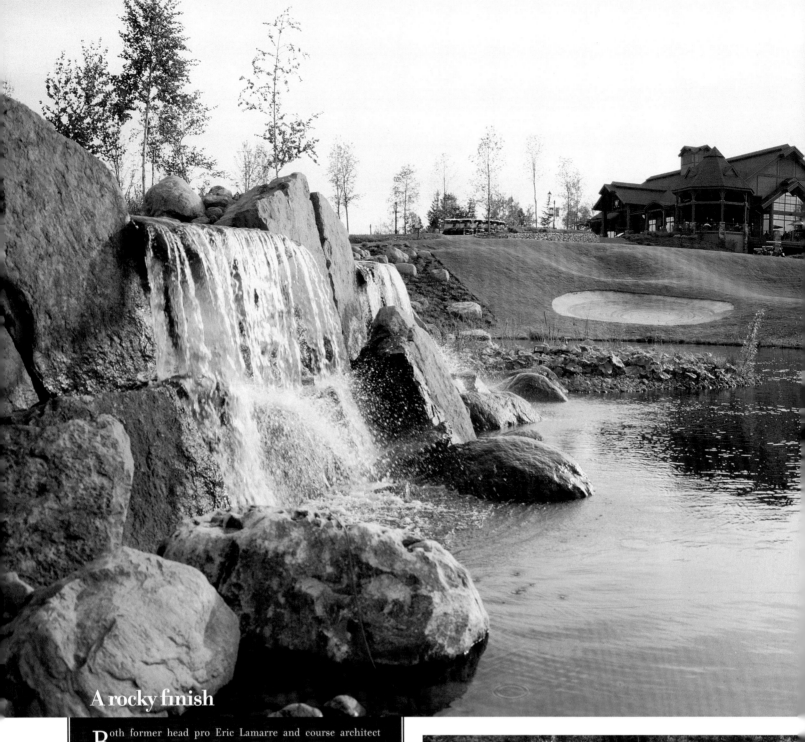

A rocky finish

Both former head pro Eric Lamarre and course architect Graham Cooke agree that the best "statement" about Le Maitre is made at the 445-yard, par-4 finishing hole.

"It's so great to come to 18 with that view of the clubhouse and the rock on the right side, and the waterfalls behind the green," says Lamarre, now director of golf at Le Fontainebleau, a ClubLink facility near Montreal. "It's awesome."

"The 18th sits below the clubhouse in a big amphitheatre," explains Cooke. "We built some waterfalls behind it, but there was a ice old Precambrian rock outcrop along the hill before you go up to the clubhouse and that we used to become a nice showcase. We planed it all off and exposed it, and just coming into that makes a great finishing hole."

Asking Cooke, one of the country's great players for more than four decades, how to play the 18th receives a less than satisfying answer. "I've hit into the water a few times, because it forces you to risk because the rewards are great. Don't play as aggressively as I do, lean a little to the right and don't pull it into the water."

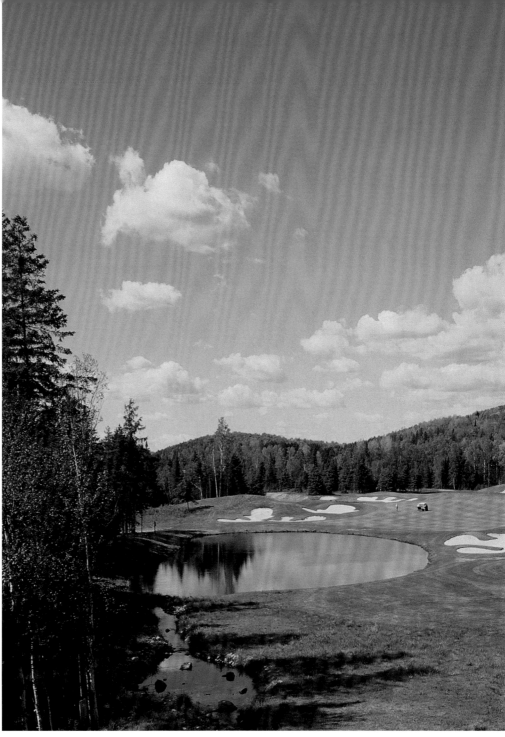

The 12ᵗʰ hole (bottom left) and the second are typical of Le Maitre: Framed by ancient forests, they require much thought and precise shotmaking to dominate what may appear at first glance a relatively easy layout.

13,000 square feet in size, it offers many traditional club amenities, including tennis courts and a swimming pool for the enjoyment of ClubLink members and guests.

"We pride ourselves on giving the best service we can offer," says Head Professional Eric Laframboise. "Not only to our members but to our guests as well. We like to call them members for a day. People come here to be spoiled a little bit."

"What we ended up with at Le Maitre was a terrific resort course, but one where if you hit great shots, you get great rewards." Cooke concludes. "It's a tremendously diverse golf course, with different looks, interesting shots and bunkering. It can be fun, but it can be tough, too."

Something like Fred Couples, when you think about it.

LE MIRAGE

Terrebonne, Quebec

"Celine Dion saw it, and she wanted it, and she bought it."

So says Graham Cooke, who designed the 36 holes at Le Mirage well before the gazillionaire Quebec-born pop diva decided she wanted to fall in love with golf after doing the same with former manager Rene Angelil, whom she eventually married.

The 350 acres about 20 minutes from Montreal are home to two, par-71 courses: Carolina and Arizona. The names alone should give a hint to their respective design characteristics.

"It's a beautiful area of Quebec, with sandy soil and big old pine trees," says the Montreal-based Cooke. "The two courses are distinctive. Carolina is a parkland course, with the same look as down there, pine needles in the rough and so forth. It's a good challenge.

"Arizona is not quite as long and has huge waste areas, not as long. There is a nice water table there, so as soon as we took the

Where else would you find Arizona (left) and Carolina (above) in Quebec?
Only at Le Mirage, owned by Celine Dion.

Like Dion's musical renderings, her courses provide a sense of serenity and harmony, as on Carolina's 18th fairway (far left). The 12th on the Carolina course (above) and the 15th (left) typify its traditional park-land heritage.

sand out, the lakes filled with pristine water. Although it's a little shorter, it's a different look and just as popular as Carolina. It's certainly not the weak sister by any means."

In 1997, Dion, turned on to the game by Angelil, purchased an interest in Le Mirage and began taking lessons from Debbie Savoy-Morel, a noted Quebec club pro. After several months of providing lessons to Dion on a part-time basis, Debbie was asked to become head pro and director of golf at Le Mirage when Dion and Angelil took full ownership.

After those initial lessons, Dion became as enthusiastic about the game as her husband, a long-time golf fanatic. Her tour manager now has to ensure that golf time be reserved when Dion is touring. Provisions are also made backstage so Dion can practice her golf swing. When not touring, much of their time is spent at their French-inspired chateau not far from Le Mirage.

"Her mental abilities are developed like those of an Olympic athlete," says Savoy-Morel. As an entertainer, "Celine has the ability to visualize the way her body moves. That's a tremendous advantage to someone learning how to swing a golf club."

"I'm looking at this microphone and I'm thinking about my

Divas and divots

When popular music icon Celine Dion, who owns Le Mirage along with husband Rene Angelil, bumped into LPGA icon Annika Sorenstam at Callaway Golf's headquarters in Carlsbad, California, the match was made in entertainment heaven.

The two hit it off personally and agreed to hit it off golfingly at Dion's course just outside Montreal.

One of Le Mirage's golf pros, Claudia Beauchesne, caddied for the duet and then played a round against Sorenstam and Dion.

"Celine plays very well," Beauchesne said. "She's a good driver."

For her part, as of this publication date, Sorenstam, a 34-year-old Swede, had 57 LPGA victories and qualified for the LPGA and World Golf halls of fame.

We know who we would have wagered on.

Big Bertha driver and I'm thinking about driving a ball through the wall," Dion told CNN's Larry King shortly after she took up the game.

"The game to me is focus, and in show business you need to be very focused."

Dion's golf profile was further enhanced when she agreed to do a television commercial for Callaway Golf, and when she jumped into the pond on national television with Karrie Webb, winner of the 2000 Nabisco Championship.

Webb, who had won by 10 shots over defending champion Dottie Pepper, jumped feet first into the murky water at the 18th green in the traditional winner's celebration at the Dinah Shore course in Rancho Mirage, California. Pepper instigated

No detail is left unnoticed at Le Mirage, where the conditioning and aesthetic touches are special. Here, the view from Carolina's 13th tee across to the 12th tee.

the watery conclusion with a friendly shove as Webb approached her for a handshake. Webb's caddie joined her in the lake, and Dion waded in to shake hands with both of them.

But to focus on Le Mirage's celebrity owners is to ignore the quality of the courses themselves. Carolina's 6,700 yards filter down to 5,300 thanks to five sets of tees, although the challenge is raised because of the six lakes and piney forests. At a relatively meager, by today's male-dictated standards, 6,400 yards, Arizona features seven lakes and extensive waste bunkers. Celebrity guests such as Annika Sorenstam (see sidebar), Ken Griffey and Per-Ulrik Johansson didn't seem to mind.

Although they were excellent Cooke designs on a great piece of property, the new owners asked for renovations on both courses.

Arizona was lengthened and many traps were added. A new target green and a practice area for the short game were built on Carolina, and the practice range was enlarged. The clubhouse also underwent significant renovations.

"Celine and Rene want Le Mirage to be a private course with high standards," says Savoy-Morel. "They want it to be one of the nicest courses in Canada."

One of Dion's first priorities was the pro shop. "The decor in the shop is gorgeous," says Savoy-Morel. "It was all Céline's choice with her personal decorator, Johanne Dastous, whom she uses for all of the decor in her homes and her businesses. Celine wants everyone to come in and feel at home at Le Mirage."

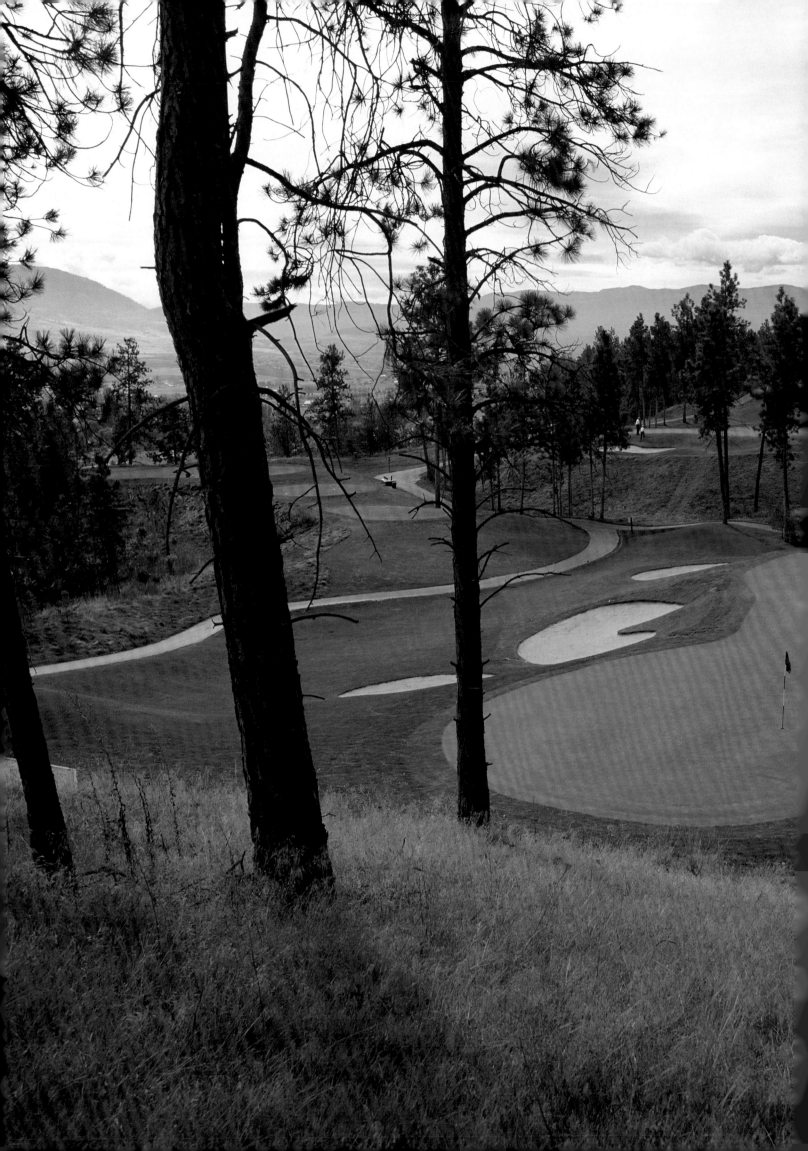

THE OKANAGAN GOLF CLUB

Kelowna, British Columbia

WHEN ONE OF THE MOST FAMOUS NAMES IN GOLF WORLDWIDE DESIGNS a course in one of the most scenic areas of the country right alongside another great layout dreamed up by one of our best homegrown architects, what have you got?

The Okanagan Golf Club.

In the early 1990s, Les Furber of Canmore, Alberta, laid out The Quail course which cut up, down and through the towering Ponderosa pines that line the hills overlooking 120-kilometre-long Lake Okanagan and its orchards and vineyards.

A few years later, Nicklaus Design was called in to build a signature course, The Bear, so called in tribute to the head of the company, Jack Nicklaus. Although the plans bore the name of Nicklaus's son-in-law, Bill O'Leary, the Golden Bear himself has input on all his company's designs and even made a guest appearance for The Bear's grand opening.

It was an auspicious start for the new track which, like The Quail, offers a swinging hike through the forest. The site features panoramic views of the valley from several holes, with the surrounding Cascade Mountains providing even more distraction from the task at hand. The enviable climate of this sun-drenched vacation destination four hours' drive from Vancouver in British Columbia's semi-arid desert Interior region makes for perfect conditions from May through November.

The par-3 sixth hole at The Bear course illustrates many of the characteristics of the Okanagan Golf Club: elevation, pines, and sand.

143

Golf legend Jack Nicklaus used some of his familiar techniques at The Bear, like generous landing areas that funnel the ball back to the fairways, and large greens.

From the back tees, The Bear plays to 6,885 yards. Well-placed bunkers, grassy swales and collection areas, sculpted moundings, and tiered greens lend the course some bite.

Visitors familiar with The Quail, which is more target-oriented, will be welcomed to The Bear by typical Nicklaus design features, says Kevin Isabey, Okanagan Regional Sales Manager for GolfBC (see sidebar).

"We find that The Bear is three or four shots easier than The Quail," says Isabey. "The contouring of the fairways directs balls back to the landing areas, and there are big greens that you fly the ball into. There are five sets of tees, so it can play as hard or as easy as you want."

The first 12 holes are cut through the trees, providing a sense

(Top) The 450-yard 10th hole is a dogleg right where the tee shot must avoid a big fairway bunker on the left while the approach is threatened by another huge trap to the right of the green. The par-3 13th (above) plays from 88 to 211 yards, thanks to The Bear's multiple tee decks. From the back decks, the tee shot must carry the water.

of separation between each hole. The next three offer a bit of a breather, but take notice of the 13th, a terrific par 5 with water on the left. At 531 yards, it is reachable if the wind is behind you, and a pyramid-shaped mountain provides a backdrop to the green. These three play over the blue waters of Lake McIvor. More than 150,000 cubic metres of earth were moved to create the lake and the dramatic topography around it, yet the course maintains a perfect harmony with the natural terrain.

Isabey points to the next three holes as a memorable finish to a round at The Bear.

"From the back tees, the 16th is about 420 yards, with a downhill second shot with anything from a 3-iron to a 6-iron depending on the drive. There's a valley and trees to the left, so

you want to veer right. The 17th hole is another downhill, dogleg right, 430 or so from the back. Eighteen is a par 5 of about 520 from the tips with a double valley fairway and an elevated green. It's reachable, but only if you can hit it over the mounds at about 290 yards out, so you catch the down slope."

In contrast to its younger sibling, the 6,785-yard Quail Course features dramatic elevation changes, multi-tiered fairways, and the occasional rocky bluff. While it demands accuracy throughout, the landing areas are fair but many greens are elevated, encouraging a high, soft approach.

As with most Furber designs, The Quail's par threes are particularly strong, all over 200 yards, and with greens terraced into hillsides, meaning a missed green can easily translate into

145

GolfBC

Since 1989, Burrard International Inc. of Vancouver has been creating or acquiring premium golf destinations in British Columbia, and since October 2003, also in Hawaii. The objective was to establish a series of facilities throughout the province and beyond where players could experience total golfing excellence.

Their properties include Mayfair Lakes (host of several Canadian Tour events), Nicklaus North (Golf Digest's Best New Canadian Course in 1996, and host of the 1997 Skins Game and Shell's Wonderful World of Golf in 1998), Furry Creek, Olympic View, Arbutus Ridge, and Gallagher's Canyon (perennially chosen as one of Canada's top 50 courses) in B.C., plus facilities in Maui and Kauai.

Burrard International promotes all of their golf facilities to players under one organization called GolfBC. This arrangement allows golfers to access information and tee times from one online location, GolfBC.com.

At 531 yards from the tips, the par-5 13th is reachable in two, as long as you avoid the water on your second shot. A layup might be preferable, however, to ensure a precise approach to the day's pin position on the two-tiered green.

a lost ball. The architect himself admires the renowned sixth, a 522-yard double-dogleg par 5.

To improve your score on both courses, the Okanagan Golf Club offers a rare chance to attend the famed John Jacobs' Golf School on site. Of the 37 courses in North America to have this facility, only two are in Canada.

A true golfing destination, the 384-acre Okanagan Golf Club offers a choice of onsite accommodations: Borgata Lodge with suites beside The Quail's first tee, Bella Sera and its 54 villa town homes, and the 120-unit Point of View, perched atop some of the highest points of the property and offering 360-degree views of the valley. Retail shops, boutiques and a spa round out the experience.

OSPREY VALLEY RESORTS

Alton, Ontario

THE HEATHLANDS COURSE AT OSPREY VALLEY REMAINS ONE OF Canada's hidden gems, even though it is perhaps only an hour's drive from Toronto. Tucked between the town of Orangeville and the village of Alton, it has become something more: The forerunner of two more terrific Doug Carrick-designed courses.

While the term "heathlands" created its fair share of headscratching back when the first course opened in 1993 (it refers to an inland links), the names of its two offspring will cause headshaking.

"The south course is Hoot, and the north course is Toot," says Carrick, seemingly unconvinced that he is correct. "I have a sus-

picion that there might have been some alcohol involved when they were named [by owner/developer Jerry Humeniuk]."

Unusual names, to say the least, but Carrick thinks he knows the rationale behind their origin. "[Humeniuk] thinks the golf industry as a whole takes itself a bit too seriously and that golf should be fun, and entertaining. And that the names should reflect that." According to Carrick, the owner toyed with the idea of calling his creations "Royal' Hoot and "Royal" Toot as a jibe at other courses who have cavalierly adopted that once-sacred prefix.

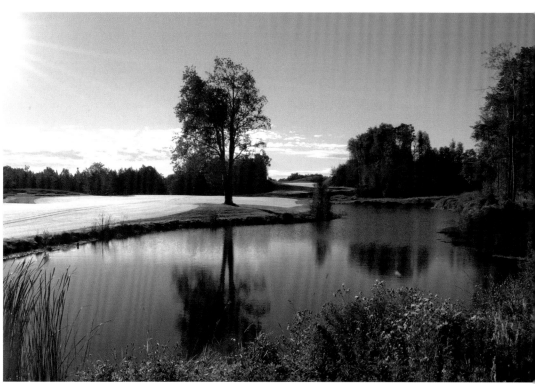

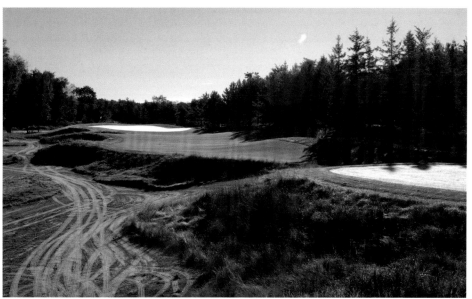

The three courses at Osprey Valley, all designed by Doug Carrick, are as unique as their names: Heathlands, Toot and Hoot. The latter is especially notable for its ragged, naturalistic feel, carved out of a former gravel pit in homage to other famous sand barrens courses, such as Pine Valley in New Jersey. At the left, Hoot's third, its seventh (top of page) and the 10th (above).

The two courses, while of widely disparate personalities, were built simultaneously under the watchful eye of Humeniuk. Toot was intended to be a user-friendly, traditional layout with wide fairways and a paucity of fescue. "At one point, Jerry said – and I think he was joking – that he wanted one set of tees where he could putt from tee to green. I think we succeeded for the most part."

Humeniuk saw golf as entertainment and wanted a course where less accomplished players, couples and families could enjoy a four-hour outing.

"The ninth is a very natural hole," says Carrick, "because it required very little grading. It just seemed to fit into the valley. The ideal tee shot is left- to-right so you will end up on the right centre of the fairway. The green opens up from there. Hit a draw on your second shot, but the elevated green will make club selection crucial. The 10th is a short downhill par 4 through a valley, with a pond on the right side of the green. The 14th is probably the prettiest corner on the golf course, a dogleg right par 4 with dramatic valley you hit across on the tee shot to the landing area. Nice topography, great roll to the ground. No. 16 is a really strong par 4, uphill tee shot and downhill to green, about 450 yards. I really like the carry angle on the 18th because the big bunkers on the right make you bite off as much as you can chew in order to get a better angle and less distance into the green." The final green is set by a large pond and future plans call for a rambling lodge to be built behind it.

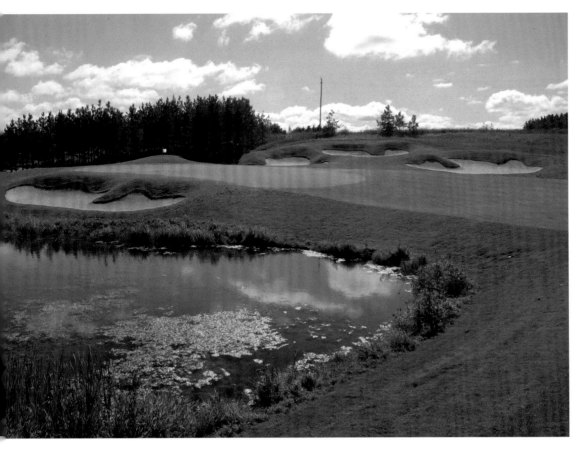

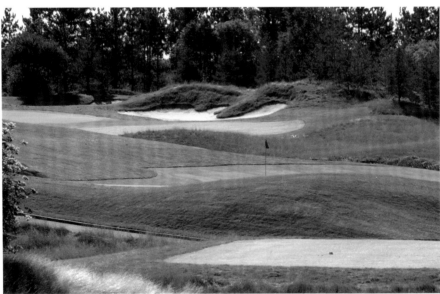

Hoot is littered with expansive waste areas and stately stands of towering pines, reminiscent of the iconic Pine Valley in New Jersey or Florida's Pine Barrens. "Much of this site was an old sand and gravel pit which had been partially rehabilitated," says Carrick. "The result of the low water table was that there are some beautiful ponds, which look quite natural, and some great contouring, with long, sweeping lines. We worked on that concept, making this a more natural, soft, ragged style course.

"The guy who did the bunkers had never done a course before, so he had no preconceived ideas of what bunkers should look like. Sitting on the machine for hours and hours, I guess he would start hallucinating, so we saw some pretty interesting stuff, like bunkers that looked like cows, and that sort of thing.

You had to really look to see what he was talking about, but it was there. He had fun and he did a tremendous job — after we gave him a little guidance."

But, as when he discusses the Heathlands which represented a new direction in his designs, Carrick's voice takes on more emotion as he takes a virtual stroll through the Hoot's routing.

"There are so many good holes here. The second hole is one of my favourites, an uphill par 4 about 410 yards, with big waste areas on right side leading up to green and some short left off the tee, and beautiful tall pines behind the green. No. 3 is through some very tall pines, giving it a North Carolina feel, with a big waste area down the right-hand side from tees to just short of the landing area and another up by the green. Six is a

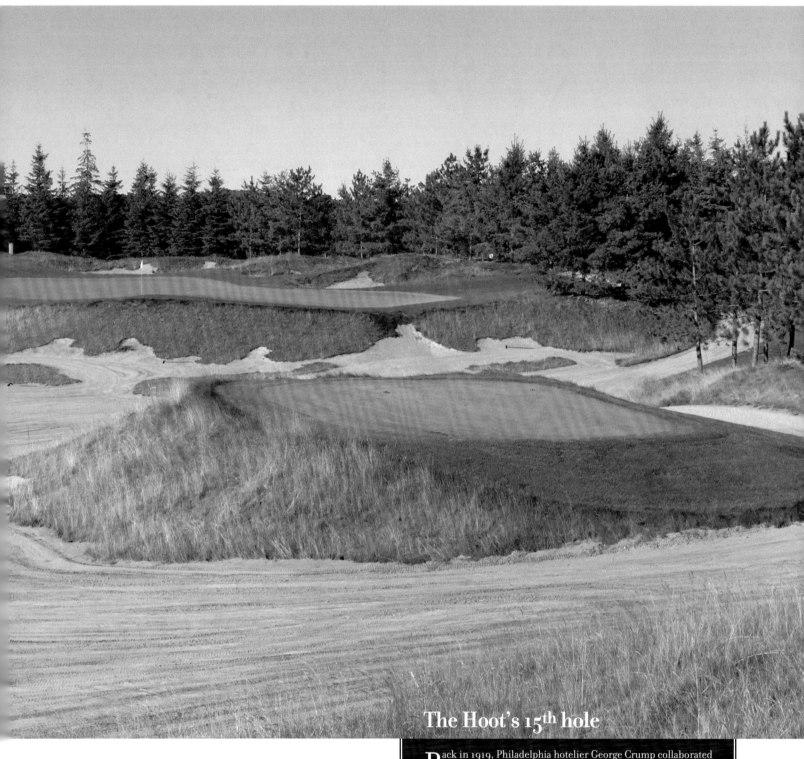

The Hoot's 15th hole

Back in 1919, Philadelphia hotelier George Crump collaborated with English architect Harry Colt to produce a true golf legend in the sandy pine barrens of New Jersey. Since Golf Digest started ranked courses in 1985, Pine Valley has been No. 1.

So it is no surprise that when Doug Carrick was confronted with a piece of property somewhat reminiscent of Pine Valley's origins, he studied the work of Crump and Colt, and came up with some holes on Osprey Valley's Hoot course that are a reasonable facsimile.

"I would say these are in the Pine Valley tradition, not really a copy," Carrick summaries. "The one that was really inspired by Pine Valley was 15, which is not unlike the 10th hole at Pine Valley in that it is a short par 3 with sandy waste from the tee to the small green. This was the most satisfying hole for me. The transformation was incredible. It was a flat, open field without a single tree, a tabletop."

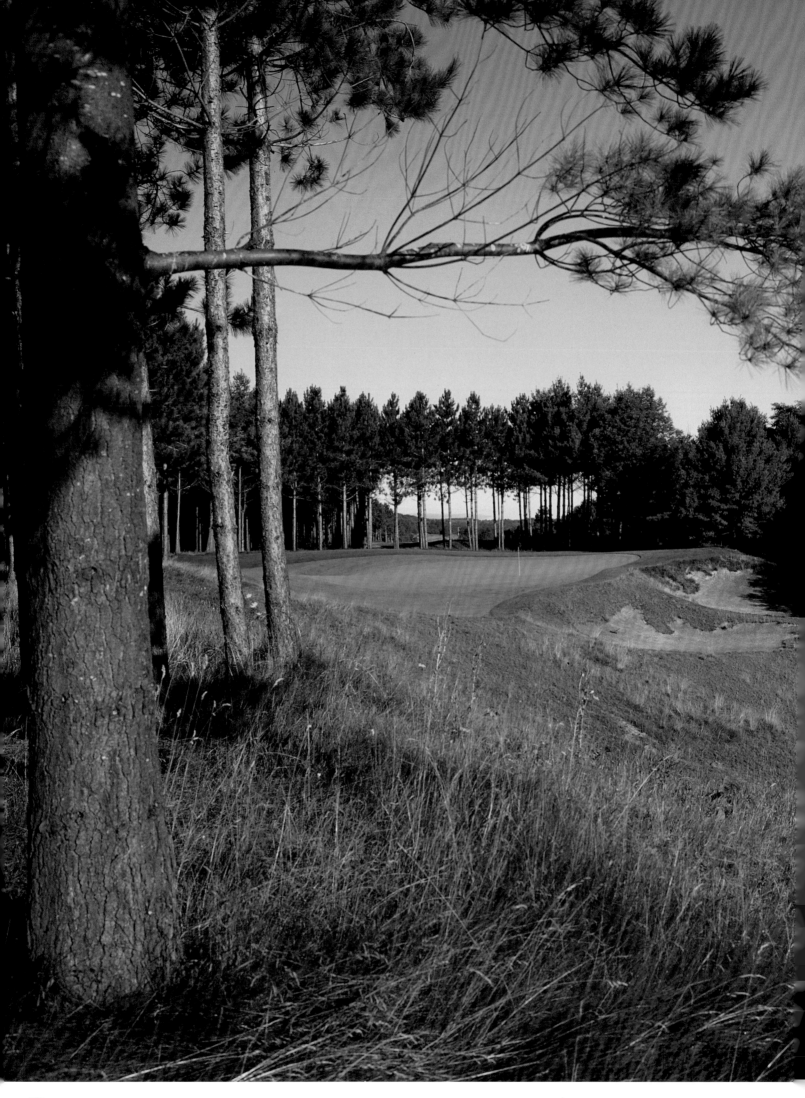

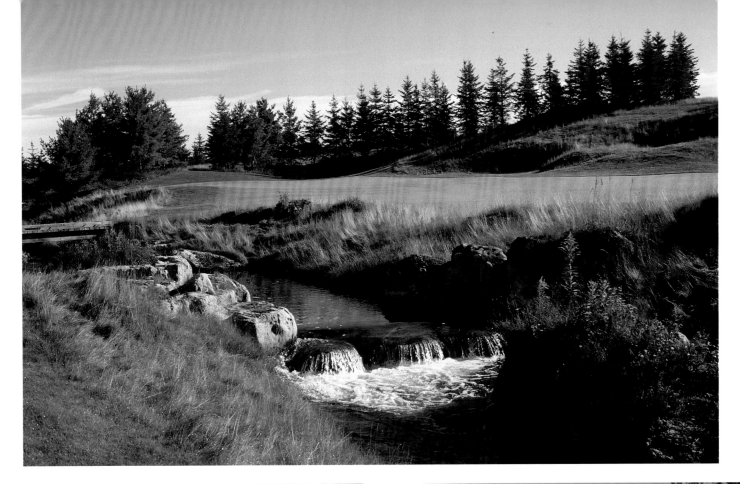

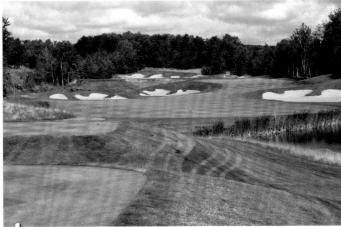

The rustic quality of Hoot (No.8 left and 17 at top of page) contrasts with the manicured traditional parkland atmosphere of Toot (No. 6 above, and 17 right).

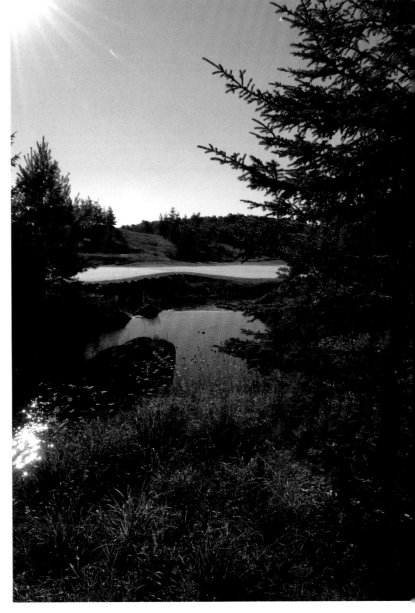

short dogleg right, par 5, with beautiful natural looking ponds on the right. If you're up to it, it allows you to bite off the corner on the tee shot and easily get home in two.

"No. 7 is a dramatic par 4 with a pond on the right side and a big tree sort of in the centre of the fairway and a waste area on the left, very elevated green. The 13th is a neat par-5, downhill, with beautiful pond on right side of green. The fairway serpentines around the left side of the pond so it's a risk-reward situation."

The 54-hole public facility an hour northwest of Toronto is intended to be the centrepiece of a conference centre, golf villas and resort. It promises to be a complex unique in Canada in the future but remains a fabulous golf destination at present.

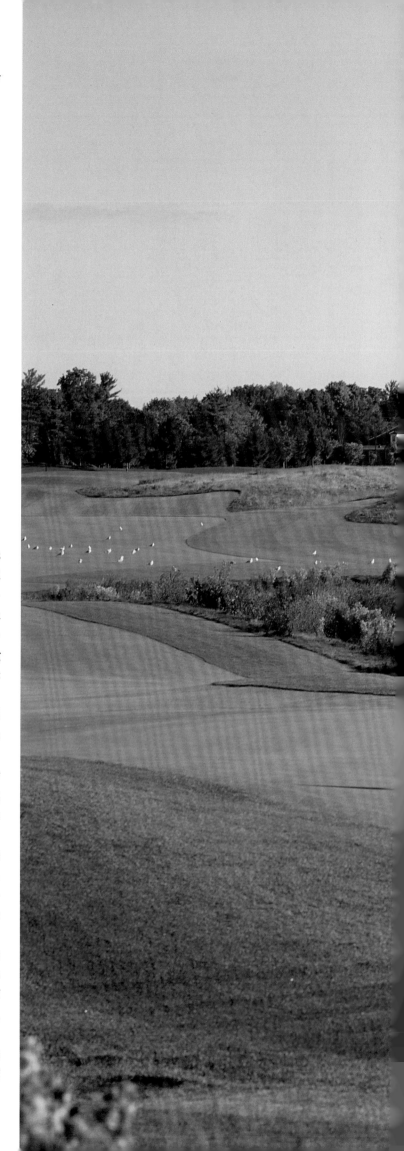

Presented with a relatively uninteresting palette, architect Tom McBroom used all his artistry and expertise to create the SideWinder and CopperHead courses at RattleSnake Point, either of which could be potential Canadian Open sites.

RATTLESNAKE POINT GOLF CLUB

Milton, Ontario

THIRTY YEARS AGO, NOT FAR FROM RATTLESNAKE POINT, A GOLF COURSE designed to be the perennial host of the Canadian Open opened its gates to less than effusive praise. While the Jack Nicklaus-designed Glen Abbey had five excellent holes running through a river valley, the other 13 were perched on a relatively feature-less tableland, their fairways demarcated by spindly young trees. While their design was strong and fair, their optics left something to be desired.

Today, a more mature Glen Abbey has gained universal respect for both its strategic and spectator attributes, and those who know and love RattleSnake Point draw a comparison.

Course architect Thomas McBroom took what he candidly characterizes as "six cornfields in a row" along busy Highway 25 and produced two very good, but very different, golf courses: the CopperHead and the SideWinder.

While SideWinder is a more linksy, fescue-lined layout, it is CopperHead that draws the comparison to Glen Abbey. Although McBroom did an excellent job designing both, a pre-mature opening in a drought-plagued 1999 hurt the initial buzz among course rankers, golf media and golfers.

"If we could get all those people who played the courses the first year to come back and play them again, they would be absolutely amazed at how they have matured," says Director of Golf Bob Kennedy. "Bill McAllister, our superintendent, always has them in the best shape and the greens are superb."

An ongoing tree planting program, plus the maturing effects of the passing years, continues to raise the profile of

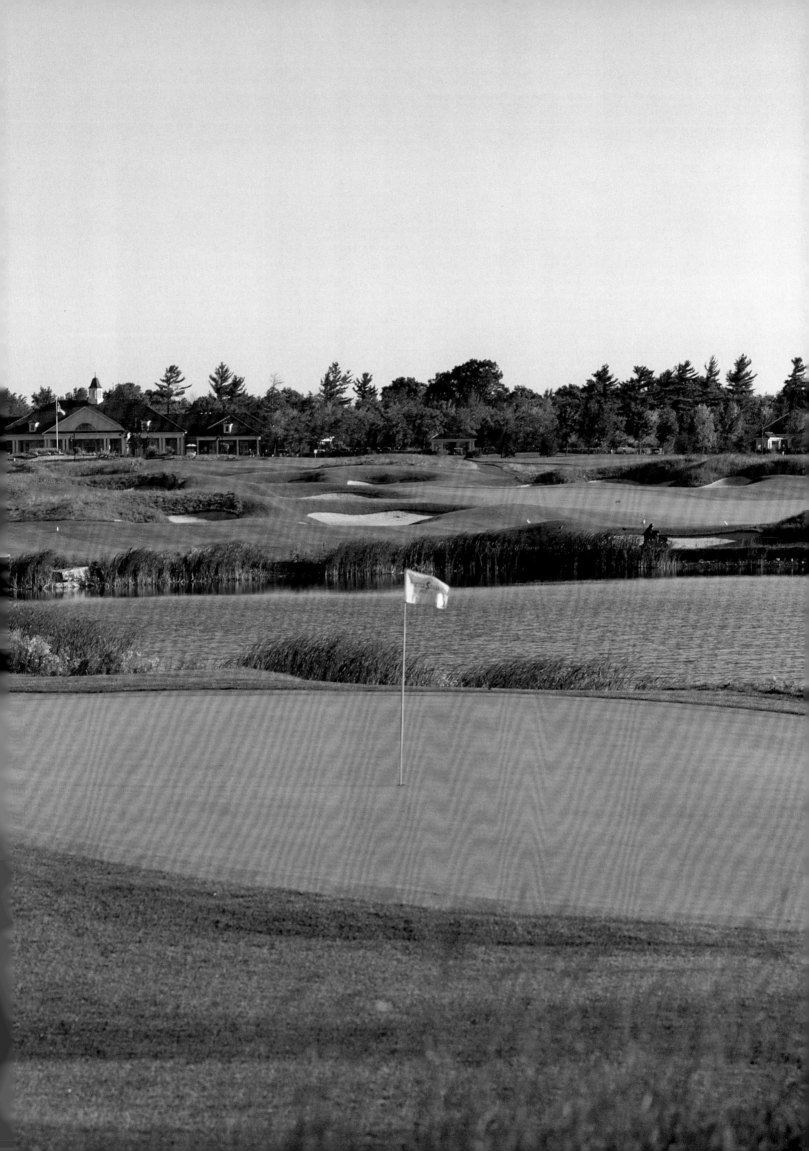

(Top) The 400-yard eighth hole on SideWinder has it all: The risk-reward par-4 dogleg slants to the left, with a forced carry off the tee and an elusive green. SideWinder's 215-yard 13th hole (right) is typical of the superb par-3s at RattleSnake Point, while the par-4 ninth (far right) demonstrates the course's reliance on shrewd bunkering and tall fescue to penalize errant shots.

RattleSnake Point. Evidence of that was given in 2004, when the Royal Canadian Golf Association chose CopperHead to play host to the final qualifying round for the Bell Canadian Open. The low score was a four-under-par 68, "and we didn't even have the tees all the way back," Kennedy points out.

At 7,300 yards, the parkland CopperHead must have appealed to the pros on a number of levels, not the least of which was the fact that the driver was never taken out of their hands by quirky design. As well, the greens that Kennedy admires are indeed some of the finest in the country and their subtle contouring allows them to roll at speeds of up to 13 on the Stimpmeter.

"Unequivocally, RattleSnake is the most underappreciated course I've ever done," says the prolific McBroom. "It's not a breathtaking site, so it has no inherent romance or spectacular aspects from that perspective. But as a golf venue, I think it's terrific. Either of those courses could hold a Canadian Open in terms of variety of holes, shot values, the big practice area, the fabulous clubhouse."

The eighth hole on SideWinder is a prime example of a well-designed hole that will only get better with age. The 400-yard par 4 is a dogleg left that demands a forced carry over marsh and fescue to a fairway angled from right to left, challenging the player to cut off as much as he dares in order to shorten the approach to a narrow green guarded by a deep, abandon-all-hope gully to the left.

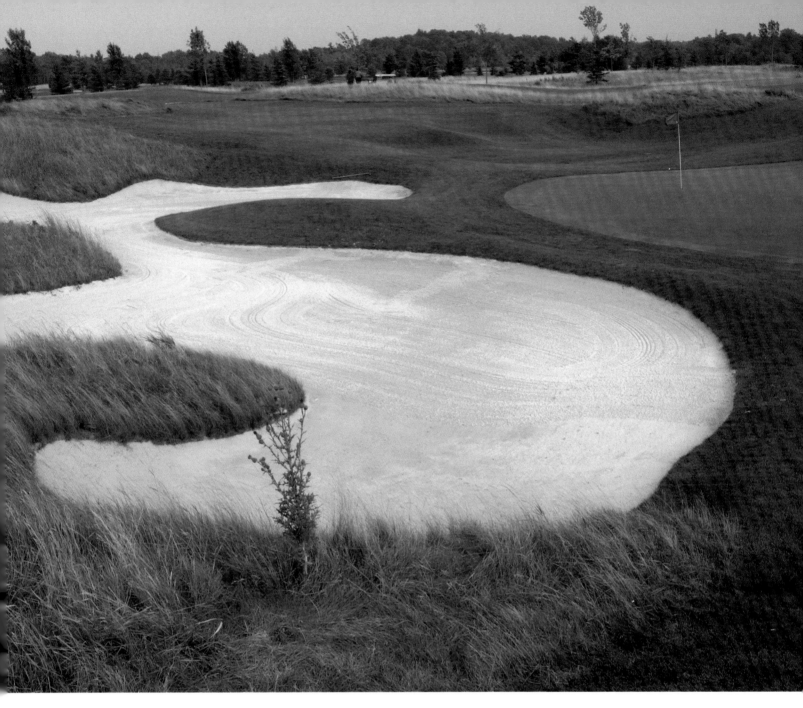

A finish that can bite you

Both courses at RattleSnake Point boast superb back nines, but Director of Golf Bob Kennedy holds the most respect for the two finishing holes on the CopperHead.

"They're both long, tough par 4s that play predominately into the wind. The 17th is a slight dogleg to the left. From the tee, you have to hit your drive over the bunkers on the left to get to the ideal landing area, one you can't really see from the tee. Your second shot is to a well-bunkered green surrounded by trees.

"The 18th is a dogleg right, where you hit your tee shot out of a chute of trees to the landing area with bunkers on the left. As you hit into the green, the backdrop is our great clubhouse with the long wraparound verandah."

Both Kennedy and course architect Tom McBroom say, on its merits, CopperHead could play host to a Canadian Open. The only stumbling block, says McBroom, is the lack of adequate gallery space around the 18th green.

Both courses at RattleSnake Point are notable for their par 3s which present the player with tee shots that usually must carry wetlands or gullies from which there is no escape as here, on SideWinder's 169-yard second hole.

While the par 4s and 5s are benefiting from each passing season, the par 3s on both courses have been notable right from the start. "They are as good a collection as you will get," McBroom says. "They span a series of incised wooded valleys, which were the only natural topographic feature on the site." In most cases, the one-shotters play from bank to bank across these gullies. Although natural features were sparse, McBroom maximized the wetlands, especially on SideWinder.

Kennedy says his more than 1,000 members are just about evenly split on which is their favourite course, but it's apparent he admires CopperHead just a tad more. (See sidebar.) While the fans of CopperHead love its traditional design and straightforward playing characteristics, SideWinder wins votes because it is a more unusual design, a thinking player's course where the vagaries of wind and funky lies challenge skill and local knowledge.

To prove the point, McBroom favours SideWinder. "I think it's a little more fun, and to me it has a little more interest because of the way we took advantage of the marshy situations."

No matter which way you lean, it's time to take a first — or another — look at RattleSnake Point. "I think they are really well done courses," says the architect. "They're a testament to how good a playing experience can be produced from what was a relatively uninteresting piece of land. Each year they get better."

THE ROCK

Minett, Ontario

At a relatively meagre, by today's standards, 6,545 yards from the back tees, The Rock appears to be surrendering to modern golf technology.

Nothing could be further from the truth. As a matter of fact, design consultant Nick Faldo – yes, that Nick Faldo– has found a devious way to confound today's longer and straighter clubs and balls.

"Instead of the usual grip-it and rip-it golf course where you step up onto every tee on a par-4 and hit driver, short iron, at The Rock you may have to fade a 4-iron to the corner of a dogleg and then hit a 7-

Six-time major champion Nick Faldo created The Rock in his own uncompromising image, using the spectacular Muskoka region of Ontario to produce some excellent holes, such as the par-5 16ᵗʰ with its granite face on the left and a pond to the right of the green.

iron to a downhill green site," says Director of Golf Kevin O'Donnell.

That strategy, out of sync with most modern course design, led to mixed reviews when The Rock opened in 2004. Critics viewed the course as scenic, but too demanding for the average golfer. But, says O'Donnell, the Marriott-managed facility bucked the trend by welcoming the course's inherent difficulty, rather than apologizing for it.

"We're embracing the difficulty. We see it as a reflection of Faldo; uncompromising and demanding of himself and a golf course. There's no question this is a challenging test of golf. It's on a tight piece of property, about 120 acres, and it demands good shotmaking and course management."

Far from softening the course, O'Donnell and his staff see The Rock's reputation being built on its unrelenting demands that a player shape his game to the layout. The fairways are tight, as are the collars and aprons which direct errant shots to green-side collection areas. The greens approach 11 on the Stimpmeter, and the forest which lines every fairway has been tended to as well.

The first 30 yards of the forest have been groomed, and then bedded with pine straw or wood chips, lending this new

The 270-yard par-4 10th at The Rock (left) may be short, but is it ever tough: A waste bunker edged with granite snakes up the right side to the back of the green while another trap pinches in the throat of the approach to the green. (Top) The green of the mid-length par-3 17th flows around severely sloped collection areas and bunkers.

course in Central Canada an Augusta National or Pinehurst feel on occasion.

The Rock, like the granite for which it is named and the designer who lent his name to it, is unrelenting, hard, uncompromising, alternately frustrating and rewarding. You must shape your shots, carefully consider your club selection, and, most importantly, select the proper tee deck from which to play. Ego and testosterone notwithstanding, the 5,600-yard whites might be the place to start. Almost 2,000 yards separate the back tees from the forward ones, where the longest forced carry is a mere 50 yards. Conversely, the fairways pinch in and the hazards become more strategic the farther back you go.

"The site dictated the vision," says Faldo. "The fairways are tight and tree-lined, and then there's the rock just everywhere, so we didn't crowd it with bunkers or other hazards. Accuracy is the key. It goes up and downhill, and a few holes remind me somewhat of Bethpage [site of the 2002 U.S. Open] with its mid-length par-4s where you play uphill. Depth perception and local knowledge are key. Strategy is the important thing, being able to work the ball both ways, especially into the greens. You have to know where to miss the greens, and understand the little nuances and subtleties."

So, while O'Donnell calls this sinister little layout in the heart of the Muskoka vacation region a "must play," Faldo implies in no uncertain terms that it is a "must-play — a lot."

In particular, the director of golf mentions the fourth hole, a

The reflection of a legend

"I'll stake my reputation on this golf course." So said Nick Faldo when addressing a crowd of media at the official opening of The Rock in 2004. That's quite a statement, considering that Faldo is widely considered to be Europe's greatest golfer of all time. In 1975, four years after borrowing clubs from his neighbours, Faldo won the English Amateur and the British Youth Championship. Two years later, he became the youngest-ever Ryder Cup team member and won all his matches. Since then, he has represented his side a record 11 times and still holds the title for the highest number of points in that most prestigious of golf competitions. Today, at the age of 47, he has won 42 events worldwide, and seemingly has reworked his swing about the same number of times, under the tutelage of David Leadbetter. Those 42 titles include six majors – three Open Championships and three Masters. Although he continues to compete at the highest level, his interests have spread to broadcasting and course design. Faldo Design has offices in Singapore, Australia and North America, and has authored courses in the U.S., Canada, Britain, China, Vietnam, Germany and the Philippines.

367-yarder from the back. "You have to finesse the tee shot – as you do on just about every hole here – fade it off the tee about 230 to the top of the hill. That leaves you with a flip wedge to a green site that's about 75 feet below you protected by a pond in front with a rock face in the back. It's an awesome hole."

He calls the ninth, a stunning 640-yard par-5, the purest golf hole on the course. "This lays out as a sold three-shot hole, but it's fairly forgiving and you can cut the corner quite drastically on your second shot, and go for it in two." Before you take on that challenge, consider this: O'Donnell and his professional staff have a standing bet, with the cash going to the first man who gets home in two shots. It still hasn't been collected.

Faldo would be proud.

In years to come, The Rock's sharp edges may be blunted as it caters to a less formidable clientele attracted by a Marriott resort due to open in 2007. Go beat yourself up while you can.

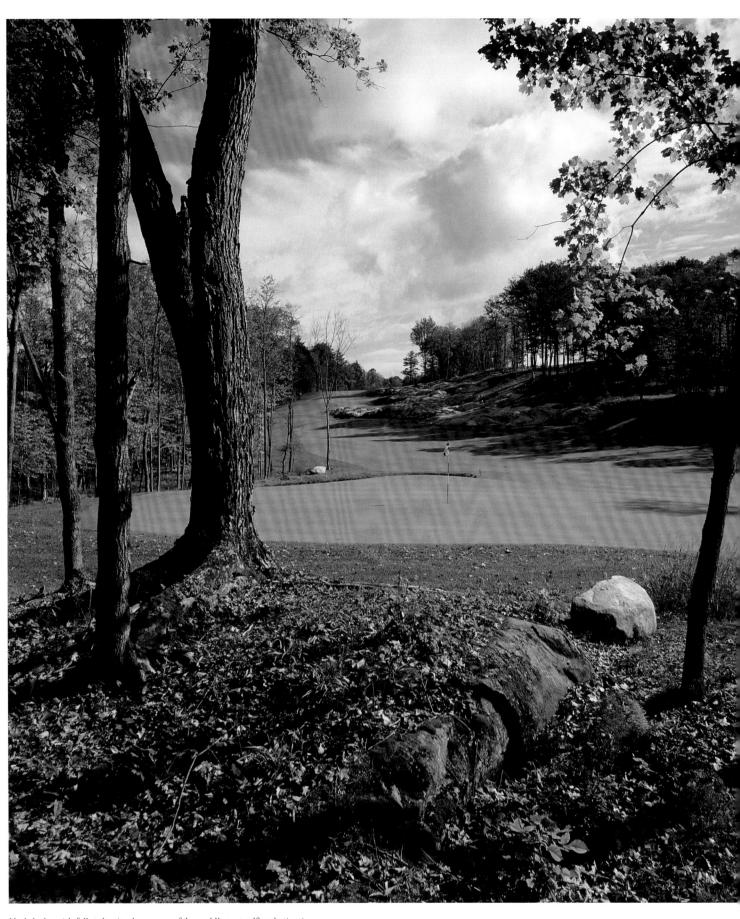

Muskoka has rightfully taken its place as one of the world's great golfing destinations
as some of the best players and architects work their magic on God's rock garden.

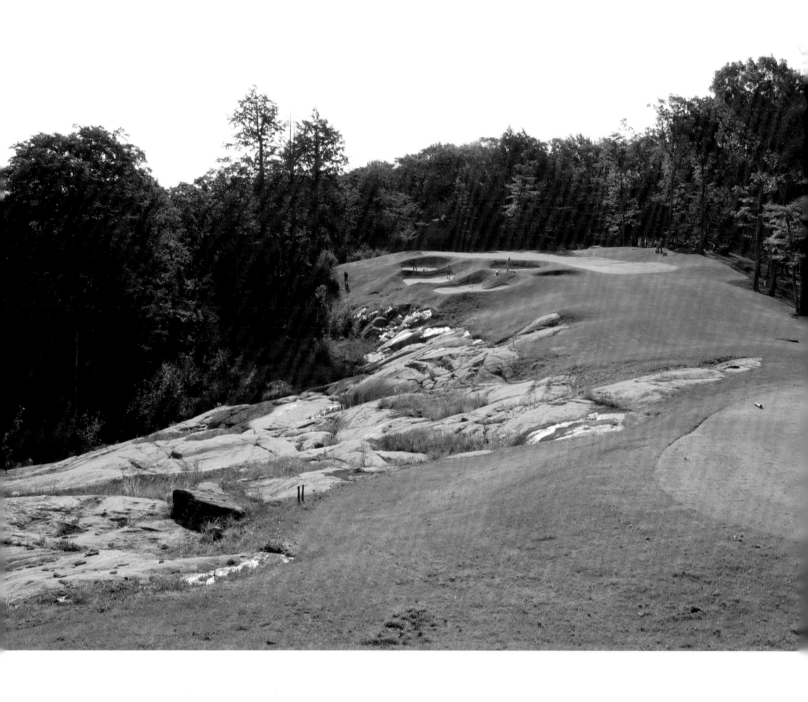

ROCKY CREST GOLF CLUB

Mactier, Ontario

Driving north on the multi-lane Highway 400 from Toronto offers what is almost a time-lapse glimpse of the geological, topographical and economic evolution of the province of Ontario.

Departing the frenetic and smoggy urban sprawl of the Greater Toronto Area, zipping through the rapidly diminishing farmland of the Vaughan and Newmarket areas and passing the exploding bedroom community of Barrie, the highway is suddenly braced on both sides by towering granite cliffs. These cliffs are part of the Canadian Shield, a massive spine which

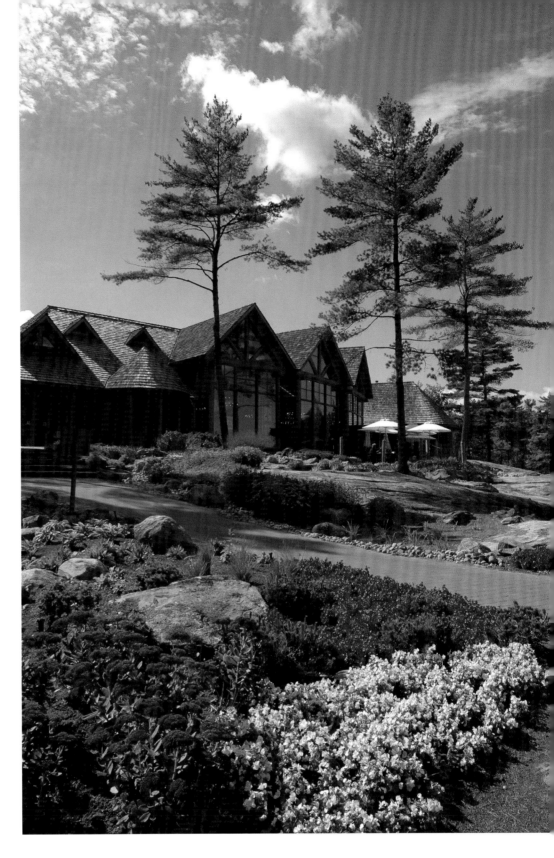

The craggy Canadian Shield has been magnificently utilized as a design theme at Rocky Crest, most often in the foreground of tee boxes, much as gorse and fescue was used in the revered links courses of Scotland and Ireland. Looking back from the green, as here on the par-3 eighth hole, is easily as rewarding as gazing down the fairway.

snakes across this part of Ontario, slithering under the sparse topsoil at times, rearing up at others.

While some architects would shudder at the prospect of building a course under such conditions, Thomas McBroom has embraced it. McBroom's love affair with the Shield dates back to 1991, when he and U.S. architect Bob Cupp collaborated on Deerhurst Highlands, near Huntsville.

Since then, he has built a number of notable courses in the region, each time refining his technique. Despite the fact that

Rocky Crest Golf Club is somewhat atypical of the Muskoka genre, many of its attributes attest to McBroom's acumen.

"This is one of my favourite courses," he says. "In contrast to most courses in Muskoka, this is fairly flattish overall, with the exception of No. 6 [see sidebar]. I was blessed with a site that isn't as rugged as most, without the heaving, dramatic topography of some others."

As a result, Rocky Crest is almost unique in Muskoka because of its walkability. The routing on what is a fairly compact site is

As the 170-yard fifth hole (left) illustrates, the par-3s at Rocky Crest take second place to no one, while the 452-yard 11ᵗʰ may be one of the toughest par 4s in Canada.

excellent, with seamless transitions from one green to the next tee reminiscent of old-style urban courses of a hundred year ago.

"It has a classical feel to it. It's not wild and rangy and meandering. You can see and feel other holes on occasion. I like to call them 'peek-a-boo views.'

"This is a very user-friendly, walkable golf course. Generally, this is very difficult to do in the North," McBroom says. "Almost invariably, courses are cart courses because of the rugged topography, with great elevation changes, and there's an unavoidable disconnect between greens and tees."

He is subtly critical of some architects who, when presented with the intractable Shield, simply reach for the dynamite.

"After you've done a few, you come to know the rock, to have an appreciation for it, you know how to work with it, you know you can't grade out a problem. Other architects who don't understand it might take on a job and say, 'OK, if we run into a problem, we'll just blast it out.' You can't do that. There has to be a lot of skill because you can't erase your mistakes.

"You have to get it close on paper, but then you have to spend a lot of time in the field because not everything is the same in the

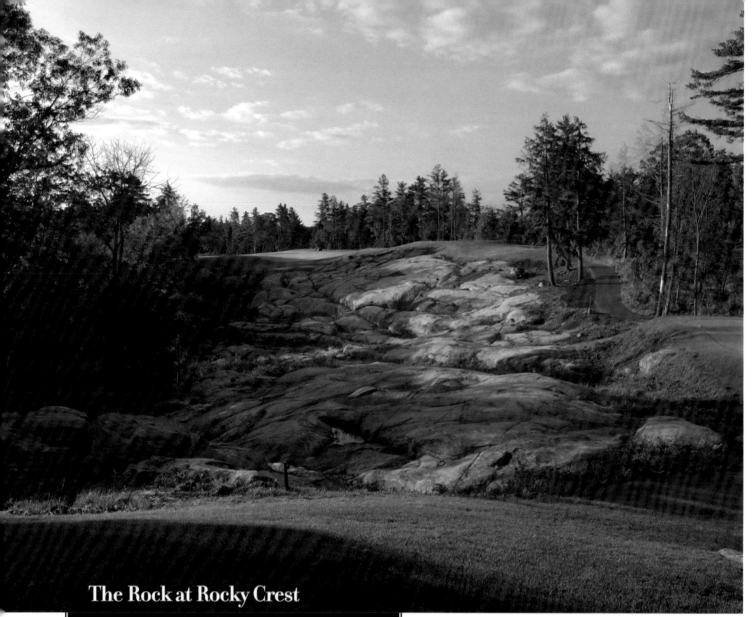

The Rock at Rocky Crest

Architect Thomas McBroom could be called the "Sage of the Shield" because of the intrinsic manner in which he incorporates Ontario's granite spine into his designs.

"You never want to use the rock so it comes into play too much, but you want to use it in the motif. Basically it's used as a foreground. It's usually between the tee boxes and the beginning of the fairway which you can really notice if you look back to the tee from the fairway or green. Rock should never be used on the sides or around greens. I liken it to the way whins and gorse are used on the old Scottish courses, to make a forced carry to the fairway. This is Muskoka, so why not do that with rock?

The best example of this at Rocky Crest is the par-5 sixth hole where, by his own admission, McBroom "went nuts on exposing that rock on the tee shot. This is truly a unique hole; there's not another like it anywhere." The result is a three-acre chasm of naked granite, which represents only a 180-yard carry even from the back tees, 150 from the blues.

Excavators removed the vegetation before huge high-pressure water hoses blasted away the soil. Despite the manageable carry, the gaping chasm and the uphill tee shot "strike the fear of God into you," the architect says with glee. "But I felt that at this stage of my career, I knew what I was doing."

The result proves the truth of that statement.

ground. You don't know from a topographical map where all the rock is and what will be blind shots. You don't know all the nuances until you actually survey the centrelines of the golf course.

The ninth hole, for example, had to be totally reworked once the field work began. Since there is practically no topsoil, construction costs run about one-third higher than average. In the case of Rocky Crest, owner/developer ClubLink Corporation actually purchased a sand and gravel pit 10 kilometres away to provide the required fill. Trucks rumbled back and forth for seven months to accomplish the task.

Aside from its exceptional aesthetics and playability, Rocky Crest represents one of the purest marriages between course and clubhouse ever created. The rustic but elegant log structure reflects the beautiful and stately white pines which frame many of the holes.

All in all, Rocky Crest represents one of the great golf experiences in this or any country.

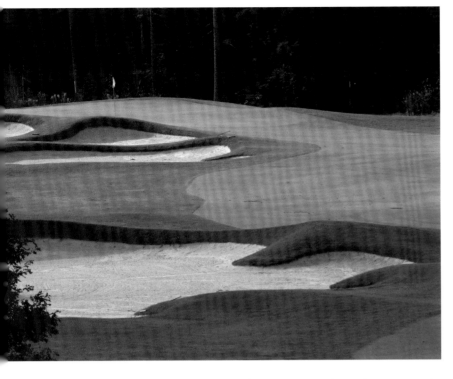

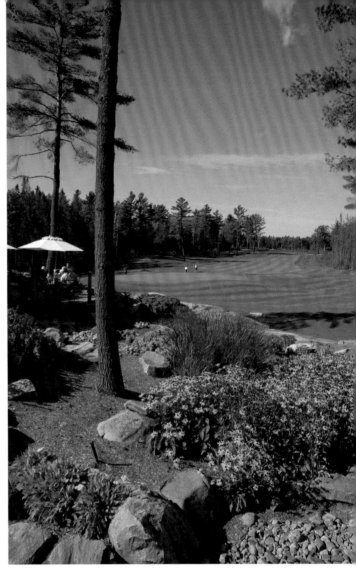

Although Rocky Crest plays to just under 7,000 yards from the tips, its strength comes from some extremely testing par 4s, such as the 450-yard 16th (above) with its convoluted and well-bunkered green, and a granite outcropping in the landing area. At just over 200 yards, the 17th green is deceptively difficult to hit, perhaps because of the forced carry over the wetlands. Walkable, beautiful, enjoyable…Rocky Crest is one of Canada's hidden gems, as illustrated by this view down the 18th fairway from the clubhouse.

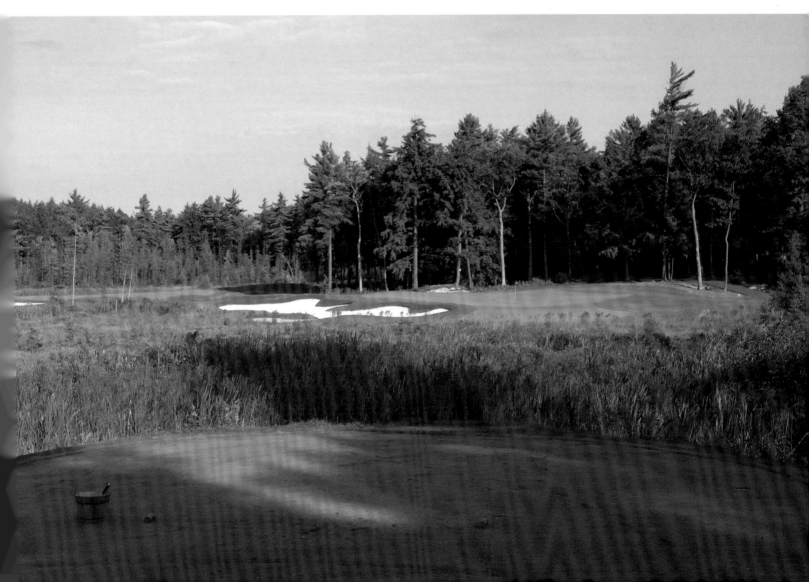

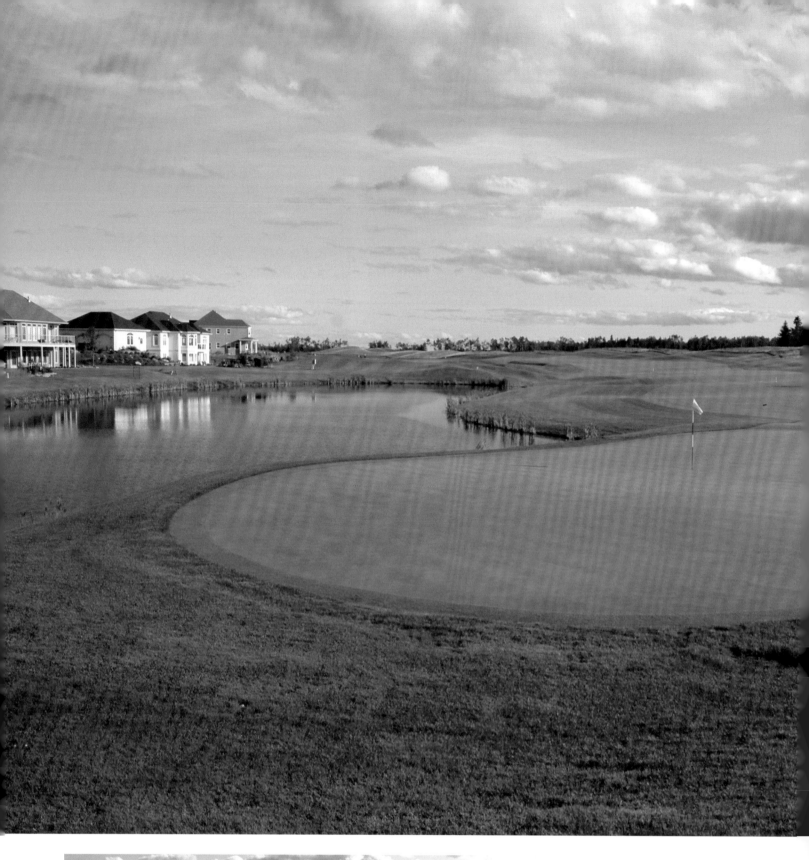

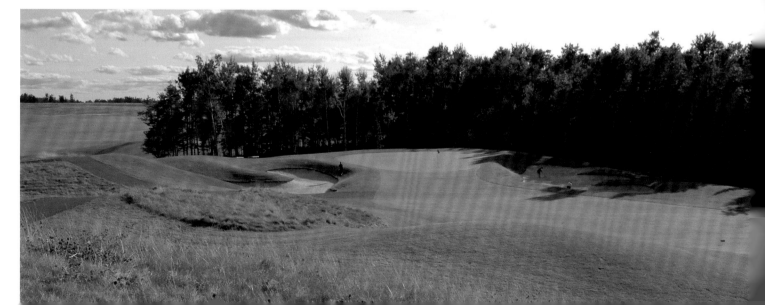

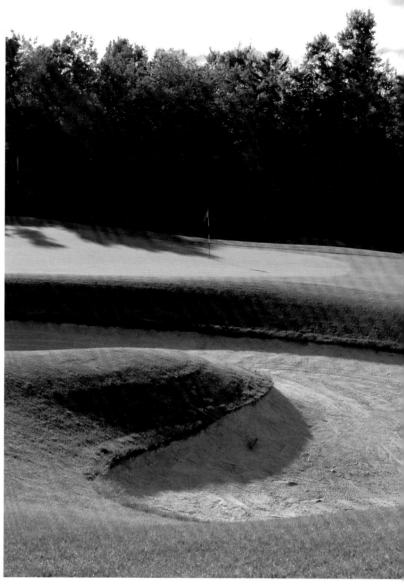

Rees Jones is the famed son of Robert Trent Jones and he took his acquired acumen from designing courses and rejigging them for major championships to Moncton, N.B., when he laid out Royal Oaks.

ROYAL OAKS ESTATES AND GOLF CLUB

Moncton, New Brunswick

REES JONES IS A QUIET, UNASSUMING MAN, SO IT WAS NOT SURPRISING that his Canadian debut was in the medium-sized city of Moncton, New Brunswick, and not filled with fanfare in major metropolitan centre.

As a result, residents and vacationers have the rare treat of playing a 7,100-yard links-style layout designed by the renowned architect known as "The Open Doctor," in conjunction with his associate Keith Evans. (See sidebar)

"It's an inland links in design," says Jamie VanWart, head professional and director of golf at Royal Oaks. Few trees remained on the former horse farm so it lent itself to this style which features generous fairways bordered by fescue-covered mounds and dunes, and 66 deep bunkers. The large greens,

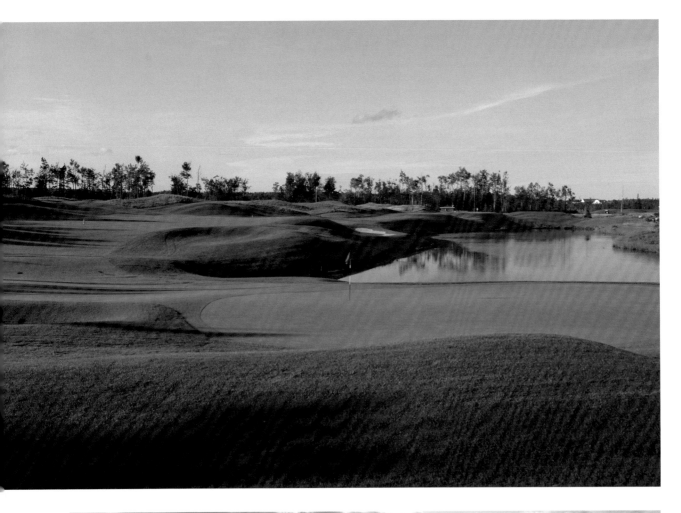

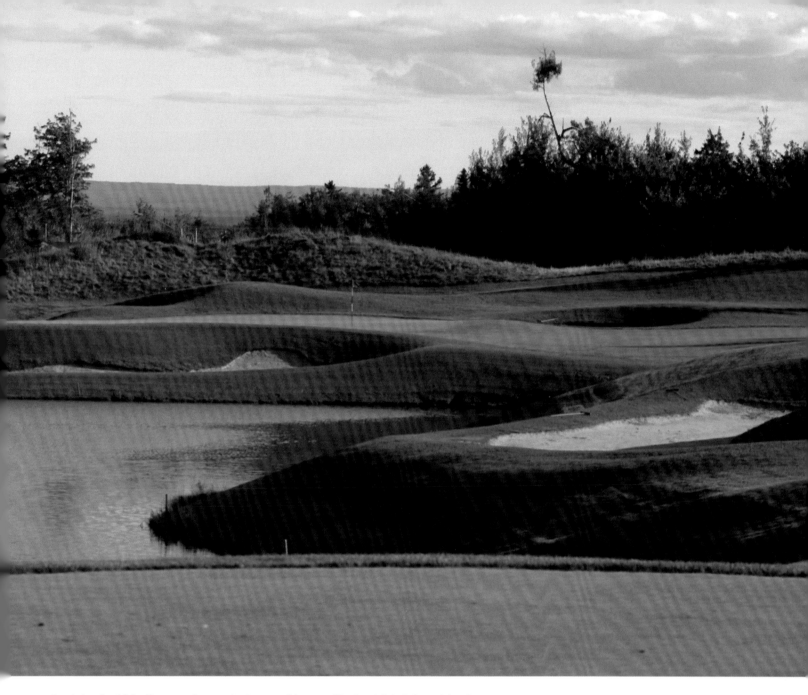

Every hole at Royal Oaks offers an easy bogey or a hard par, one of the tenets of Rees Jones's father's design philosophy.

which average 10,000 square feet, feature subtle breaks and usually roll about 10 on the Stimpmeter. "Any faster, and they would be unfair for the average player," says VanWart.

The nature of the property attracted the interest of Jones, a self-admitted fan of the traditional Scottish links. "I was awestruck from the first time I played St. Andrews as a teenager," he has said. "Primarily, the style of a course is dictated by the contours of the land…Natural elements are embellished and created elements are made to look natural."

Having said that, VanWart says that most visitors are impressed by holes 16 and 17, because of their tree-lined fairways. He admires those two holes not only for their aesthetic appeal, but also because they are half of what he calls "four of the best finishing holes anywhere.

"The 15th through the 18th holes are all very, very strong par 4s. For the most part, if there's a little wind and you've got a good round going, those four can make or break you."

The 455-yard 15th demands a drive down the right side over a pond, and avoiding fairway bunkers in the crook of the dogleg left. At 412 yards, the 16th isn't long but bunkers on both sides of the fairway call for accuracy over length. Two huge bunkers guard the approach to the green which is also protected by a small pot bunker behind and a collection area to the left and rear. The 17th is 429 yards and a drive to the right side of the fairway leaves a precise shot to a small green guarded by a huge horseshoe-shaped bunker on the right. A big drive on the 467-yard 18th which avoids the three immense fairway bunkers on the right still leaves at least a mid-iron to a large green ringed by sand.

"You have to concentrate on getting your drive in the right position, and that's true all the way around, really, because this is a second-shot golf course," says VanWart. "If you hit it in the wrong spots, you will get eaten alive because all the greens here are very well bunkered, big and deep, and they

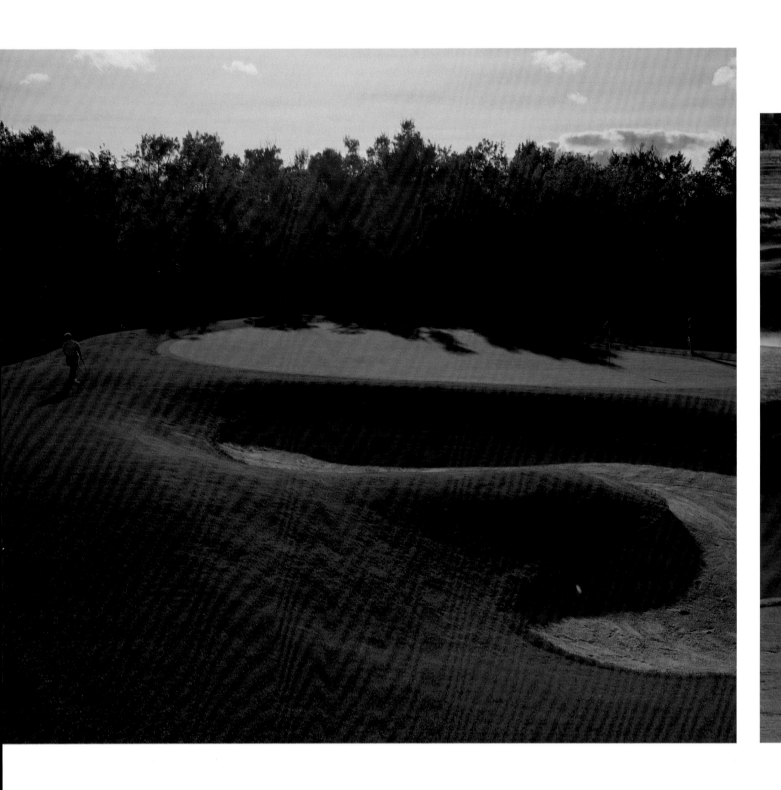

can destroy a good round pretty quick. I know, because I think I've been in them all."

But higher-handicappers need not despair because an integral part of Jones's design philosophy is fairness. "No one enjoys getting beaten up by the course," he says. To that end, four tee decks stretch from 7,100 yards (with a course rating of 76.2 and a Slope of 143) all the way down to 5,300. That provides enough length and challenge for golfers of all abilities.

"I think golfers enjoy being reasonably challenged," Jones has said. "Golf holes that unfold with a variety of shot options requiring intelligent management of the game – choosing the right club and the right strategy – make for a more interesting round. When making decisions about strategy, golfers must choose the degree of risk they are willing to take. A golfer can either use caution, playing it safe and avoiding hazards, or may choose to go for it, and flirt with trouble."

Royal Oaks also offers an excellent golf academy with a 28,000 square-foot bentgrass practice tee, a 10,000 square-

Keeping up with the rest of the Joneses

foot putting and chipping green, five target green, two practice bunkers and an approach fairway. Private lessons, clinics, one- to three-day schools, corporate clinics and playing lessons are available.

Guest fees in 2005 range from Cdn$60 to $80, a true bargain price to play a Rees Jones' creation. Stay and play packages are available, but a real treat would be to stay onsite in the Arnold Palmer Suite, with full kitchen, racquet ball court, pool table, shuffleboard, poker table, dartboard, and its own bar.

Even though his illustrious father, Robert Trent Jones, and his older brother, Robert Trent Jones Jr., had designed courses in Canada previously, it took until Royal Oaks' opening in 2000 for Rees Jones to make his mark in this country.

Born in 1941, Rees Jones traveled with his family to golf course projects around the world and was a principal in his father's firm at the age of 23. Ten years later, he founded his own company in New Jersey. Since then, he has designed more than 100 courses, primarily in the United States.

Perhaps more famous, however, is his skill at preparing courses for tournaments, including U.S. Opens, a skill for which he has acquired the nickname, "The Open Doctor."

His remodeling skills have been applied to seven U.S. Open venues, five PGA Championship venues, three Ryder Cup sites, and his redesign of East Lake in Atlanta, Georgia, is the permanent site of the Tour Championship.

ST. EUGENE MISSION GOLF RESORT

Cranbrook, British Columbia

At St. Eugene Mission Golf Resort, you get three golf courses for the price of one. And you can bet on that.

Let us explain: The 7,000-yard Les Furber layout traverses three very different zones, and is the centrepiece for a resort that also features a full-service casino.

Halfway between the cities of Cranbrook and Kimberley in British Columbia's East Kootenay Mountains, the four-diamond resort is built around the mission itself. Opened in 1912, the former Catholic mission now houses the golf clubhouse, and 25 suites of the 125-unit Delta hotel.

Designed by Furber, the guru of alpine golf design, St. Eugene Mission is a very walkable track that begins its routing in wide-open, linksy fashion before heading into deep piney forests and then re-emerging into the open once more.

The linksy portion is dominated by sand, mounding and natural grasses. In this area, Furber wisely decided to use sandy waste areas to heighten the Scottish feel, rather than add trees. The woodlands portion is a series of soft, meandering doglegs with subtle elevation changes, beautifully framed by Ponderosa pines. The towering Ponderosas drop their large needles on the forest floor, keeping underbrush to a minimum, thus allowing players to usually find their ball. The third zone at St. Eugene runs along a bench skirting the glacier-fed St. Mary River.

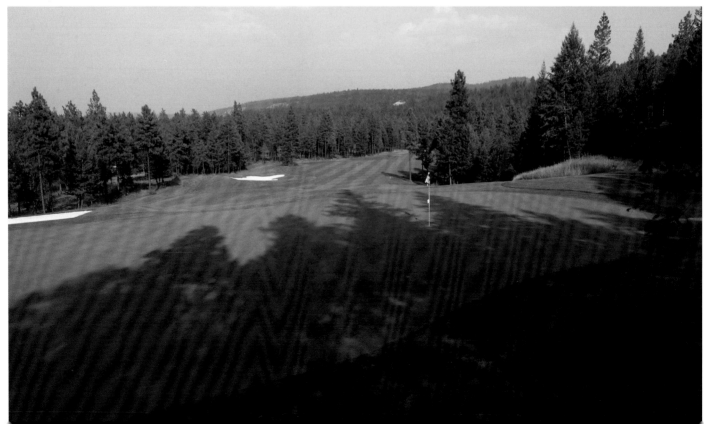

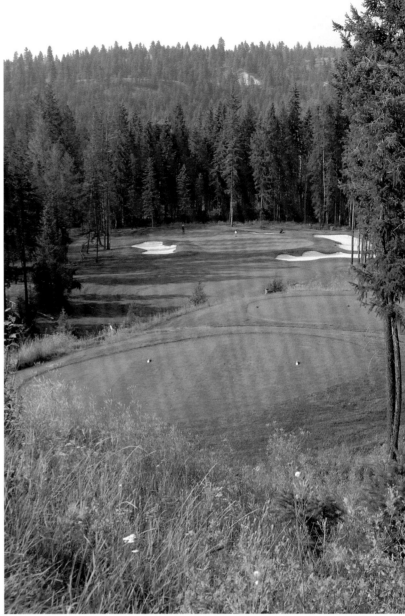

The aboriginal origins of this region are undeniable as are the modern architectural challenges, like on the 220-yard, par-3 13th.

Head Professional Shawn Paduano calls Furber a "masterful router who synergized the different areas beautifully." In his routing, Furber detoured from the traditional par equation by building five par 3s and five par 5s, a decision that leads to a fantastic finishing sequence at St. Eugene Mission.

"The finish is par 3, par 5, par 3, par 5," explains Paduano. "The 15th is a long par 3 that's all carry to a green that has a false front and a collection area and bunker to the left. At 539 yards, the 16th is a reachable par 5 with a wide-open tee shot but then you're looking at what I would call a pseudo-island green, because it's surrounded by sand. If you don't reach the green, then you will likely be faced with a long bunker shot, which is one of the toughest shots in golf. That risk-reward element is great drama if you're playing a match.

"The 17th is a true links-style par 3 because you get a number of different options to get to the green You can run it up the front or up either side, but there's a large sod-wall bunker short and right. It's 215, slightly uphill and usually into the wind. A truly wonderful hole."

The 558-yard 18th is one hole that visitors will not soon forget both for aesthetic and golfing reasons. The old mission sits behind the green with Fisher Peak towering ominously over it.

"There's water all along left side in the first landing area," says Furber, "and a big bunker complex in the middle of the fairway. You can choose the right side which is safer but longer, or play the left between the bunker and the water, or try to carry it. Then there's Joseph Creek in front of the green."

Paduano says he has made more birdies by laying up short of the creek and then wedging his ball close to the hole on a green that is some 42 paces deep.

Somehow, a risk-reward finishing hole here seems very appropriate.

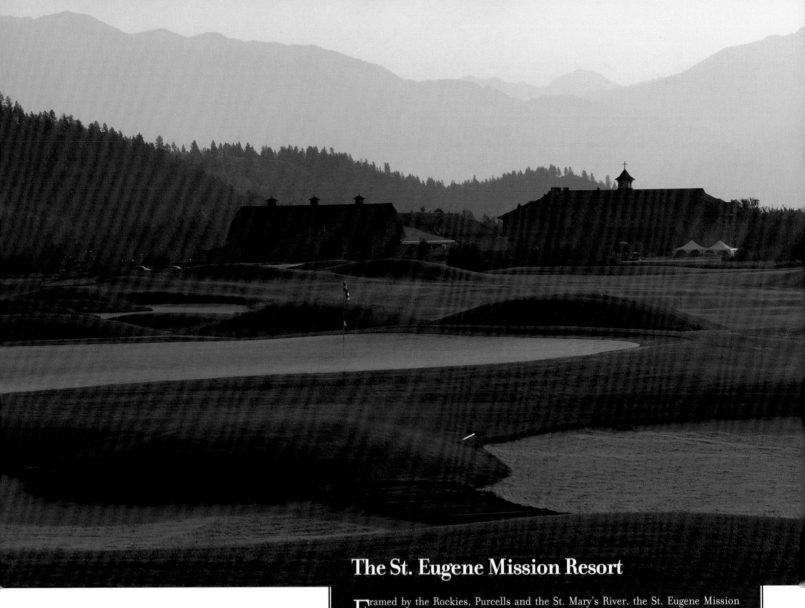

The St. Eugene Mission Resort

By selecting the correct tees, anyone can enjoy their round at St. Eugene Mission. Better players who want to play it from the tips will find that it plays every inch of its 7,007 yards.

"You have to be a good shot maker to shoot good scores here," says Furber. In contrast to some of his other designs, he has made it challenging to get close to the pins unless you are coming in from exactly the right angle. The excellent course maintenance enhances the contouring and collection areas that protect many of the green complexes.

"The overall strategy is to aim for the 150-yard marker on each par 4 and avoid the fairway bunkers on the par 5s, and you will be rewarded with a good score," advises Paduano. "Many of the greens here are more than 30 yards deep, so your club selection on your approach shots is critical."

Framed by the Rockies, Purcells and the St. Mary's River, the St. Eugene Mission Resort is a spectacular destination for getaways, vacations, conferences and retreats.

The Resort includes a full-service, 4.?-star hotel, the Casino of the Rockies and the St. Eugene Golf Course, rated by Golf Digest as one of the top three new courses in Canada in 2001.

In addition, St. Eugene Mission Resort offers the best dining in the vicinity ranging from clubhouse barbeques to casual elegance in the Purcell Grill.

As well, there is a fitness centre with a fully equipped gym, steam room, sauna, year-round heated pool and hot tubs.

Steeped in tradition, the original St. Eugene Mission is an impressive turn-of-the-century stone building. Within its historic walls and the connecting Lodge are beautifully appointed modern guestrooms and conference facilities.

The Oblate Order founded the first mission near the site of the current mission in 1873. The building served initially as a school, residence, and later as a hospital. Financing the new mission buildings was, in part, provided by the discovery in 1893 of a rich ore body by Pierre, a Ktunaxa First Nations member.

He brought a sample of rich galena ore to Father Coccola, head of the St. Eugene Mission, and the two staked claims above the town of Moyie. Father Coccola sold the claim for $12,000 and constructed the St. Eugene Church (prefabricated in Italy) in 1897, which graces the Mission area today.

In 1910, the Canadian Government funded and constructed the present Mission school, presently a part of the hotel complex at St. Eugene Mission Resort. The Mission instructed 5,000 children from the Okanagan, Shuswap and Blackfoot Nations in addition to the area's Ktunaxa Nation Council. The school was closed in 1970 when government policy changed to encourage public education for Indian children.

The 378-yard 14th provides a brief respite before heading into St. Eugene Mission's challenging finish.

SILVERTIP GOLF COURSE
Canmore, Alberta

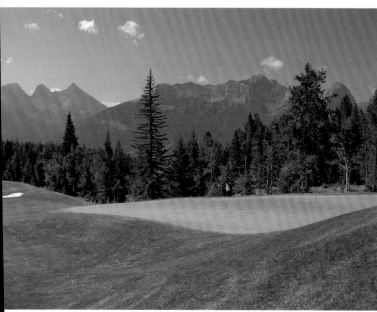

(Left) Right from the opening hole, it is obvious why architect Les Furber calls SilverTip "an extreme golf experience." (Top) The 444-yard 18th is a fitting conclusion to the SilverTip experience. (Above) The 464-yard par-4 ninth features more than 100 feet of elevation change.

PERHAPS MORE SO THAN MOST OTHER COURSES INCLUDED IN THIS book, SilverTip will generate much discussion about whether it is a "great golf course."

But as with all the others, we must use the "subjectivity" card on this one. Even the architect hesitates to apply the standard adjectives. He even avoids using the noun "course."

"The phrase we use for SilverTip is 'extreme golf experience,'" says veteran designer Les Furber, who lives near SilverTip in the town of Canmore in the Rocky Mountain foothills outside Calgary, Alberta.

"I'm using the philosophy that the stand-alone, upscale, user-fee golf course, whether it's a resort or not, has a lot of one-time, transient golfers going through the facility. As a designer, I try to give them a golf experience that's dramatic. I try to get as much visual impact as I can on every hole, by using elevated tees, artistic bunker shapes, and so on."

That Furber accomplished what he set out to do at SilverTip is indisputable. The first tee is 5,000 feet above sea level and the

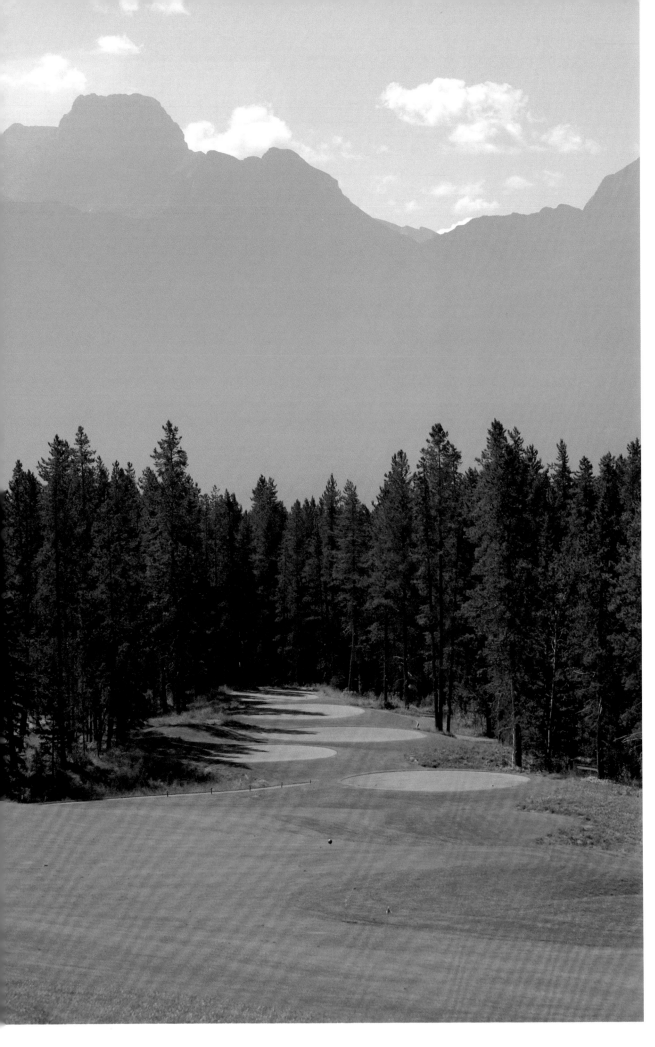

(Left) Tee shots hit to the right side of the short par-4 16th should funnel back into the fairway, leaving a good angle to the well-bunkered green. (Right) The 555-yard par-5 17th is a fine three-shotter, with a creek bisecting the generous fairway, and a very tricky elevated green. (Far right) Attempting to maintain your concentration at SilverTip is difficult, what with the distractions of Mother Nature and architect Les Furber's innovations.

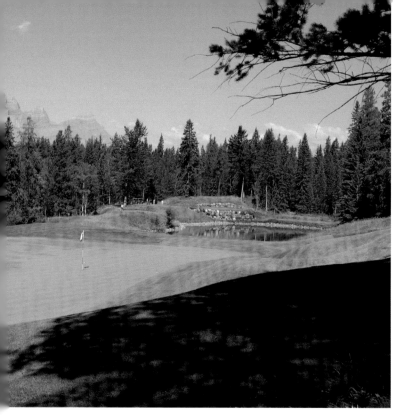

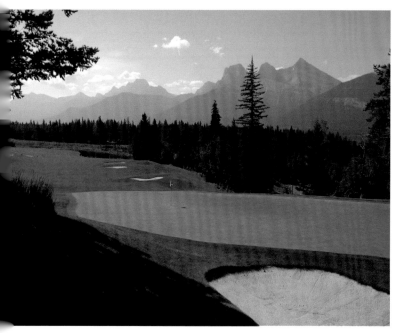

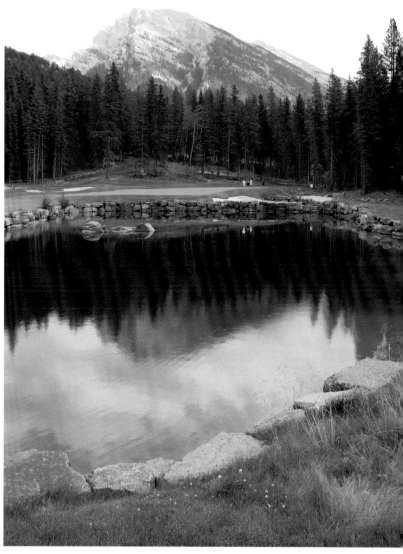

course rollercoasts wildly through 600 feet of elevation change, one of the most violent up-and-down sites we have come across. As if the elevation change alone doesn't make club selection all but impossible, Furber points out that for each 1,000 feet above sea level, a golf ball can fly up to two per cent farther, meaning a 10-per-cent increase in distance at SilverTip.

That detail may be immaterial to many visitors, who will be so overawed by the edge-of-the-world green settings and breathtaking scenery that their score is a lower priority than usual. That may be a good approach for all but scratch players to adopt, seeing that the Slope rating is also extreme at 153 from the back, 7,200-yard tee blocks.

"The elevation changes are extreme; you're playing golf on the edge like you can't anywhere else," says Furber. "The bold-

ness of the site, the vastness of the mountains, and the extreme contours that you play on, make that course visually intimidating the first time you see it."

However, if it's possible to focus even momentarily on the task at hand, players of most abilities will realize that Furber has managed to distill some excellent shot values from this carnival ride. The architect, who spent years working in Europe with the late Robert Trent Jones, had considerable experience in mountainous terrain, including Europe's highest course, Switzerland's Zuoz-Madulain.

The most forward of the tees plays to 5,100 yards, another indication that Furber has a better understanding than most of his peers about the requirements of the average golfer.

"Everyone's apprehensive about whether it's their kind of

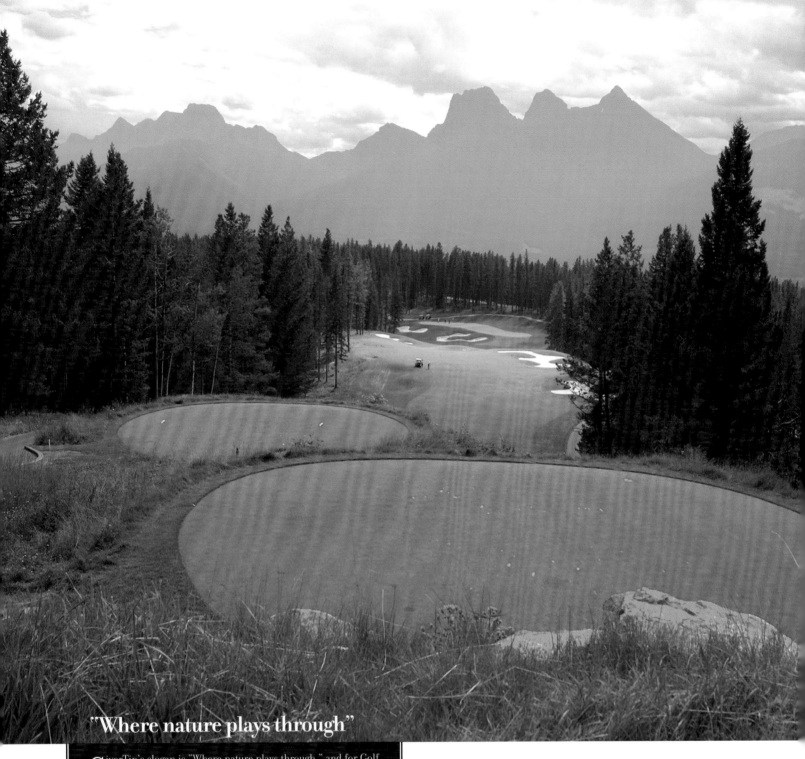

"Where nature plays through"

SiverTip's slogan is "Where nature plays through," and for Golf Operations Director John Munro, no hole better exemplifies that motto than the par-4 fourth.

Ranging from 311 to 454 yards, depending on the tees you choose, the fourth hole stands out for more than strictly shot values or design considerations, Munro says.

"The tee boxes are raised easily 100 feet. Your tee shot must be right down the middle to avoid the bunkers on the right and the trees on the left.

"But, as you're standing there getting ready to tee off, you're looking straight at the Three Sisters [mountains]. You just want to leave the club in the bag and sit down on the wooden bench and absorb everything. You are completely alone with nature. It's the perfect concept of mountain golf.

"It's a great golf hole, but it's the whole atmosphere that you will remember."

course or not. But after having played it, almost everyone comes off with a great feeling. There are no forced carries, there's always a safe way to play the hole, so it suits just about everybody. SilverTip has a real magnetism."

Adding to the extreme aspect of SilverTip, itself named for a type of grizzly bear, is the number of wildlife corridors which not only surround it, but traverse it. As a result, it is not unusual to see, at a safe distance, bears, deer, elk, coyotes, lynx and other fauna during a round.

Although SilverTip will continue to get its share of criticism by purists, it is indisputable that Furber has created one of the world's most interesting venues for the game of golf. While it will never play host to a major tournament, the very idiosyncrasies that prevent that are the same ones that make SilverTip a memorable and thrilling outing for adventurous recreational golfers.

"One of the main things I learned by working for Jones is that you can't just think 'championship, championship' every time you're looking at building a course," Furber says. "You have to understand who's going to play it. You have to leave entrances to the putting surfaces and let the average golfer get away with a less than perfect shot. And when you get to the putting surface, there should be an opportunity to make the putt; you shouldn't just be trying to avoid a three or four putt.

"You have to design courses for the masses, not just to cause controversy."

Well, Les, one out of two isn't bad.

SPEARGRASS GOLF CLUB

Carseland, Alberta

About half an hour east of Calgary, on a relatively benign property and with a modest budget, architects Gary Browning and Wade Horrocks created a Western Canadian interpretation of a links-style golf course.

Called Speargrass, this wide-open layout sprawls on the prairie, with the first 15 holes gently moulded by mounding covered with tall native grasses waving in the ever-present wind. The closing three holes border the Bow River and provide an exciting finish.

An old Scottish saying states that if there's "nae wind," then it's "nae golf." In that case, those old Scots would be pleased with Speargrass, a linksy layout with non-stop wind.

"That's one of the characteristics of the course, and one of the things I like about it," says Browning. "For example, the sixth hole is a staunch par 4 of 400 yards that plays directly into the teeth of the wind, and then you step onto No. 7, a par 3 that plays directly downwind with water off the back of the green.

"So now, you're really tinkering with the golfer's mindset as he stands on that [seventh] tee, especially if the wind is howling. He has no clue as to what club to hit to keep his ball on that green."

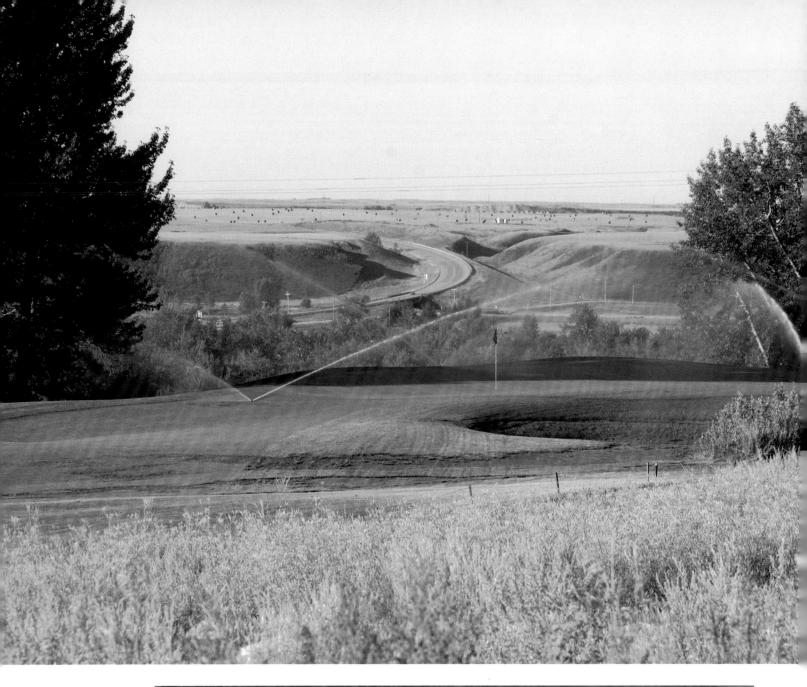

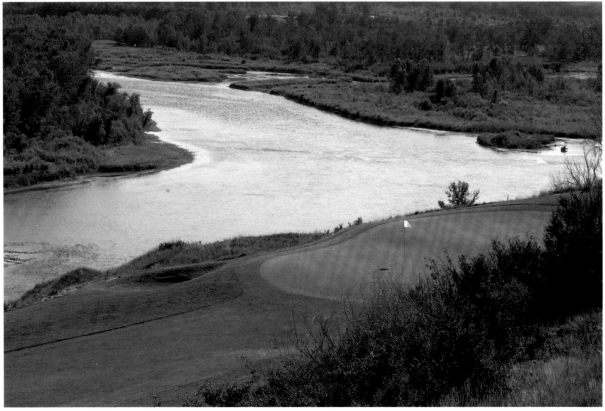

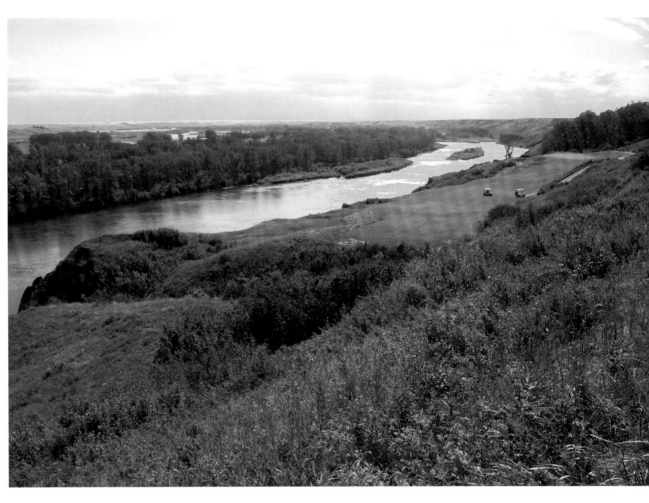

The Bow River provided a God-given design component that architects Gary Browning and Wade Horrocks used brilliantly, on the 18th hole (left). Its elevated green requires careful consideration before choosing a club, a common theme here.

Browning says the wind was an important design consideration in determining the routing. Wide playing corridors were essential, as were open approaches to greens allowing for knockdown and run-up shots. Flashed faces on bunkers were avoided because the wind would whip the sand out of them in short order, so pot- and waste-style bunkering predominates.

On the front nine, Horrocks points to the eighth hole as a fine example of a couple of their design trademarks: A combination of strategic interest with golfing enjoyment. "The eighth is a Cape hole, so you can bite off as much as you want. I like the fact that it makes you think and challenges your faith in your ability."

A Cape hole is a heroic design originated by Canadian-born C.B. Macdonald at his National Golf Links of America on New York's Long Island a century ago. Usually played over water, it forces the player to cut as much of the corner as he dares. The greater the carry, the more advantageous the approach to the green.

The final three holes utilize the steep banks of the Bow River and can jeopardize what has, up until then, a good round. (See sidebar.)

An interesting aspect to Speargrass is the fact that it offers an untraditional mix of six par 3s, six par 4s and six par 5s. Browning says this was an unintentional result of the shape and nature of the site. One benefit was that the additional par 3s and par 5s offer additional birdie opportunities.

"We didn't set out to do that par sequence," says Horrocks, "but we don't want to be locked into the mindset that a course

It's not over 'til it's over

"The finishing sequence is often mentioned because of the alternate green on the 16th hole," says Wade Horrocks, co-architect of Speargrass, "which evolved simply because we had two great par 3s side by side, not because we had seen it somewhere else and wanted to duplicate it.

"We first came up with the lower green site, but we couldn't build a green large enough on that plateau to accommodate the play that the golf course was going to get, so that's how the alternate green was developed."

As on every hole at Speargrass, club selection is vital. Missing this green means either finding a deep pot bunker or losing your ball in the fescue.

The 17th is drivable – theoretically. "It's 330 from the back tees from an elevated tee to a fairway that is only about 20 yards wide," says Course Manager Brady Shave. "It is possible to hit driver, but you have to be super accurate. It's better to hit a couple of short irons back to back, and try to score that way." Should you miss the drive to the left, the river awaits. Anything right will end up in scrub brush.

The par-4 18th plays along the river and once again, accuracy is key. Take an extra club to ensure hitting the elevated green, which is again bordered by the river and scrub.

must be par 72, 7,000 yards, and so on. We simply try to find the best 18 holes on that particular property. If that means something non-traditional, then so be it."

Browning and Horrocks take pride in the fact that none of their courses bears a resemblance to any other of their works. "We never arrive with any preconceptions," Browning says. "We like to let the site tell us what kind of course it wants to be. If you can take what is unique about a site and incorporate that into the design, then that naturally ensures that each course is itself unique."

"In the end, our prime consideration is to allow golfers to have fun, period" says Horrocks. "We want them to keep coming back."

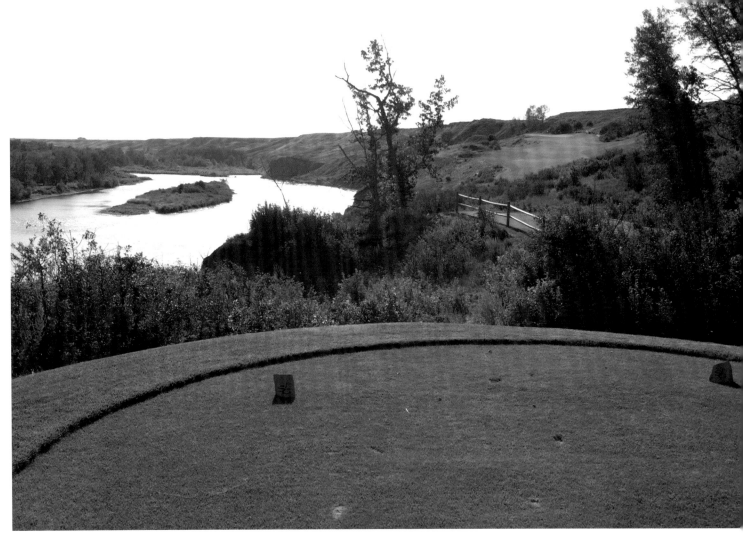

Speargrass offers generous landing areas and fair-sized greens, but brush, trees, native grasses, and, of course, the recurrent river dictate serious penalties for a very wayward shot.

To that end, Browning and Horrocks designed hospitable entrances to the green complexes at Speargrass, although the best angle of attack is achieved from a specified side of the landing area. Despite the generous fairways and greens, correct club selection is paramount to avoid the fescue and bunkers. That task is complicated by the wind (see sidebar) and the deceptive elevation changes.

"Don't let wide fairways and large greens fool you," says Course Manager Brady Shave. "This isn't a grip-it and rip-it golf course. It's a thinking man's course. If you play smart, you can have a lot of fun here."

STEWART CREEK GOLF CLUB

Canmore, Alberta

To say humility is in short supply among golf course architects is a bit of an understatement, but a couple of exceptions would be Calgary-based Gary Browning and Wade Horrocks.

Stewart Creek, tucked into the Rocky Mountain foothills west of Calgary, opened to rave reviews. Normally, the architects would be front and centre to take the kudos. Not these two.

"That was a very special piece of property," Browning says. "People stand up on the first tee and they look at the forests and the mountains, and they say, 'My God, didn't Browning do a spectacular job here!'

"All we tried to do was to strategically fit the best golf holes we could come up with into those contours, and I think we pulled it

off very well. We tried to do it as sensitively as possible. I guess we were trying minimalist architecture before it became popular and a cliché. Whenever we had to manipulate the ground, we tried to make the artificial look natural, like it's been there for a hundred years. That was the goal."

Head Professional Clinton Schmaltz begs to disagree. "The setting is spectacular, no doubt about it, but it's designed so well that you could take it anywhere, even to the Prairies where I grew up, where it's as flat as a table, and it would still be recognized as a great golf course.

"You can see your tee shots land, and your good shots are rewarded. It's not goofy golf, like some mountain courses where you hit your ball and you have no idea where it ended up. The

fairways are generous fairways, the contours are very slight, and all the contours and hazards are visible from the tee."

Built as the first of 36 holes on a 3,000-acre resort site (Browning and Horrocks have laid out the second course which should open to the public in 2008), Stewart Creek is indeed very special and not only because of what is on top of the ground. Built on top of about 80 kilometres of unused coal-mining tunnels, this course is an aesthetic and engineering marvel. (See sidebar)

For Browning and Horrocks, it was a career milestone when they were chosen to design Stewart Creek over big-name architects from Canada and the United States. But at times, they must have thought they had bitten off more than they chew.

"We had some almost insurmountable constraints," recalls Browning. "The whole area is rife with underground coal mines, and the golf course sits on top of that, so we had to reinforce the surface to prevent settlement or sinking. We had to weave wildlife migration corridors throughout the golf course to satisfy the wildlife biologists who were watching us with a microscope. We had storm water torrents that would tear down the mountain during the spring freshet, and you can't believe how extreme those conditions are. Upstream of the golf course, we had to build deposition ponds to catch debris the size of Volkswagens."

But overcome those hurdles they did, and visitors need look no further than the first tee to see evidence of their success.

The short par 4 starts from a promontory some 100 feet above a wide landing area, looking straight down the valley at the Cascade Mountains.

"The first hole is so cool," says Schmaltz. "You aim at an exposed mine opening and hit a gentle left-to-right shot off that to a very, very generous fairway on a 380-yard par 4.

More than 18 holes

Coal mining may be all but gone from this part of Alberta, but its souvenirs remain. About 80 kilometres of defunct mining tunnels crisscross under Stewart Creek Golf Club, necessitating the reinforcing of two fairways.

More than 120,000 square feet of incredibly strong geo fabric was laid under the turf at a cost of about Cdn$300,000 to ensure golfers would remain on the green side of the golf course.

In addition, the entrances to old mine shafts were blocked off. Some were refurbished and now function as rain shelters.

Make your par and off you go. The 10th is somewhat similar in that it welcomes you to the back nine with a tee shot that isn't quite as elevated as the one on the first hole, but the fairway must be 90 yards wide in spots. Even if you've had a beer or two at the turn, you shouldn't miss that."

The real test at Stewart Creek starts on the 14th, a number that may be your score if you don't hit the perfect tee shot if going for the green. An environmentally protected zone guards the left and a hazard awaits on the right. Those golfers of the "dis-

cretion is the better part of valour" school will hit a pair of 8-irons to avoid a ridiculous number.

The 15th is a brutal par 4 where, even if you hit a 300-yard drive, you're still left with a mid-iron to a tricky green that is sloped from back to front.

"Sixteen is my favourite hole on the golf course," says Schmaltz. "It's a bear from the back, probably 470 yards. You have to hit it at the bunker on the left with a fade. It's tree lined all down the left with a rock wall and it's absolute jungle to the right.

"The 17th is a great little par 3 of only 158 yards from the back, but the reality is that the green is very long but very narrow and there's a very deep bunker on the left hand side that's a magnet, and the right-hand side is all natural bedrock." Chances are that visitors will be treated to the sight of bighorn sheep who stick to the rocky banks because predators can't climb it as nimbly as they can.

The par-5 18th is a complete risk-reward hole where only a perfect drive will permit going for the green in two.

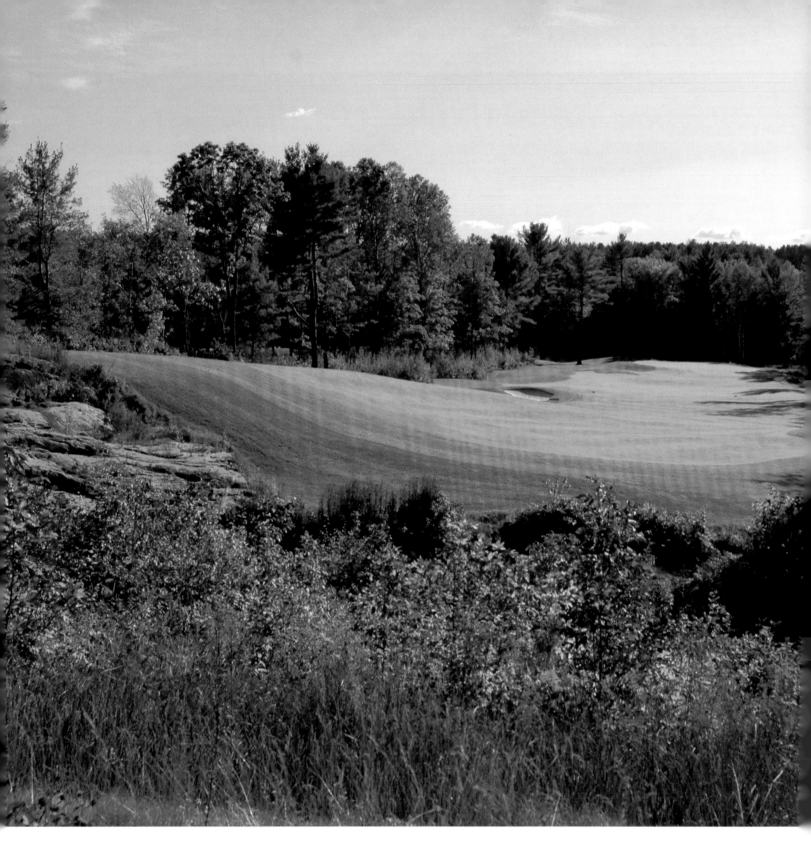

TABOO

Gravenhurst, Ontario

At what used to be known as the Muskoka Sands Resort, everything is Taboo. Everything, that is, but change.

To clarify, Taboo is the name of the Ron Garl-designed golf course a couple of hours north of Toronto that opened in 2002. It is built upon the Canadian Shield, the enormous granite geological formation that, when viewed from the air, must look like God's rock garden. Garl created a straightforward design in the traditional mode, one that was a joy to play from its inception.

But the owners, brothers Norman and Elly Reisman, were not content to rest upon their laurels. In total, eight new tee decks and additional strategic bunkers have been added as the course continues to evolve. The 14th green has been totally revamped,

Taboo, the home course of 2003 Masters champion Mike Weir, is typified by granite outcroppings and dense Ontario forest. Combine that with great design and excellent maintenance, and the result is a fantastic golf experience.

and the 489-yard par-5 16th hole was changed to a par 4, making the layout a 7,173-yard, par-71 challenge. A 14-acre multi-deck practice facility provides a welcome opportunity to tune your swing before challenging the course. It is also home to the resort's teaching academy.

"They [the Reismans] are passionate golfers and passionate that the game of golf retains its integrity," says Nigel Hollidge, Taboo's director of golf, marketing, and spa operations. "They didn't want

a golf course that's tricked up. It had to be part of nature."

That theme led, in an indirect way, to the unusual name which might, to some, have a negative connotation. And they would be right, in a manner of speaking, says Hollidge.

"Taboo? The name is one of the things I really like about this golf course. When you're out there, you really do see quite clearly the areas you don't want to be in, the areas that are taboo." He is referring to the rocky outcroppings, centuries-old oaks, maples, hemlocks and pines, and wetlands of varying severity. However, generous landing areas make those gut-wrenching instances relatively infrequent.

"From every tee deck, Taboo becomes a totally different golf course," Hollidge notes. "That is the mark of a great design. There are no gimmicks. Everything's right there in front of you, but it rewards only really good shots and severely penalizes bad ones. You have to earn a good score at Taboo."

Canada's best resort?

The former Muskoka Sands had a lot to offer, but was starting to show its age. Its rejuvenation began with renovation of the existing hotel, construction of cottage chalets, and expansion of the marina facilities to accommodate up to 60 boats. The European-style Indulgence Spa caters to hedonists, and a massage would be appropriate after participating in the many activities, both land- and water-based. Water sports along the kilometre-long sandy beach on shimmering Lake Muskoka include canoeing, kayaking, windsurfing and personal watercraft. Four swimming pools and five tennis courts also whet the appetite for Taboo's varied and exquisite cuisine, including a new and unique culinary theatre.

If "taboo" also means breaking with convention or tradition, then Mike Weir, the course's touring PGA Tour professional, did that with extreme prejudice in April 2003 when he became the first Canadian to win a major at The Masters.

Garl, a Florida-based architect, did a superlative job with the expansive setting, especially in selecting green sites. When Weir attended a media day after his Masters triumph, he chose the par-3 seventh hole to demonstrate his skill with a 6-iron. The hole plays more than 200 yards slightly uphill to a relatively accessible green, although any shot to the right will find native undergrowth.

The controversial design of the par-5 18th hole means that it will never play the same way twice. "After your tee shot, you crest a hill, and there before you are rocks, fairway, big trees,

and the hole sweeps back up to the green. It's a feast for the eyes," rejoices Hollidge.

That phrase could be used to describe the entire layout which had the luxury of wending its way over and through a couple of hundred acres of rugged topography. As a result, each hole stands on its own with a sense of happy isolation from its neighbours.

So enthralled were the owners with the positive reaction to the label "Taboo," that they renamed the entire 1,200-acre resort, formerly known as Muskoka Sands.

"As soon as the golf course opened, it was recognized as a great layout," Hollidge says. "We had done the deal with Mike before that and having him at the media day [following The Masters] was a coup that focused a lot of attention on not only

the course, but the whole resort. So we decided to build on that momentum.

"Our goal is to make Taboo the best resort not only in Muskoka, but in Canada, and the name change is a symbol of that."

The crowning proof could come when and if Weir collaborates with an architect to design a second course. The association with the 2003 Masters champion is something of which Taboo's owners and staff are very proud, says Hollidge, because of his well-earned reputation for integrity and refusal to accept anything other than a best effort.

"When we did the deal with Mike, when he put his name beside Taboo's, then we knew that this place was as good as we though it was."

They were right.

THE WILDS AT SALMONIER RIVER

Salmonier River, Newfoundland

JUST A FEW YEARS AGO, GOLF WAS SCARCE IN NEWFOUNDLAND. SO SCARCE that eager players lined up at midnight at the only public course in the provincial capital of St. John's just to get a chit that allowed them to come back at dawn to book a tee time. Those in more remote locations, unwilling to make the several hours' drive to the closest course, would flatten the sand on the local beach to create a rudimentary links.

Those days are gone, thanks to a recent growth spurt that has given Newfoundland a couple of dozen courses, some of them worthy of the status of "golf destination." Such is the aptly named The Wilds at Salmonier River in the middle of the Avalon Peninsula.

Forty-five minutes after arriving at the international airport and driving through the lively, historic and interesting city of St.

Just minutes away from Newfoundland's capital of St. John's, the Wilds at Salmonier River provides top-notch golf and other resort amenities in a peaceful wilderness setting. The river, while not in play, is a thrilling backdrop to several holes, including the 18th (previous pages), the ninth (above) and the 17th (right).

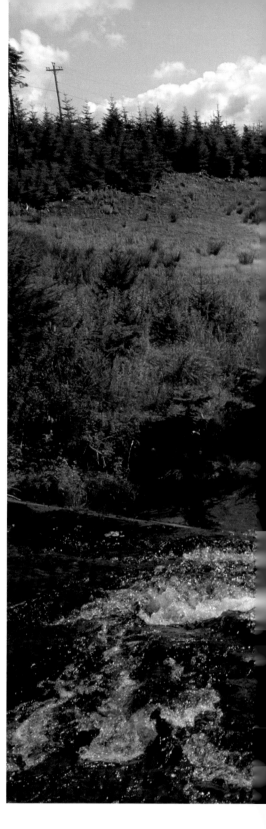

John's, visitors must think they are "in the middle of nowhere," says Trevor Morris, general manager of The Wilds and its affiliated courses, The Willows at Holyrood and The Woods at Southlands. (The latter two are located closer to St. John's.)

"Then you come over the hill and, boom, you see the golf course, and then you come over another hill and, boom, you see the resort, then you go past the resort and you see the beautiful Salmonier River running behind it. For the golfer, it's a real escape into the wilderness, but with a world-class, championship golf course and a full-service resort."

Make no mistake: At 6,800 yards, The Wilds offers a complete golf experience, starting with a double-ended range that

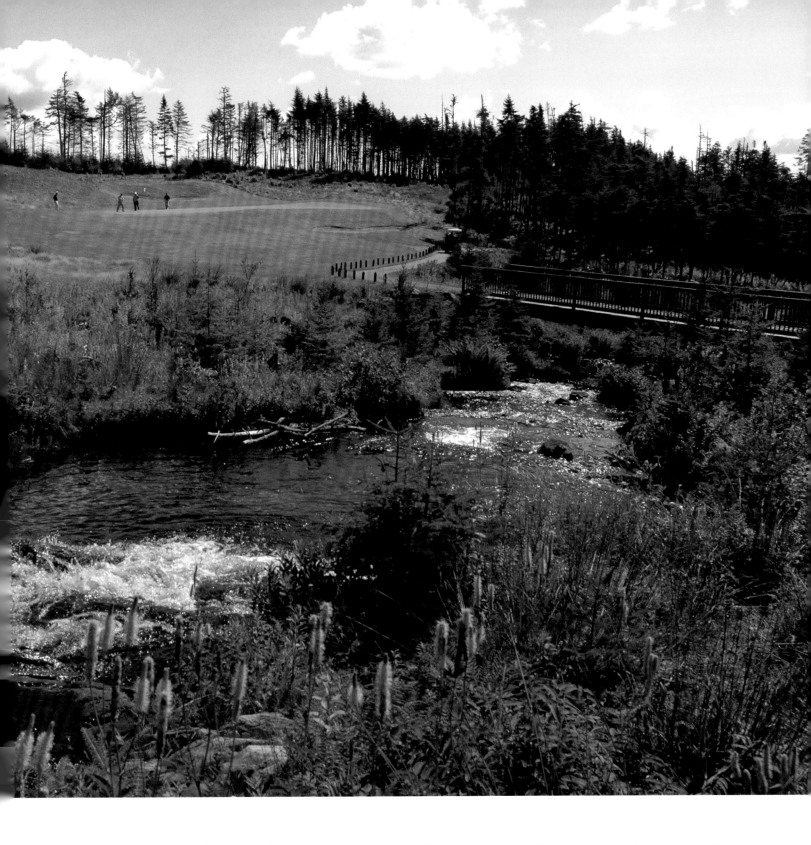

serves as home for its golf academy, bentgrass greens, and closely trimmed fairways. The fact that it offers this in an environment populated with moose, ospreys and bald eagles is a bonus, as is the superb salmon fishing on the river.

While the river (pronounced "salmon-eer") doesn't not come into play, it does provide for some stunning vistas from the course which plays up, down, over and through the rock outcroppings, bogs, ponds, and Henders Brook over 100 feet of elevation change. Stands of spruce and fir are interspersed with "rampikes," gnarled, grey corpses of trees. The ever-present wind is another natural factor and Morris warns that should it, or a bad swing, send a ball into the bush, reload.

"It's a challenging golf course, but the fairways are wide, so it's fine as long as you're reasonably straight. But once you're outside the margins of the turfed areas, it's all over."

A major expansion is being considered for The Wilds, which at present has a 40-room hotel, 19 self-contained cabins, a conference centre, bar, restaurant and swimming pool. For course architect Robert Heaslip, who has worked on various Newfoundland projects including The Wilds and The Woods for the past 15 years, the spike in golf development represents a potential boon.

The Toronto-based Heaslip, who has several courses on the drawing board, says designing, building, and maintaining

A great finish times two

No matter whether you tee off on the first or 10th holes at The Wilds at Salmonier River, you are in for a treat when you finish your nine.

While General Manager Trevor Morris gives kudos to the finishing holes on both the outward and inward nines, he appears to fancy the 429-yard, par-4 ninth a touch more than the 18th. "The ninth is a phenomenal hole. You hit down to the landing area and then pop over a gorge to get to the green, which is like an island green without the water. Short and left is dead.

"But the 18th is amazing, too. It's a tough call. They're both memorable, extremely dramatic."

For his part, course architect Robert Heaslip picks the 508-yard, par-5 18th. "By the tee, there's a rock cut of about 20 to 25 feet where the water channels through. When you're on the tee, all you hear is the rushing water from the falls. The hole plays over the gorge to well-defined landing area and then the watercourse comes back into play. Anything to the right heads for that big ridge that drops down to the Salmonier River. You're up high, looking at the backdrop of trees and hills. That hole demonstrates all the elements that are contained within the entire golf course."

courses on The Rock has less in common with North America than with Scotland, Northern Ireland or even Sweden because of the unique topography and weather.

"The rugged weather conditions affect just about every aspect, from the topsoil to the type of grasses we can use. It's a learning process all the time. The wind is always a factor. They joke that if the wind ever stopped, everyone would fall over because they're so used to leaning into it."

Heaslip's success in down-home, back-to-basics Newfoundland is due in no small part to his blue-collar approach to design. He never apprenticed under a name-brand architect, choosing instead the school of hard knocks. It appears he learned his lessons well.

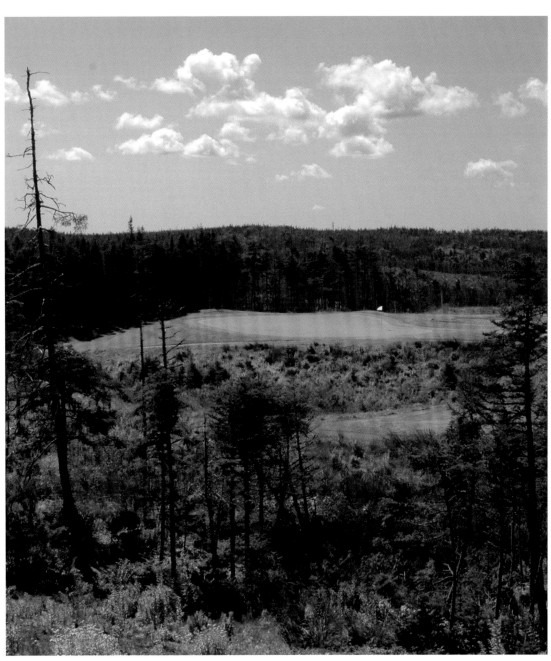

The heaving topography of the Avalon Peninsula offers
spectacular views of the golf courses and beyond.

"Less is more, is the way I would sum up my approach. What stands out to me is not necessarily the eye candy that's so popular, but what brings out the true game of golf. You can have a golf course that looks fantastic, but does it really bring you the game? How much is over-design and how much really incorporates all the elements of the real game of golf? Has each hole been considered to bring you all those elements? Then you try to exploit the aesthetics and the other dynamics that the site offers.

"I'm still learning because, and I think it was Donald Ross who said this, 'God gave us the golf course, it's up to us to find the holes.' I'd rather play a solid golf course than one that just looks good. Of course, if you can have both, you've got a great golf course."